Oskar KOKOSCHKA Drawings, 1906-1965

Oskar KOKOSCHKA Drawings, 1906-1965

Edited by ERNEST RATHENAU
in collaboration with the artist

UNIVERSITY OF MIAMI PRESS
Coral Gables, Florida

Translated by Heinz Norden
from the German edition, *Oskar Kokoschka Handzeichnungen 1906-1965*,
published in 1966 by Ernest Rathenau, New York,
formerly Euphorion Verlag Berlin.
Copyright © 1966 by Ernest Rathenau.

Copyright © 1970 by
University of Miami Press
Library of Congress Catalog Card Number 76-129665
ISBN 0-87024-176-1

Designed by Bernard Lipsky
Manufactured in the United States of America

IN MEMORIAM PAUL WESTHEIM

PLATES

FOREWORD

WHEN I DRAW OR PAINT, visitors are not welcome. An animal about to give birth, a man awaiting his last hour—these too are best left alone. For every creature the keynote grows purer with the approach of the threshold that isolates it from the din and gossip of the day—be it a mother giving birth, a dying man, or an artist in the throes of creation. As if behind a window pane the outer world remains outside.

I put on an apron beforehand, of the kind butchers wear in Britain, lest everyday wear hamper me in an activity requiring all my skills and capacities—but also the luck to succeed at a single stroke. Like a surgeon who must first find within himself the assurance of being able to control what he is bent on undertaking. Before an operation, when homespun logic and routine alone fail to help surmount the crucial moment; one must learn to bring the wonted world of appearances to a standstill.

Opening a newspaper, one asks oneself involuntarily: What's new in the world? For experience shows that reality fishes from the ocean of the possible what hitherto has seemed impossible, even if one would be amply endowed with imagination. It's that way with the telephone too. To the voice announcing itself, one must imagine anew a figure although one may be intimately associated with the speaker.

Anyone who leafs through a photograph album of his closest relatives will note how swiftly memory allows the treasury of appearances to yellow. And finally, how enigmatic reality turns out to be, as one's memory impoverishes the world at the end of a year! One steps out the door from the warmth of the dark room in front of the house into freshly fallen snow and no longer recalls exactly the ozonic taste of the invigorating air of spring, the clamor of the blackbirds pursuing one another in the dry bushes, the sweet scent of the first violets underneath the pale sun. How mysterious the burgeoning of the first buds, if luck permitted it and the night frost has not prematurely plucked the flower by the neck! Luck must attend the hour of birth, the star under which one came into the world to experience in this moment the full range of destiny. No homespun

logic nor routine avails as I draw or paint, with my object or the landscape before me or left alone with the model, best of all a girl. Rather the fairy tale grows true, beginning and ending with "once upon a time . . ."

A story of which no grown-up today wants to know—a story that joins in a common journey some no longer in this world, others who are still alive, and perhaps still others who are yet to come. Such a journey becomes an adventure in the present book, a journey from which one cannot send a greeting to friends and acquaintances on a picture postcard. The harmless recipient would think he were standing on his head, for here, conjured up from nothingness, loom traces in the sand of transitoriness, endless and imperishable footprints that lead to the altar of the god unknown—reality.

November 15, 1965 Oskar Kokoschka

ACKNOWLEDGMENTS

Photographs were obtained from the following individuals and institutions:

Albertina, Vienna
Brenwasser, New York
Alfred Carlebach, London
Conzett & Huber, Zurich
Efraim Erde, Tel Aviv
Gertrude Fehr, Territet
Foto-Commissie, Rijksmuseum, Amsterdam
John R. Freeman & Co. Ltd., London
Gnilka, Berlin
F. Jezerský, Prague
Museum für Kunst und Gewerbe, Hamburg
Rosmarie Nohr, Munich
Öffentliche Kunstsammlung, Basel
H. J. Orgler, London
Eric Pollitzer, Garden City Park, New York
A. E. Princehorn, Oberlin, Ohio
Reiffenstein, Vienna
Rheinisches Bildarchiv, Cologne
Oscar Savio, Rome
John D. Schiff, New York
H. Schmeck, Siegen, Westphalia
Ingeborg Sello, Hamburg
Staatliche Museen zu Berlin, East Berlin
Rudolf Stepanek, Vienna
Stickelmann, Bremen
Marc Vaux, Paris
Weizsäcker, Stuttgart
Walter Zorn, Dresden

Oskar KOKOSCHKA Drawings, 1906-1965

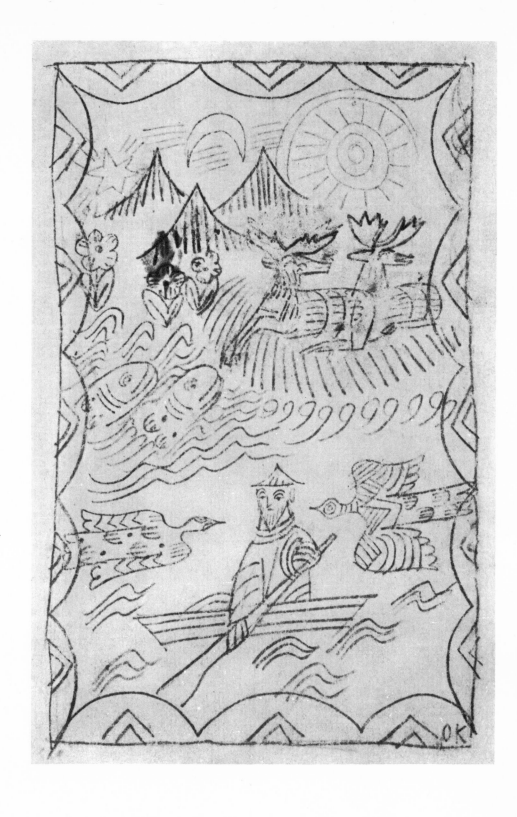

Man with Serpent.
About 1906. Pencil, pen, wash. 22.2 x 18.2 centimeters.
Marlborough Fine Art Ltd., London.

A study for the lithograph series
Die träumenden Knaben, reproduced in the Viennese
magazine *Erdgeist,* 1908, volume 3, number 6,
page 175, titled *Der schmale Weg.*

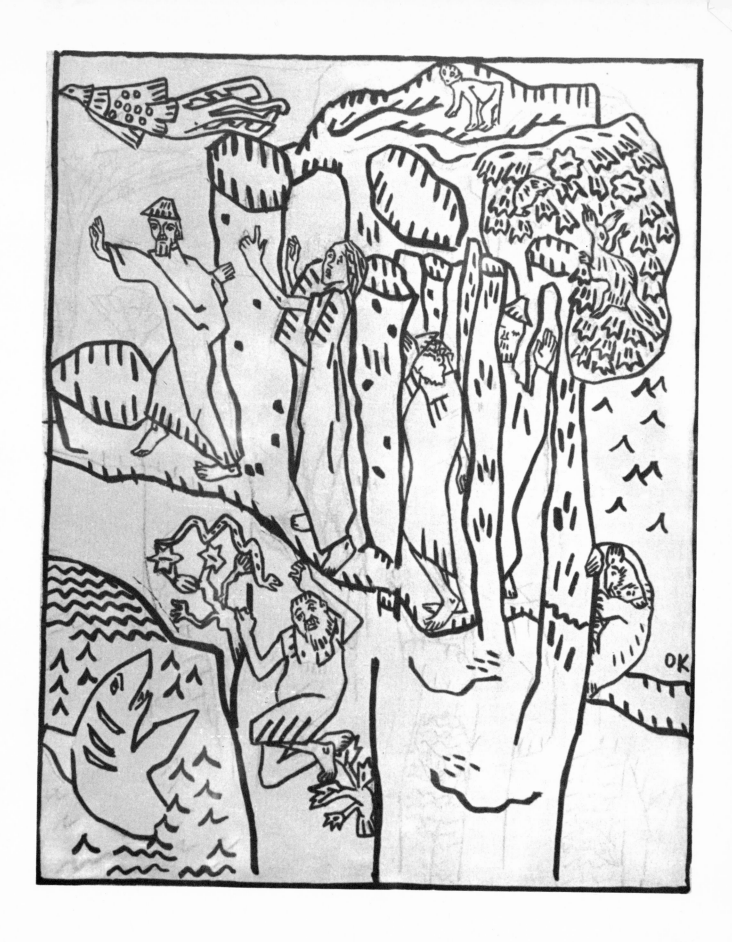

Study for a postcard of the Wiener Werkstätte, Genevieve.
1906-1907. Pencil, pen, wash, watercolor. 13.4 x 8.4 centimeters.
Städtische Kunsthalle Mannheim.

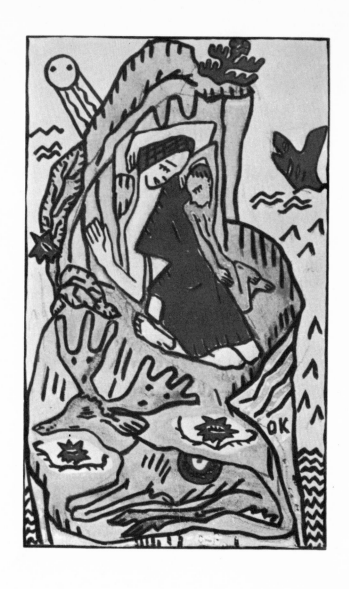

Female motion study.
1906-1907. Pencil. 37 x 50.5 centimeters.
Ernest Rathenau, New York.

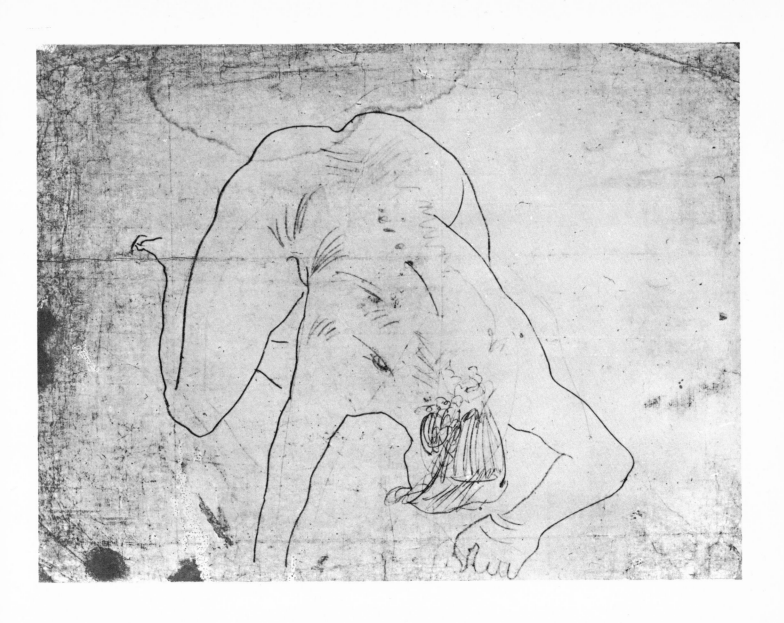

Nude study.
1906-1907, possibly 1905. Pencil, watercolor. 44.1 x 30.3 centimeters.
Oberlin College, Allen Art Museum, Oberlin, Ohio
Bequest of Elizabeth Lotte Franzos.

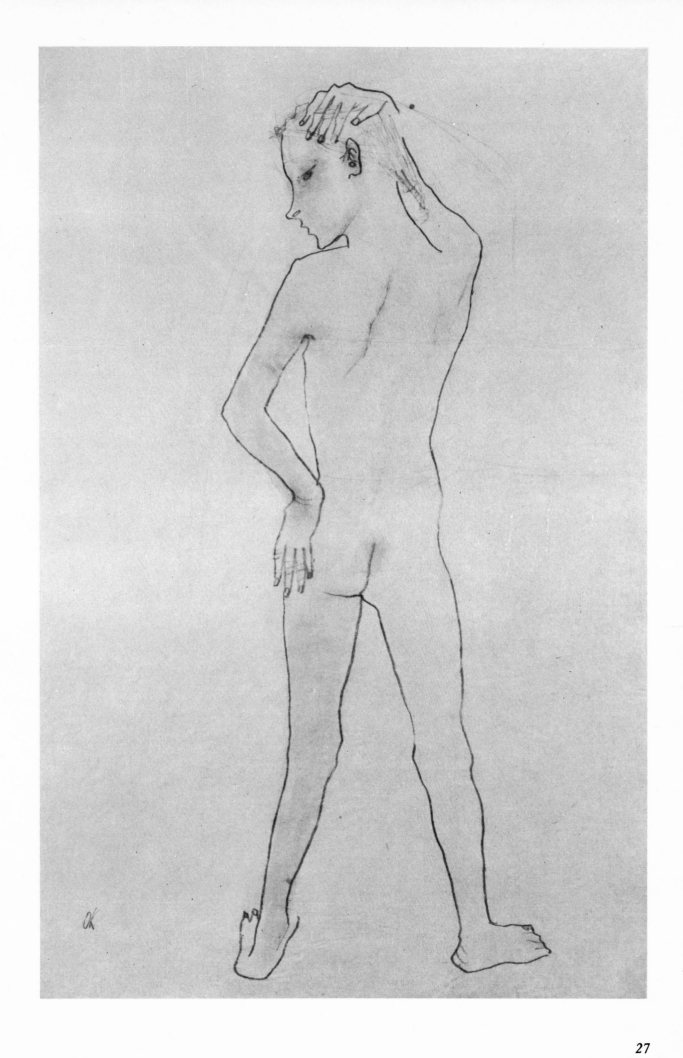

The Juggler.
1906-1907. Pencil. 38 x 24 centimeters.
Colonel Norman Colville, Launceston, Cornwall.

Subsequently signed lower left:
Bestätige dass diese Zeichnung aus
dem Jahre 1907 echt
und von meiner Hand stammt
OKokoschka.

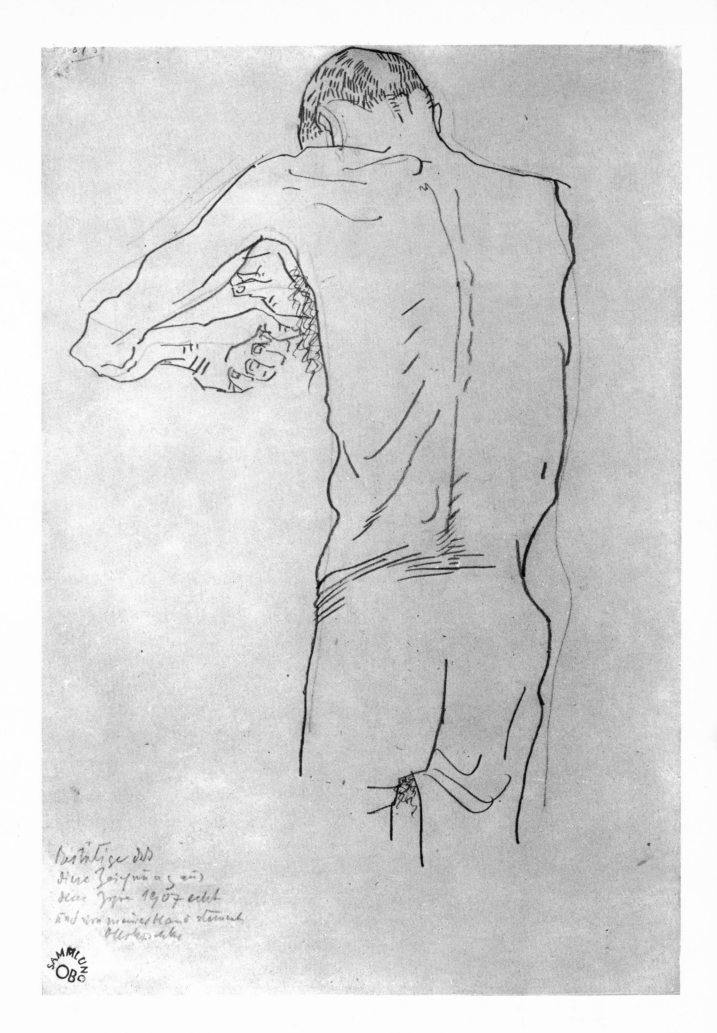

Bestätige daß
diese Zeichnung aus
dem Jahre 1907 echt
und von meiner Hand stammt
Oskar Kokoschka

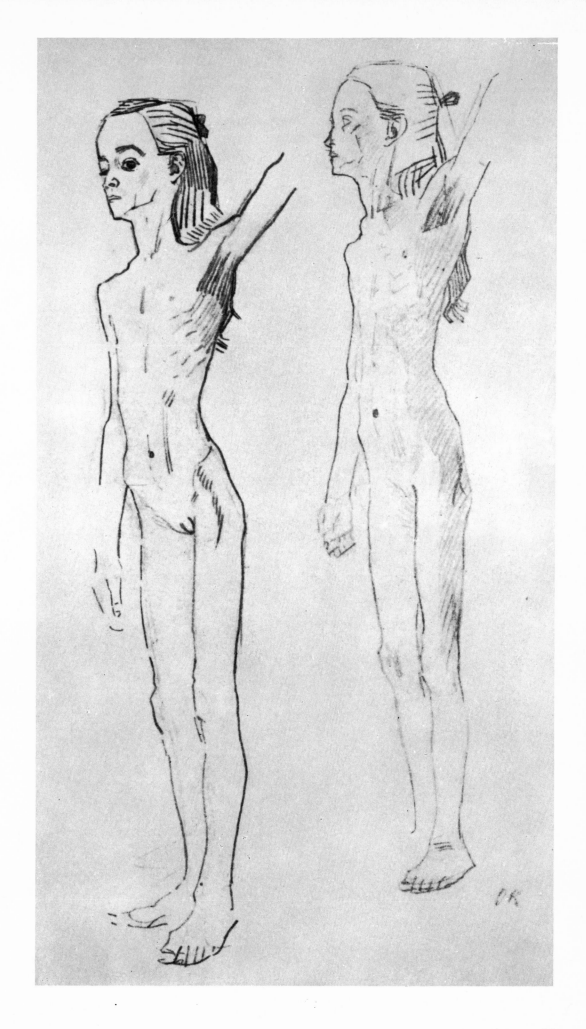

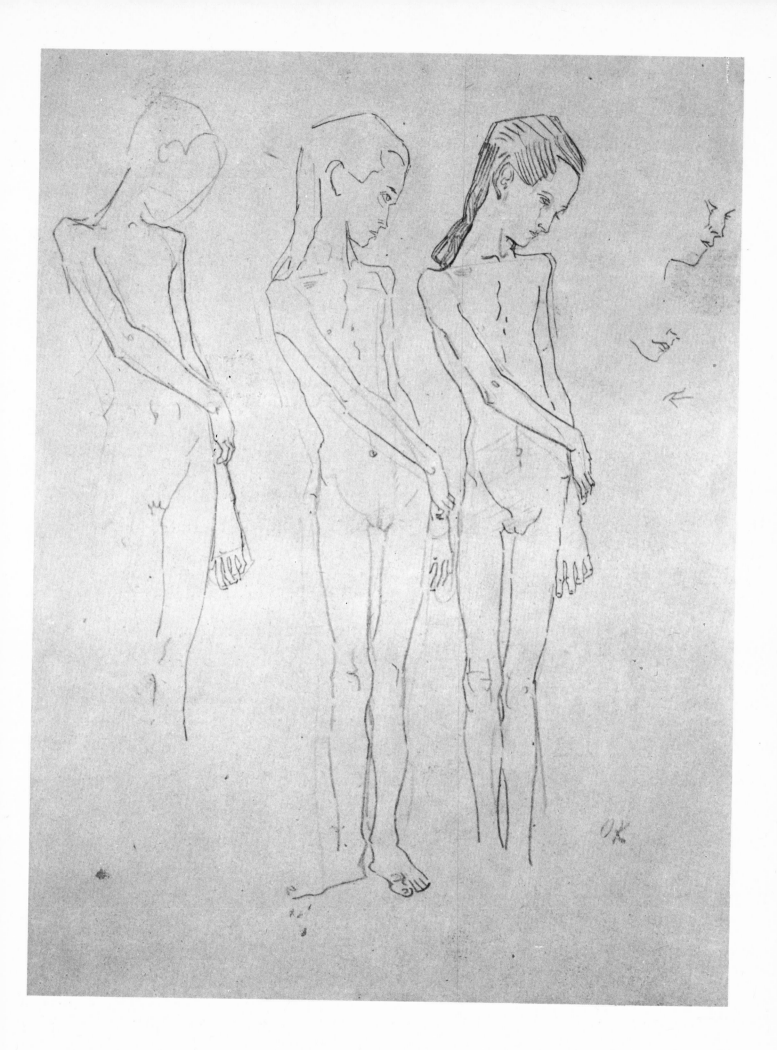

Daughter of the Juggler.
1906-1907. Pencil. 45 x 30 centimeters.
Professor Edgar Horstmann, Hamburg.

A study for the lithograph series
Die träumenden Knaben.

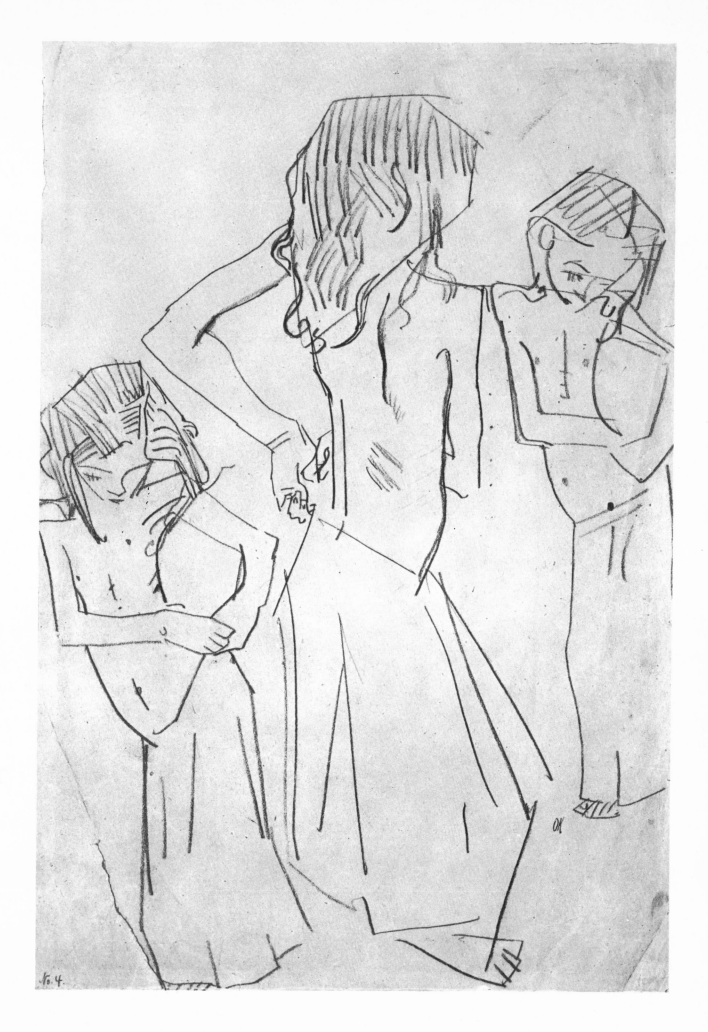

Daughter of the Juggler.
1906-1907. Pencil, watercolor. 42.9 x 25.4 centimeters.
Staatliche Kunstsammlungen Dresden, Kupferstich-Kabinett.

A study for the lithograph series *Die träumenden Knaben,*
(girl in blue skirt, upper part of body bare).

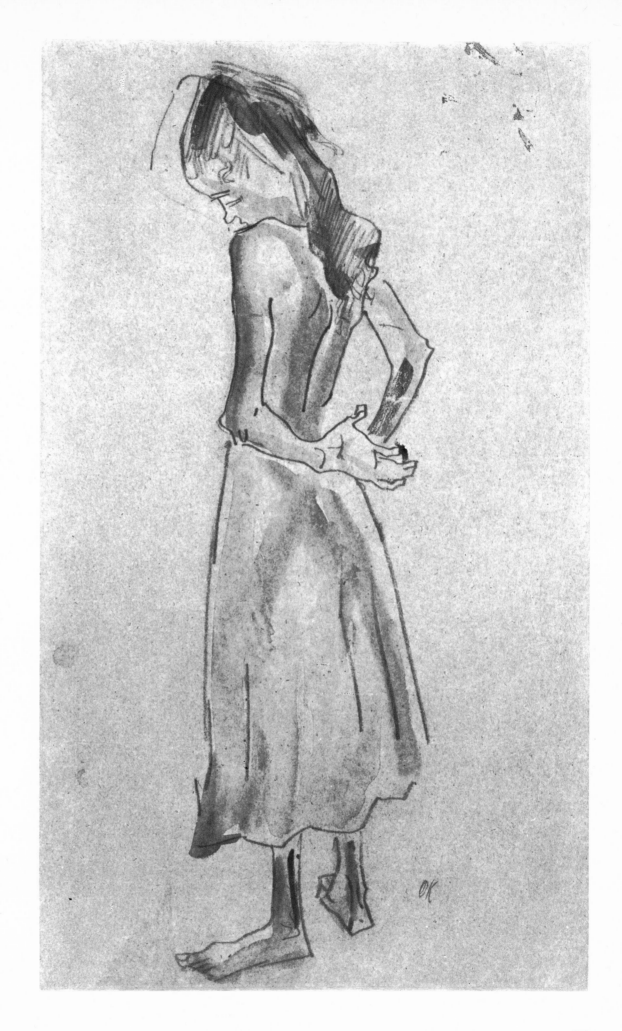

Daughter of the Juggler.
1906-1907. Pencil, watercolor. 42.9 x 25.4 centimeters.
Staatliche Kunstsammlungen Dresden, Kupferstich-Kabinett.

A study for the lithograph series *Die träumenden Knaben*
(one female nude kneeling toward the left, another crouching).

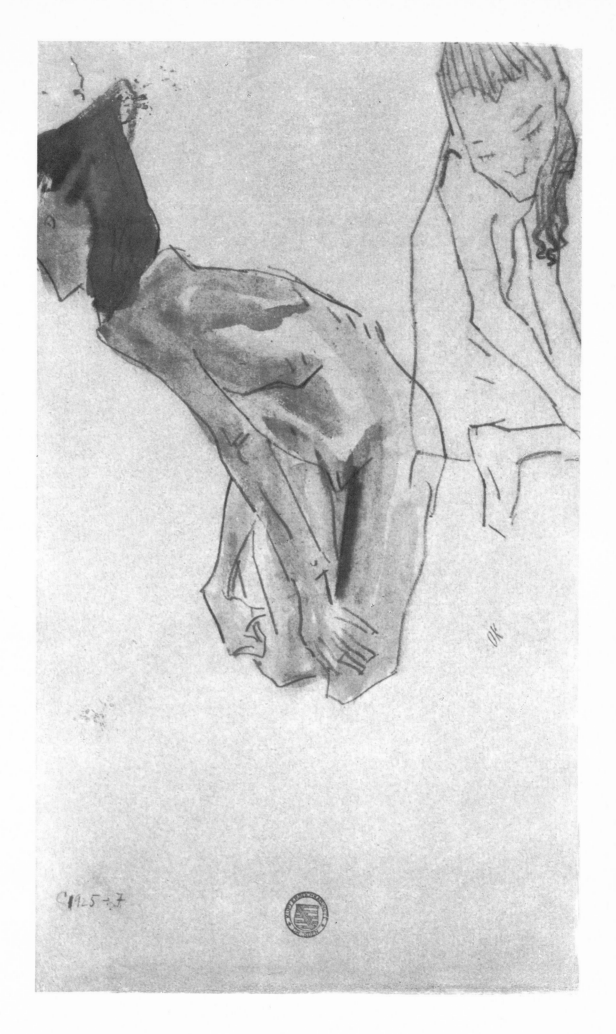

Daughter of the Juggler.
1906-1907. Pencil. 44.7 x 31.7 centimeters.
Wallraf-Richartz-Museum, Kupferstich-Kabinett, Cologne.

A study for the lithograph series
Die träumenden Knaben.

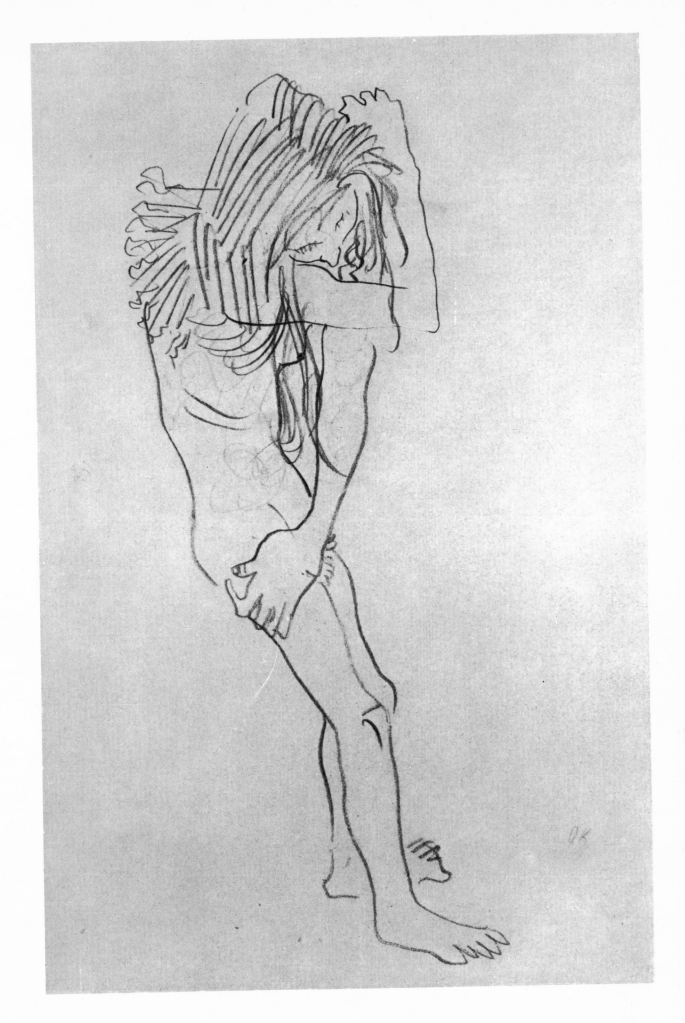

Two Girls.
1906-1907. Pencil, watercolor. 44 x 30.7 centimeters.
Private ownership.

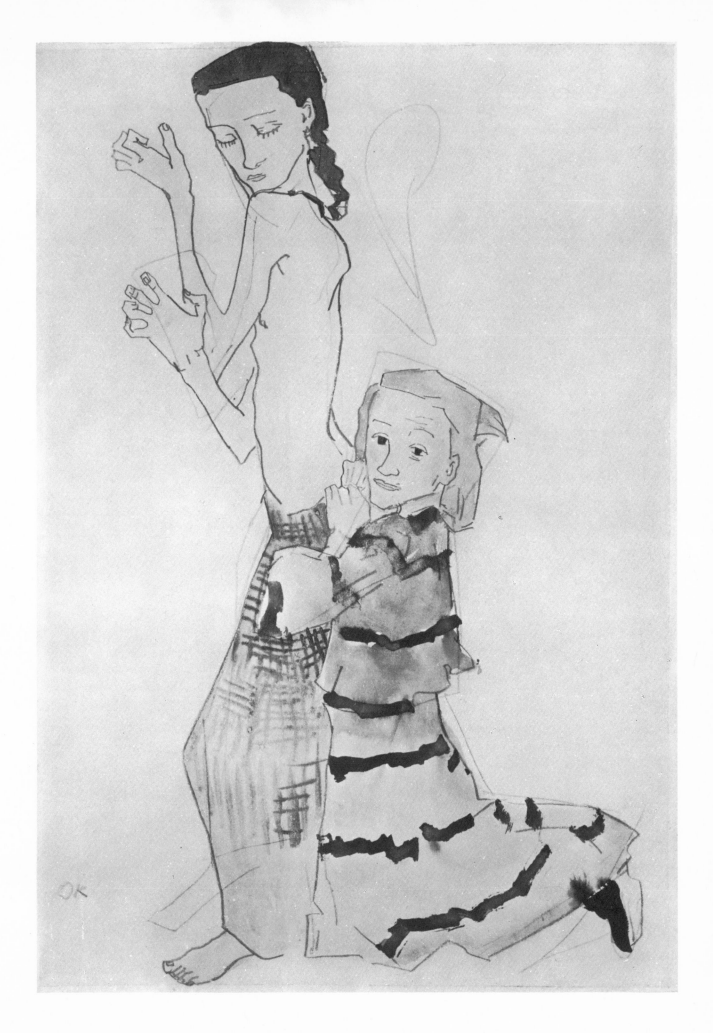

Motion study.
1906-1907. Pencil. 44.7 x 29.5 centimeters.
Dr. Hans Kleinschmidt, New York.

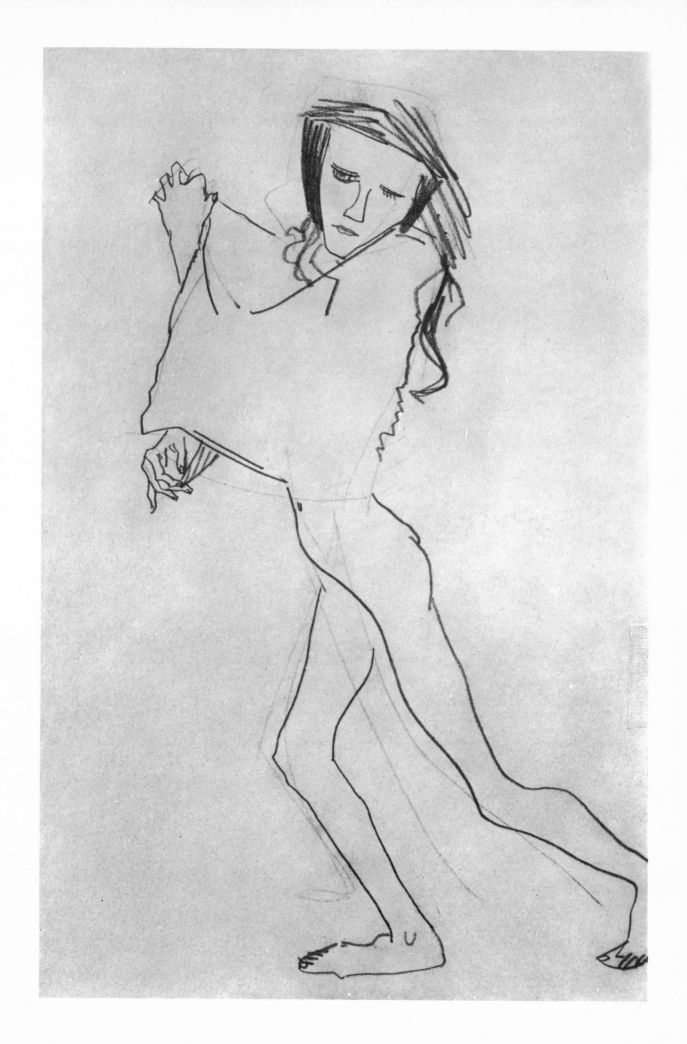

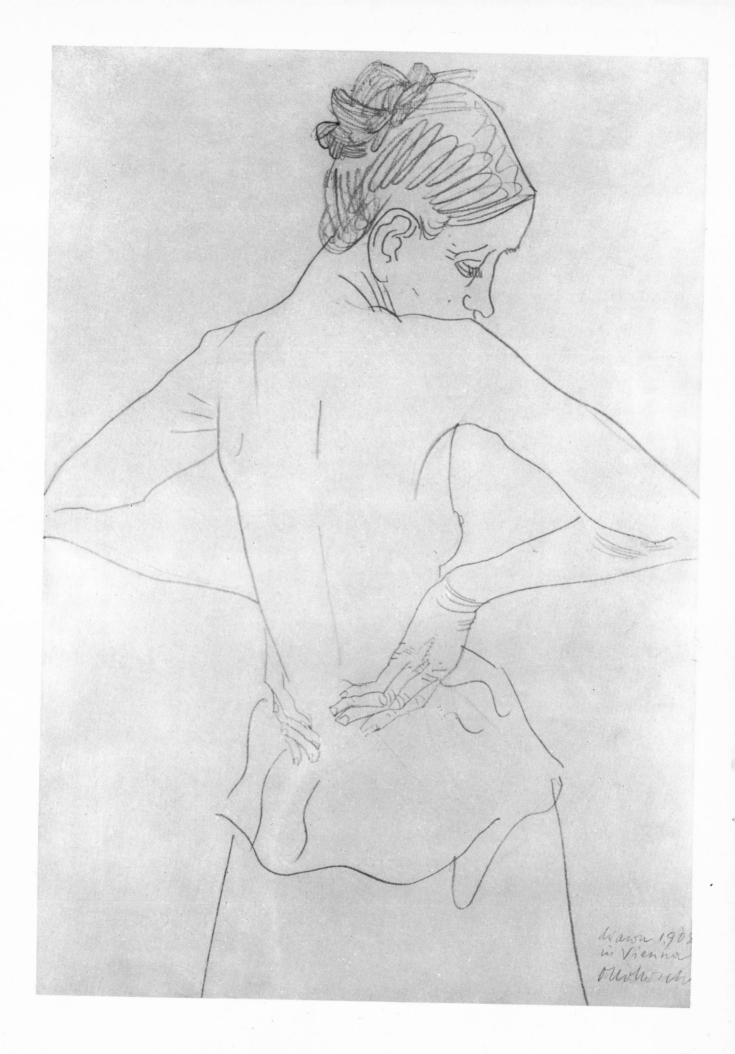

March 1903
in Vienna
O Kokoschka

Young Girl with Outstretched Right Arm.
About 1907. Pencil, watercolor. 43.7 x 30.4 centimeters.
National-Galerie, East Berlin.

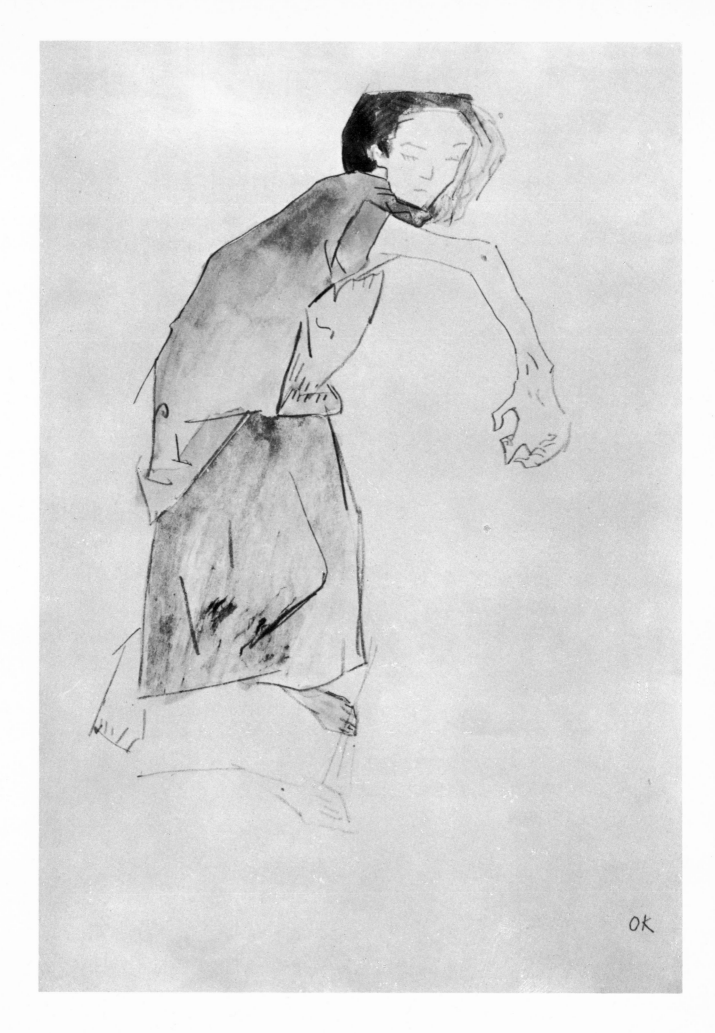

49

Kaiser Jubilaeums Huldigungsfestzug Wien 1908 Juni.
1908. Tempera. 134 x 92 centimeters.
Historical Museum of the City of Vienna.

Poster design for the emperor's jubilee procession.
On the back of the photograph the artist wrote:
*Vom Comitée des K. J. Festumzugs vermutlich
nicht angenommen weil damals bloss Ornamente, Meander,
Ranken etc. erlaubt waren von der Kunstgewerbeschule,
die die Geschmacksrichtung officiell leitete.*

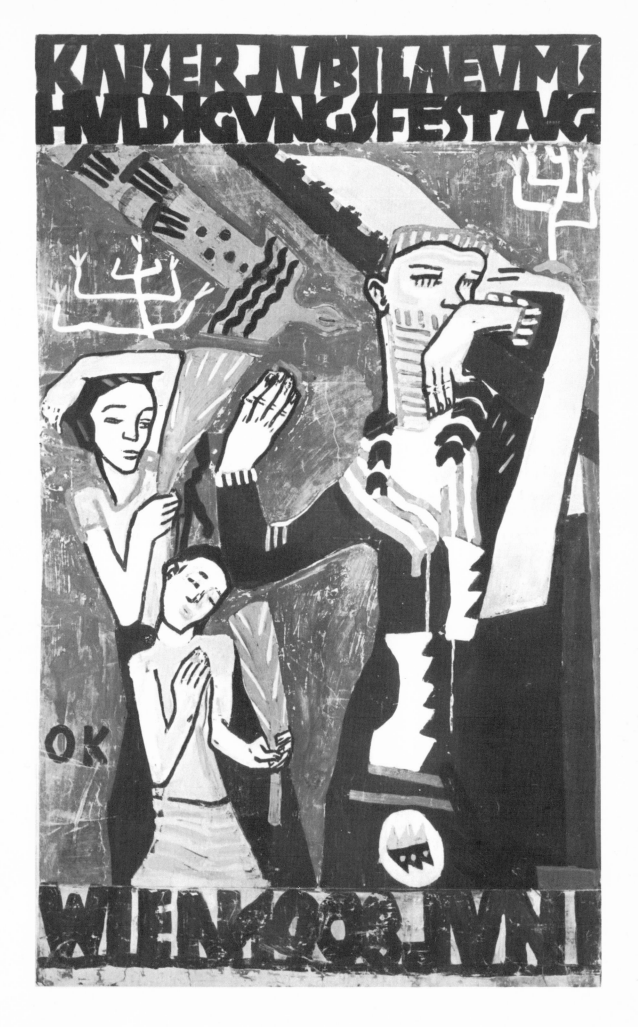

51

Design for the emperor's jubilee procession.
1908. Pencil, wash, tempera. 24 x 17.9 centimeters.
Historical Museum of the City of Vienna.

On the back of the photograph the artist wrote:
*Skizzen für die Winzergruppe, die ich für
den Kaiser-Jubiläumsfestzug ausstatten durfte,
dank Prof. Roller und Prof. Czeschka.*

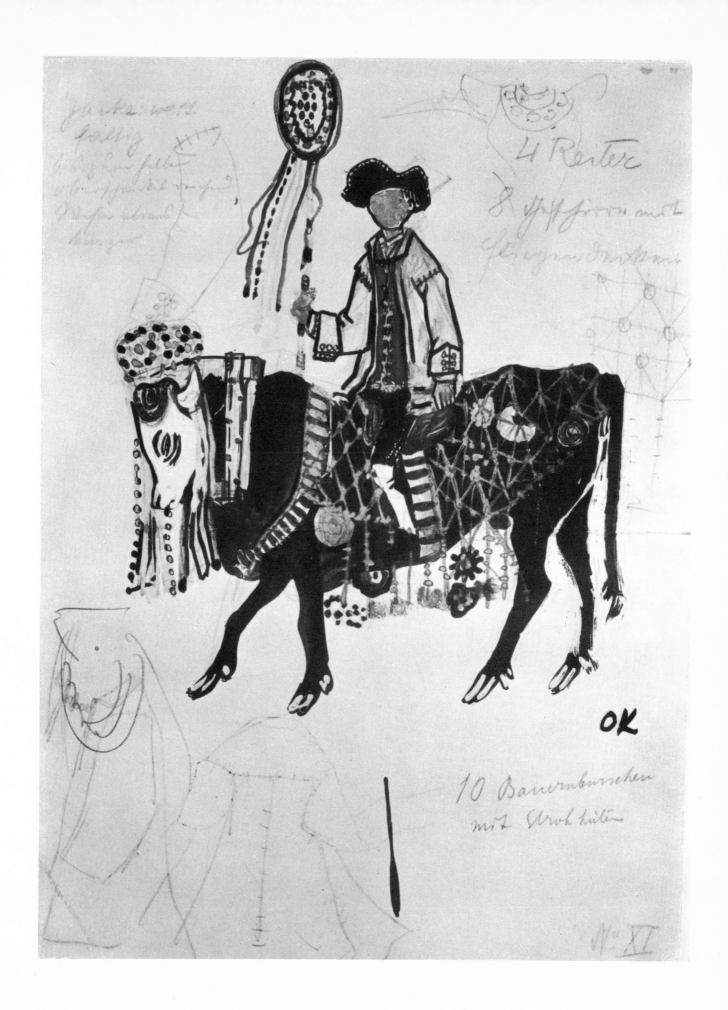

Sketches for the vintner's group in Emperor Franz Josef's jubilee procession. 1908. Pencil, wash, tempera, 31.8 x 45 centimeters. Historical Museum of the City of Vienna.

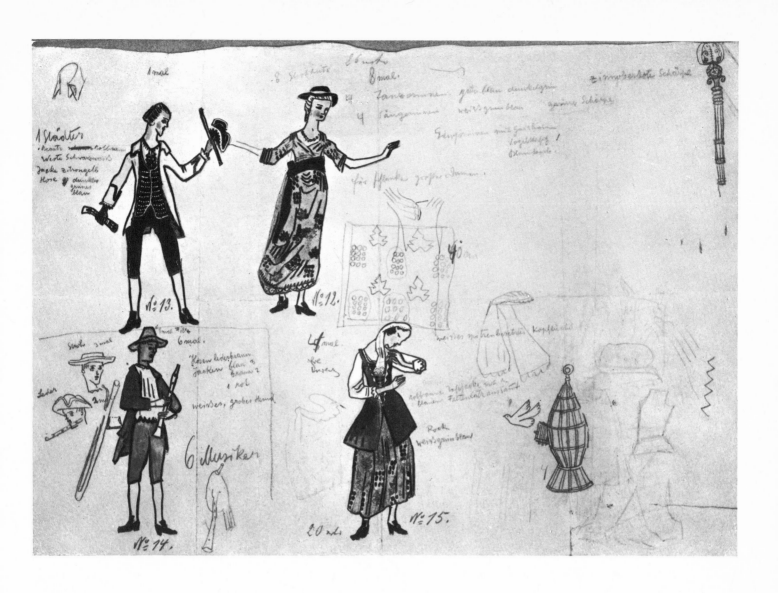

Motion study.
1908. Pencil, watercolor. 43.5 x 31 centimeters.
Wolfgang Gurlitt Gallery, Munich.

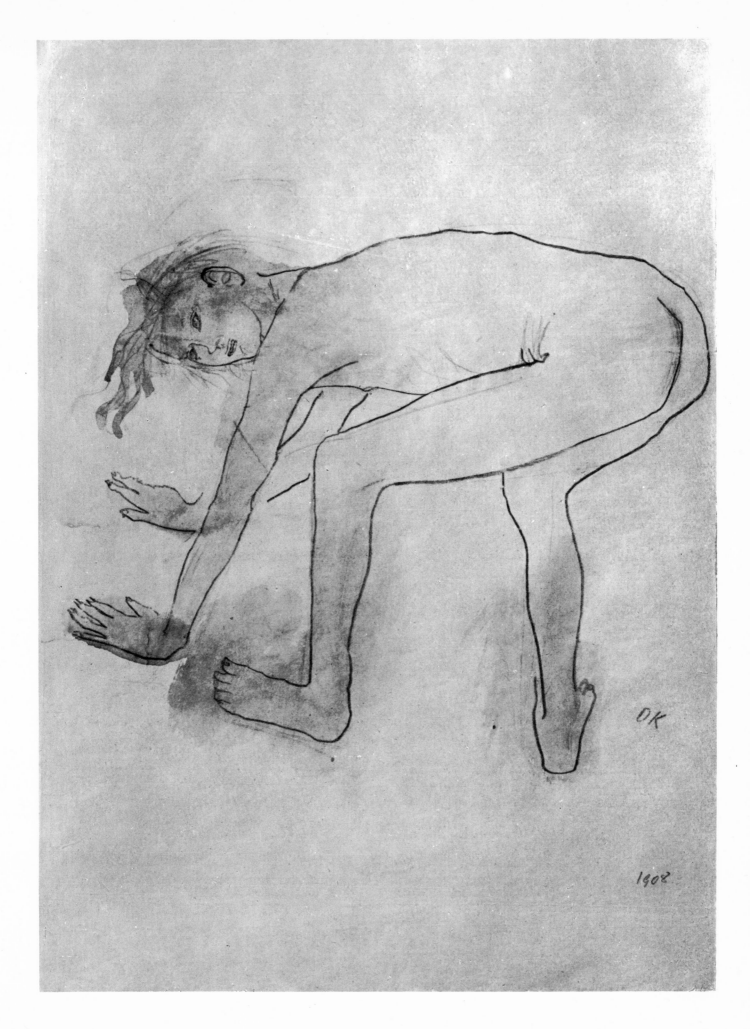

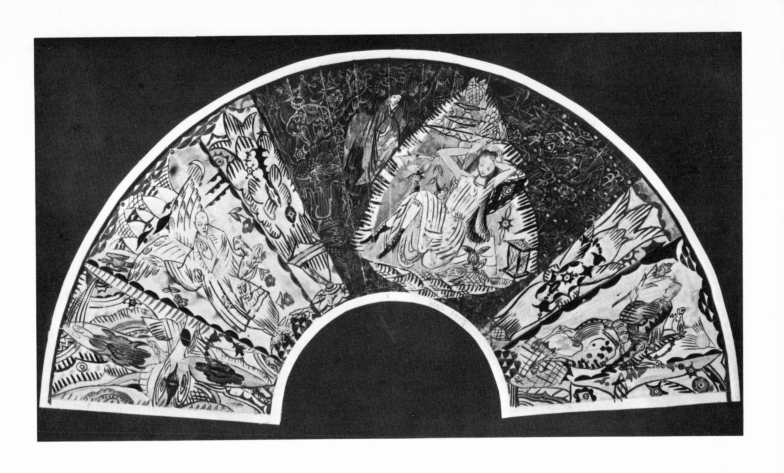

Sketch for a Poster, Kokoschka Drama-Comedy, Summer Theater, Art Exhibition.
1908. Charcoal.
Photograph from the Dorotheum, Vienna.

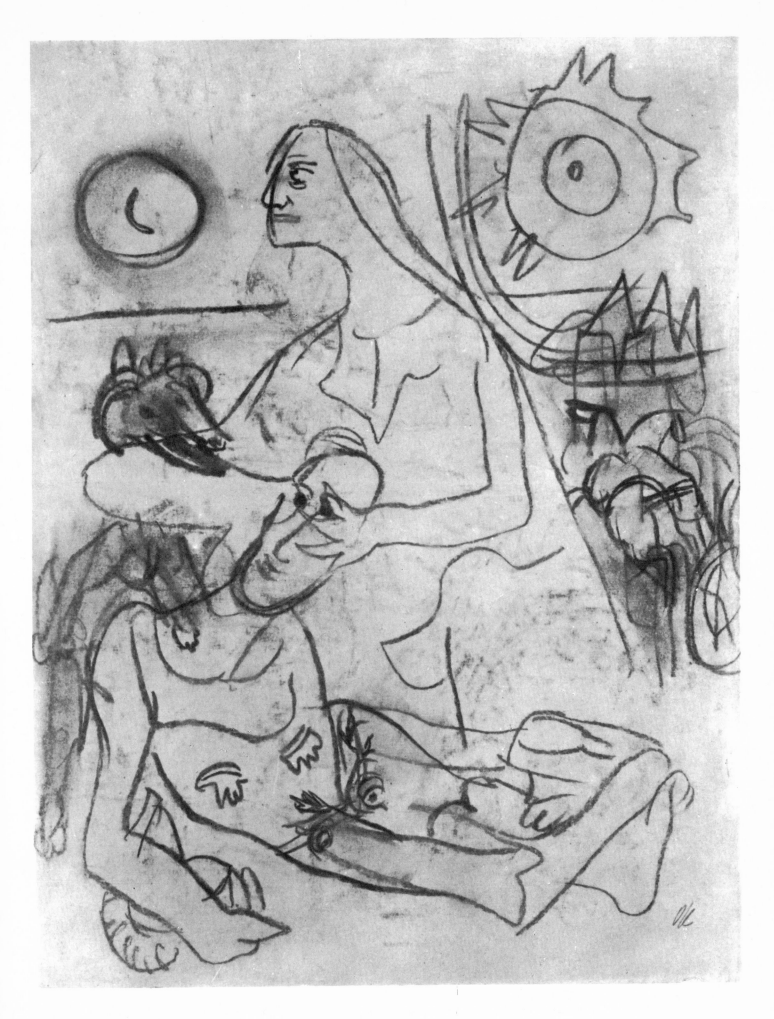

Mrs. Elise Reitler.
1909. Chalk crayon. 54 x 38.5 centimeters.
Dr. Hans Röder, Zurich.

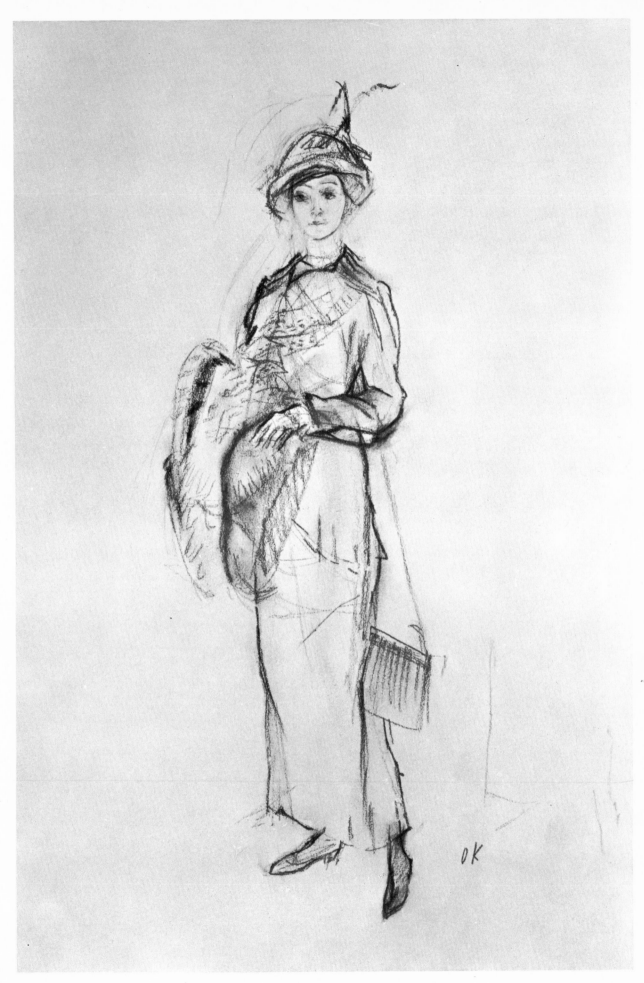

This

Study for a lecture poster in 1912 (self-portrait).
1912. Pencil. 25 x 18.7 centimeters.
Wolfgang Gurlitt Gallery, Munich.

Signed lower right
26.1.12
Vortrag OKokoschka.

26.1.12

Vortrag OKokoschka

Alma Maria Mahler.
1912. Chalk crayon.

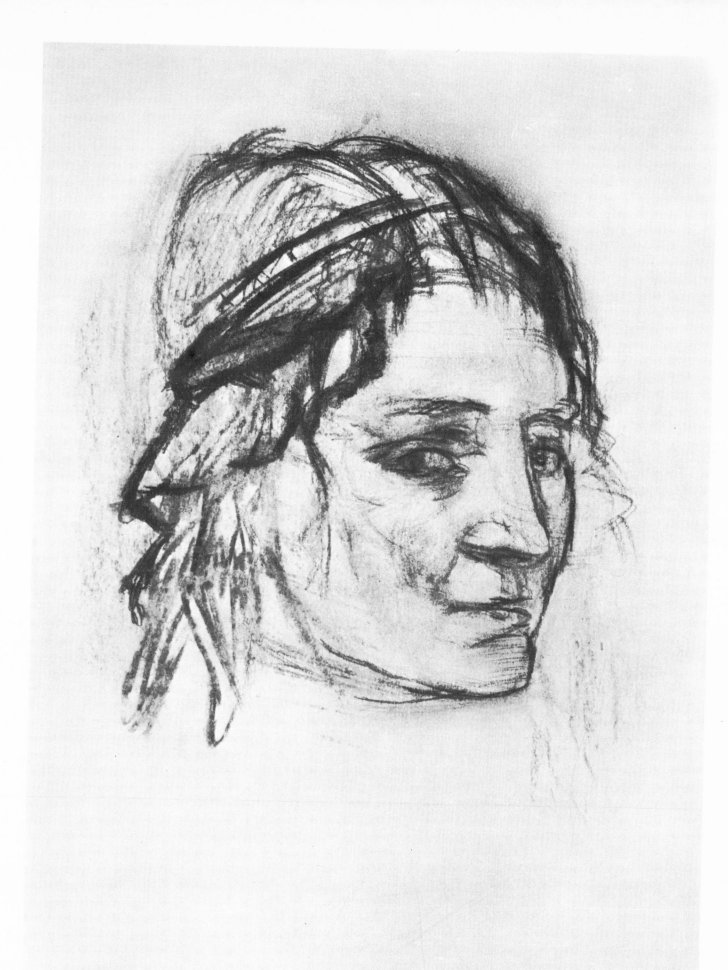

Alma Maria Mahler.
1912-1913. Pencil chalk crayon. 33.3 x 33.6 centimeters.
Stattliche Kunstsammlungen Dresden, Kupferstich-Kabinett.

Portrait study for *Der gefesselte Columbus*
and the painting Wingler 78.

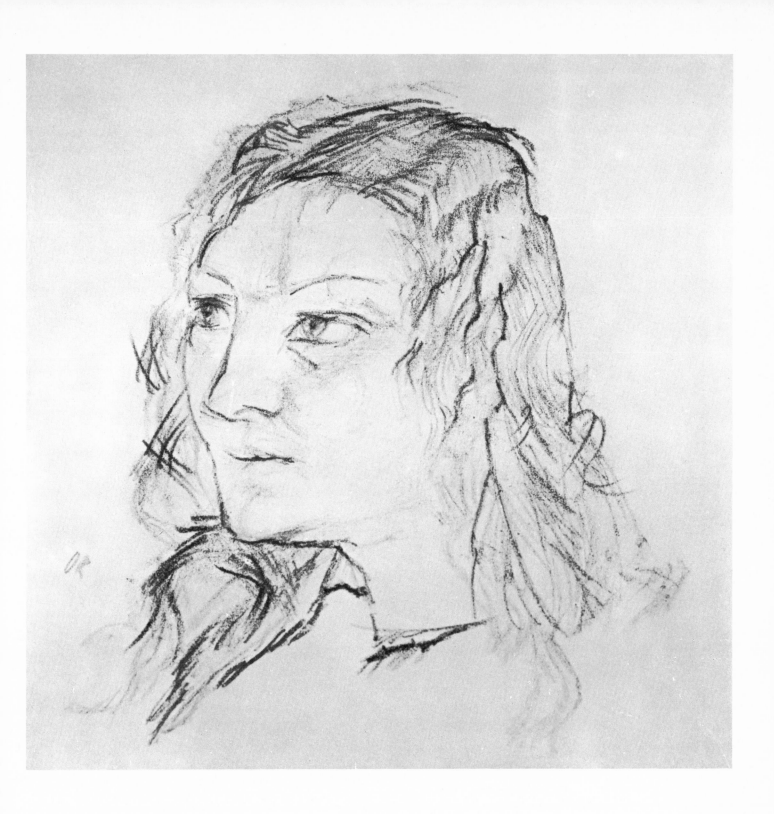

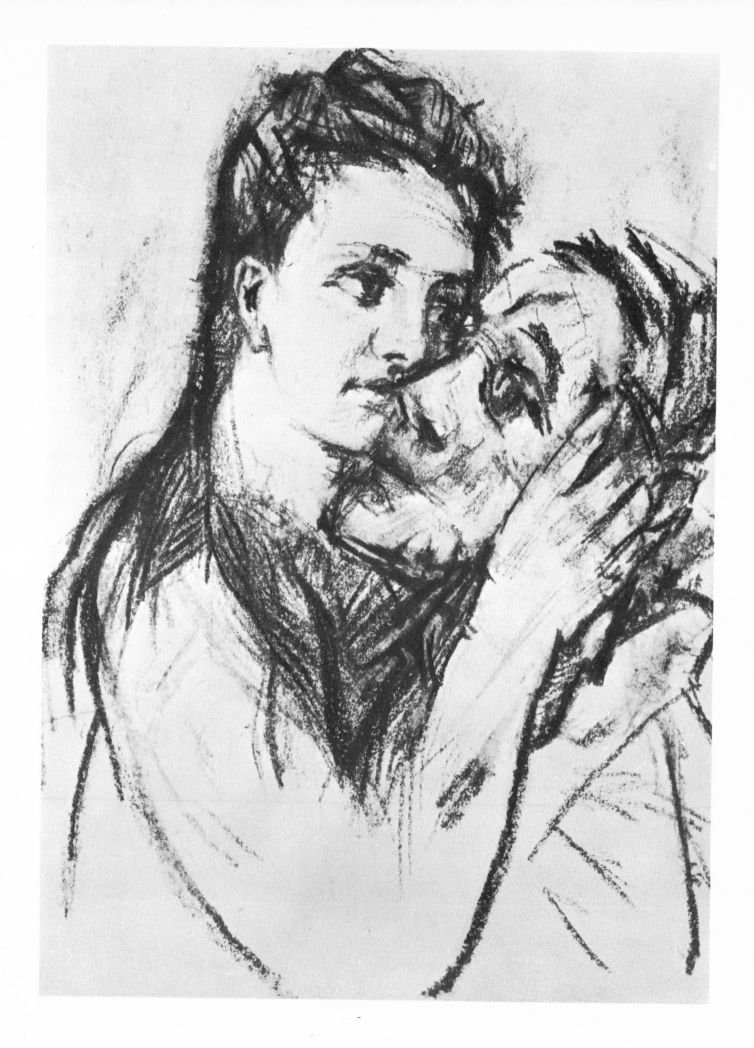

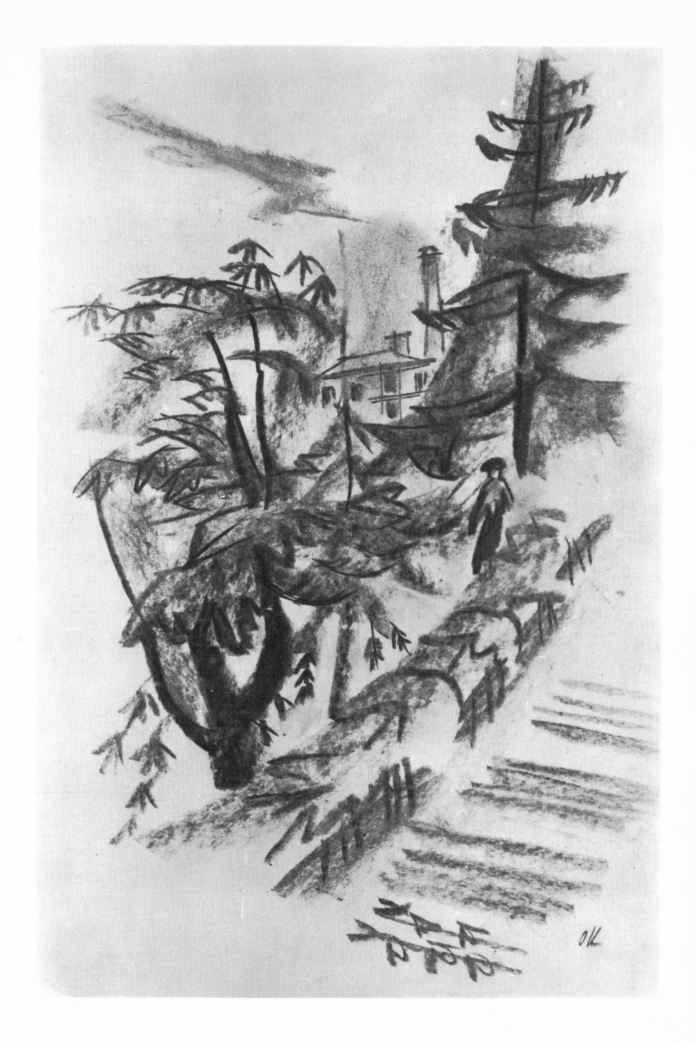

73

Posilipo.
1913. Chalk crayon. 25.4 x 37.5 centimeters.
Private ownership, United States.

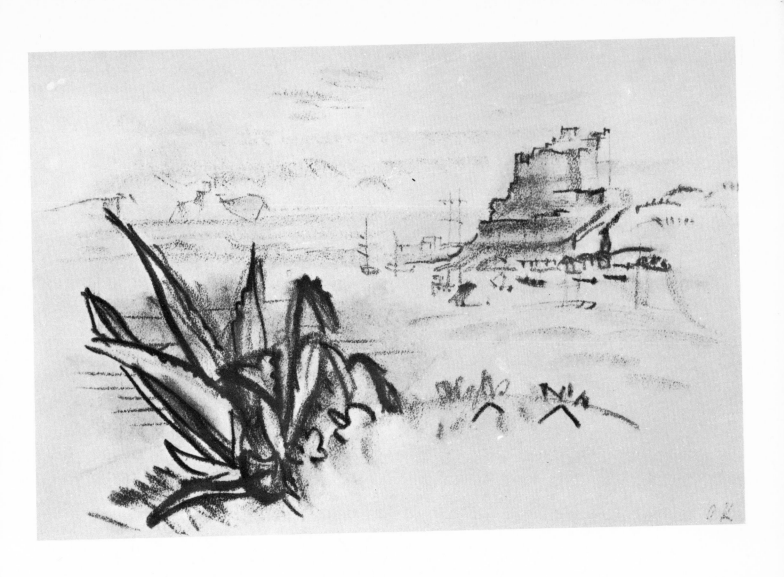

Harbor of Naples.
1913. Pastel. 25.5 x 34.5 centimeters.
Galerie St. Etienne, New York.

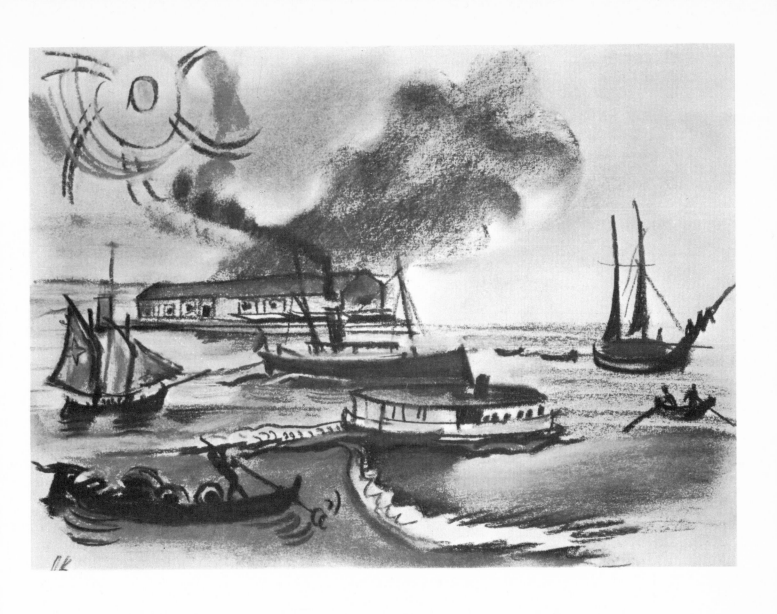

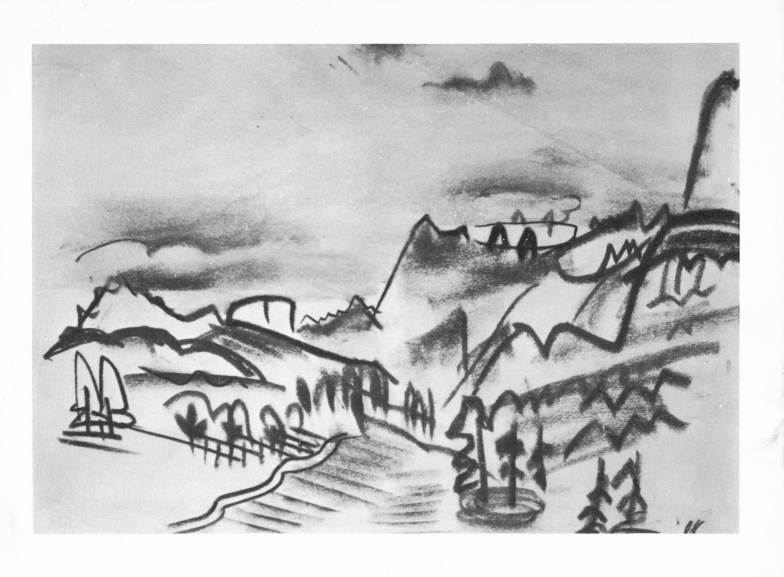

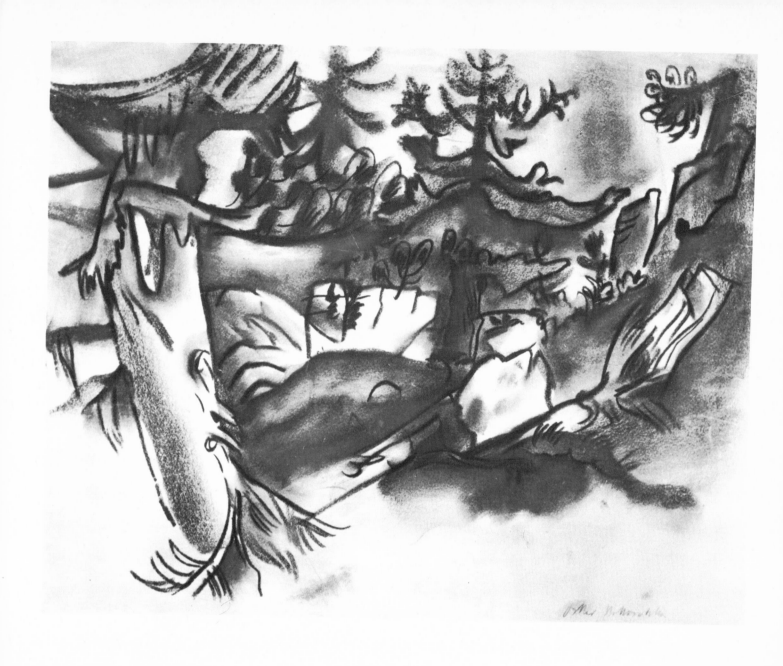

Study for Karl Kraus' *Die chinesische Mauer* (not used).
1913. Charcoal. 29.5 x 22 centimeters.
Mrs. Lotte Friedlander, New York.

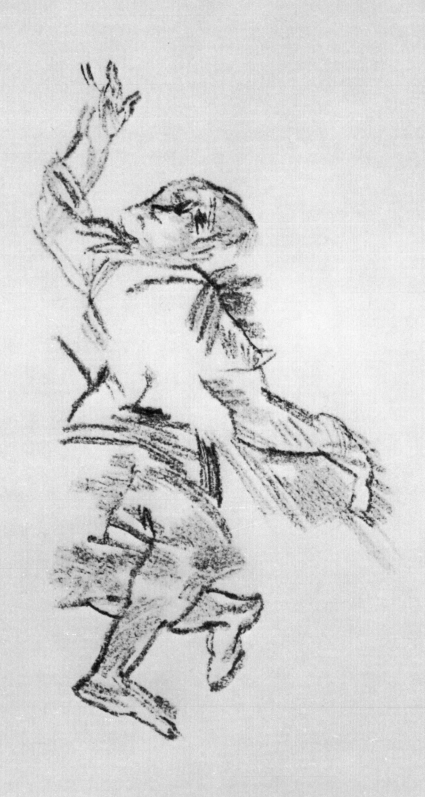

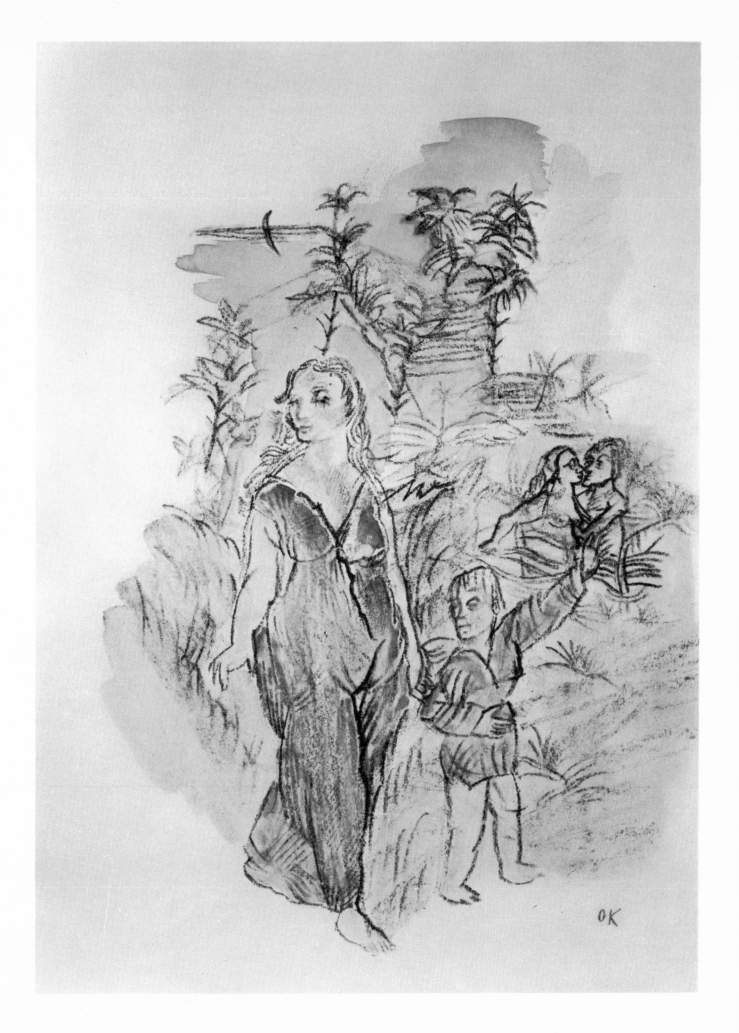

The Innkeeper Josef Hauer.
1914. Chalk crayon. 41.1 x 30.9 centimeters.
Neue Staatsgalerie, Munich, gift of Sofie and Emanuel Fohn.

A study for the painting Wingler 92.

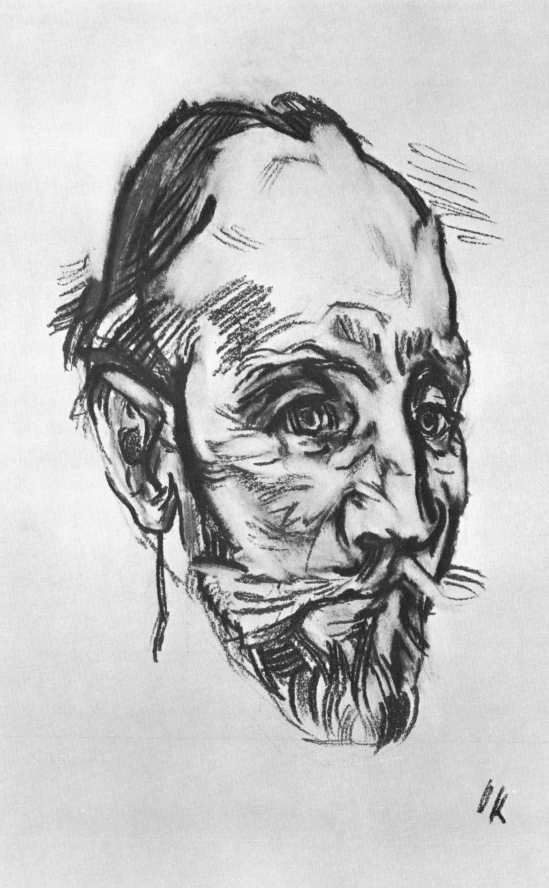

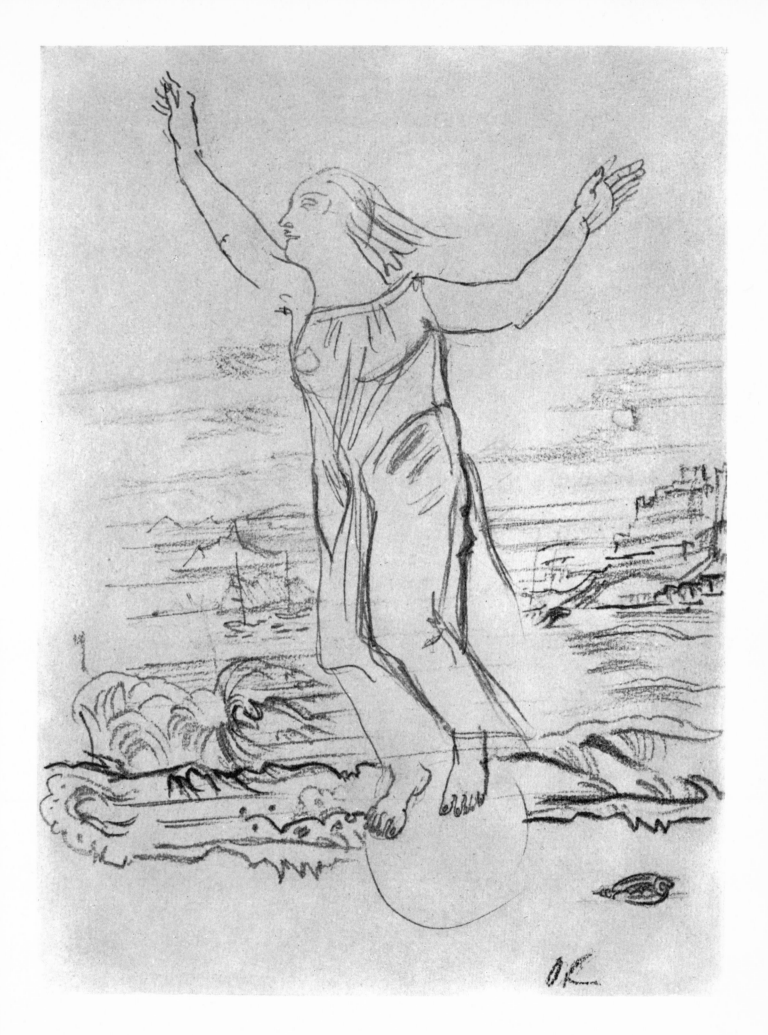

Preliminary drawing for *Bach-Kantate,* Woman Leading Man.
1914. Chalk crayon. 48.3 x 31.5 centimeters.
Rudolf Plaas, Siegen, Westphalia.

To go with the recitative *Oh schwerer Gang
zum letzten Kampf und Streite. . . .*

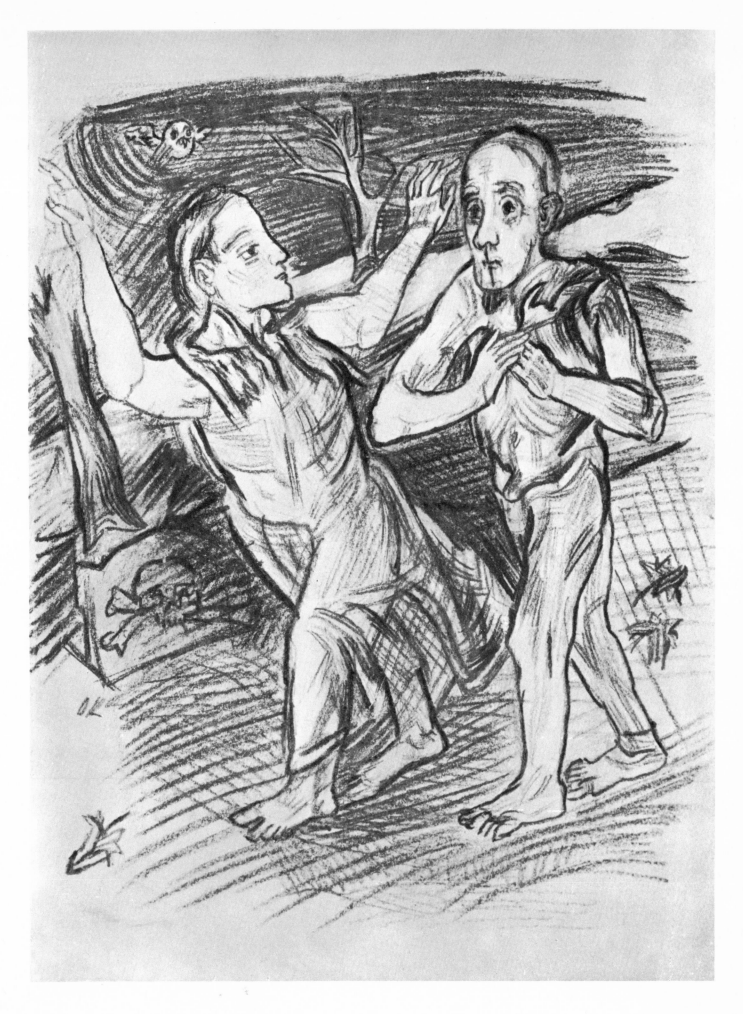

Study for *Die Windsbraut*, Wingler 96.
1914. Charcoal.
Photograph from the Welz Gallery, Salzburg.

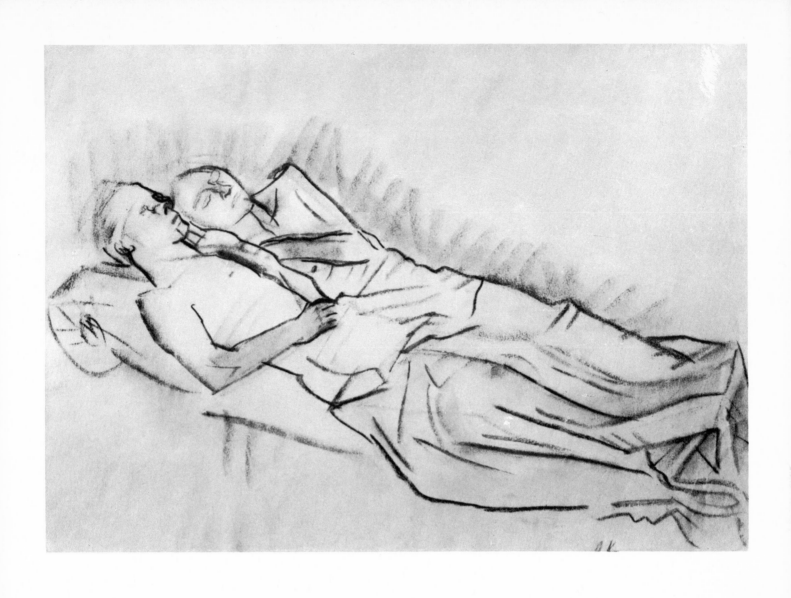

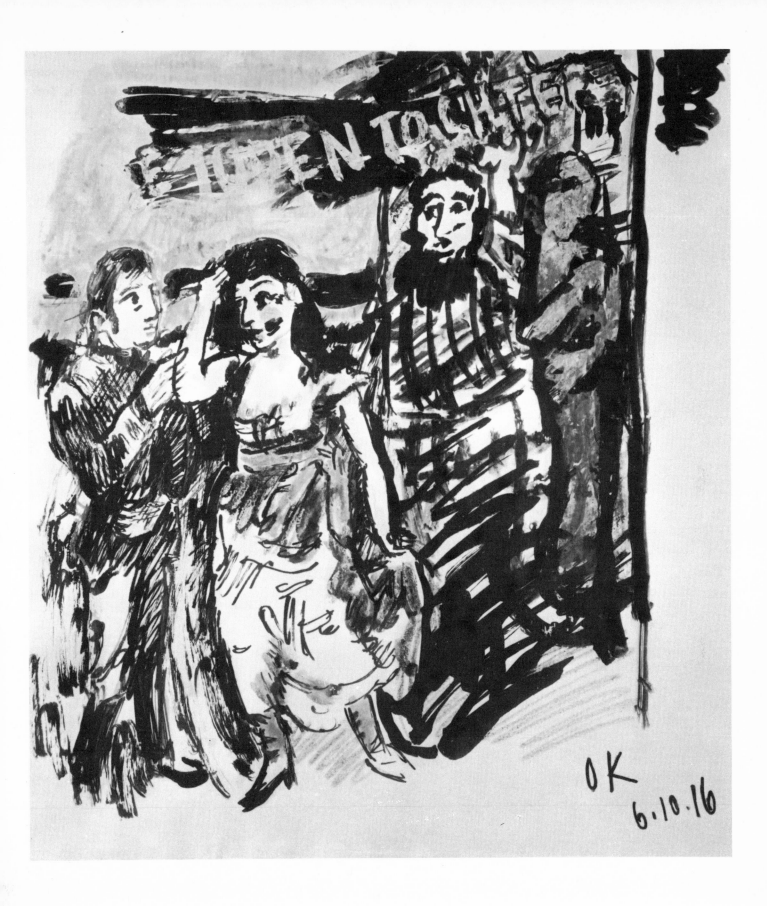

Jacket for Herwarth Walden's *Die Judentochter.*
1916. Brush, wash. 35 x 29 centimeters.
Wolfgang Gurlitt Gallery, Munich.

Die Judentochter is a poetic work from
Des Knaben Wunderhorn, for voice and piano, work 17,
published by Der Sturm, Berlin. For publication, *Jude* was
removed and the drawing hand-colored.

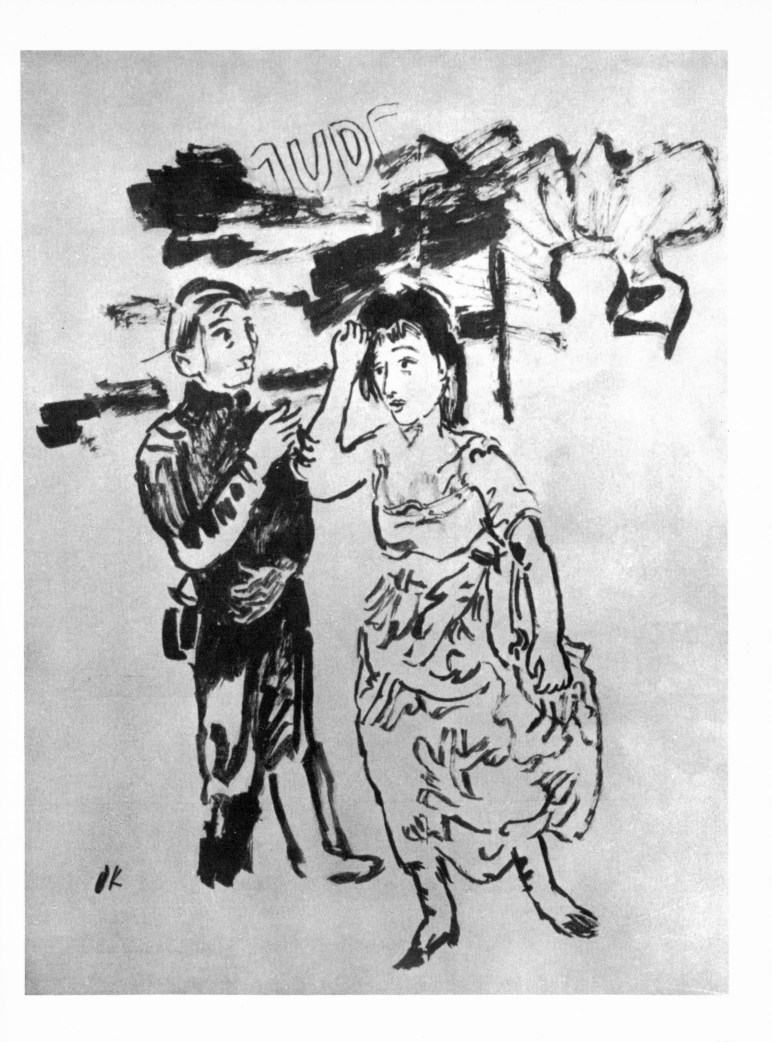

The Battle, larger version.
1916. Reed pen, wash. 33 x 31 centimeters.

The smaller version of The Battle,
chalk crayon and wash, done at about the same time, was
formerly in the Nell Walden collection.

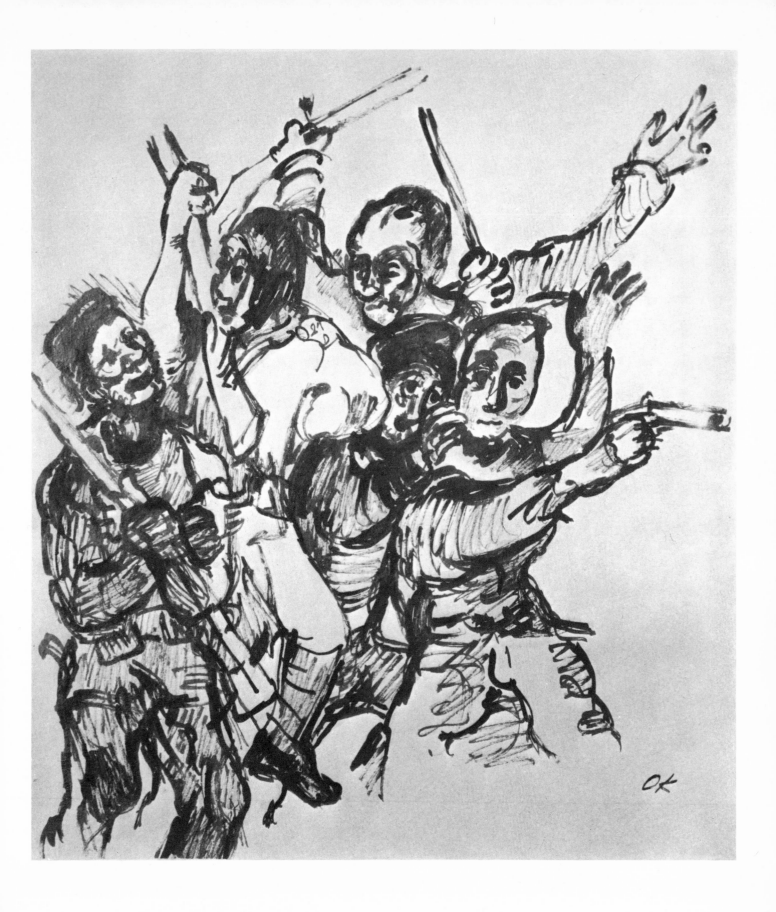

Crucifixion, drawing for *Die Passion*.
1916. Chalk crayon. 27 x 31 centimeters.

Die Passion is a sketch for a lithograph
in *Der Bildermann,* volume 1, number 12, September 20, 1916.

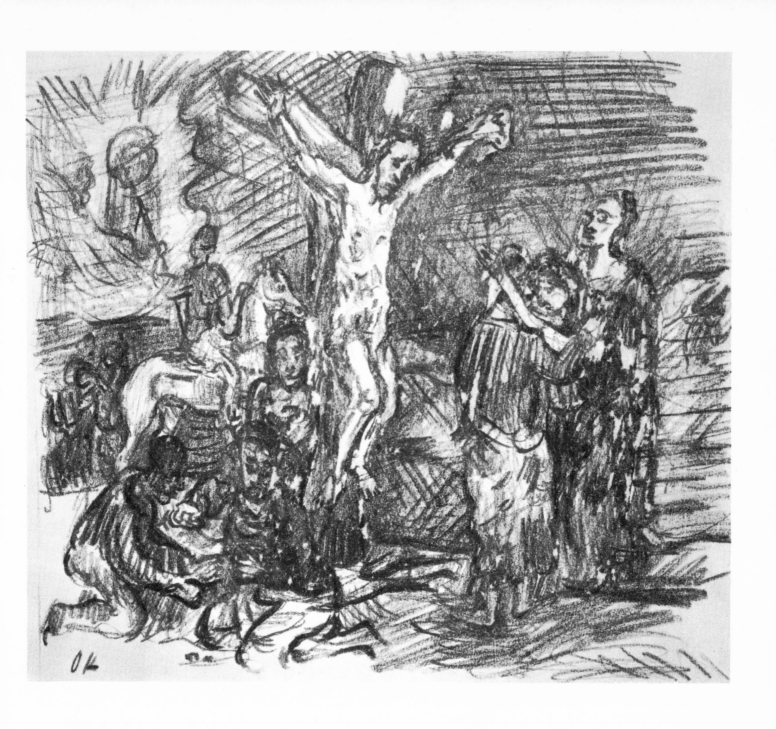

Flight into Egypt.
1916. Chalk crayon. 28.7 x 42.5 centimeters.
Wolfgang Gurlitt Gallery, Munich.

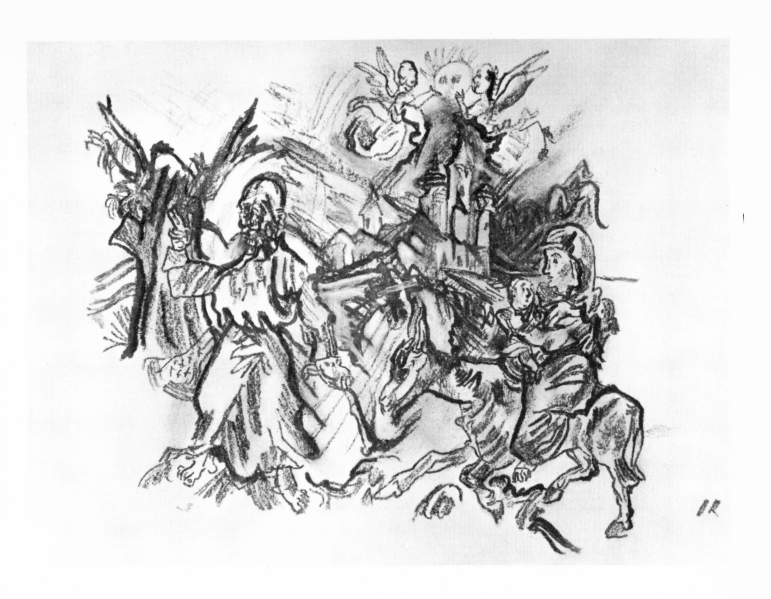

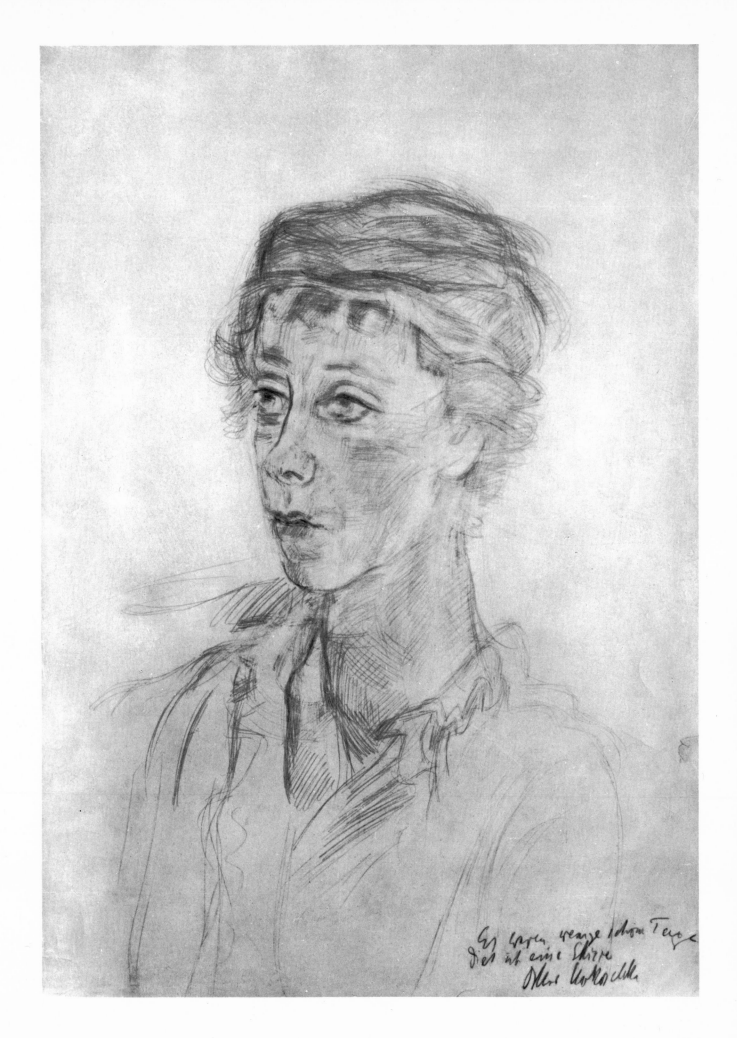

Es gegen wenige schon Tage
dies ist eine Skizze
Oskar Kokoschka

Sketch from the First World War, Recollection of a Battlefield in Russia. 1917. Red pencil. 49 x 34 centimeters. Wolfgang Gurlitt Gallery, Munich.

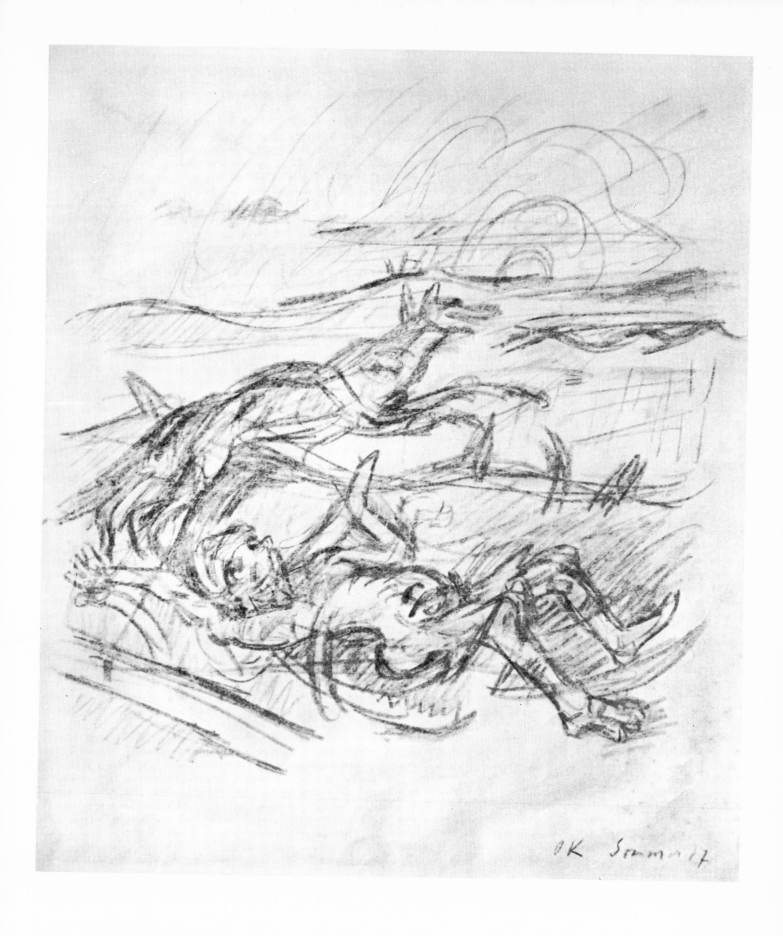

Study for *Hiob*.
1917. Brush, wash, chalk crayon. 45.4 x 46.7 centimeters.
Wolfgang Gurlitt Gallery, Munich.

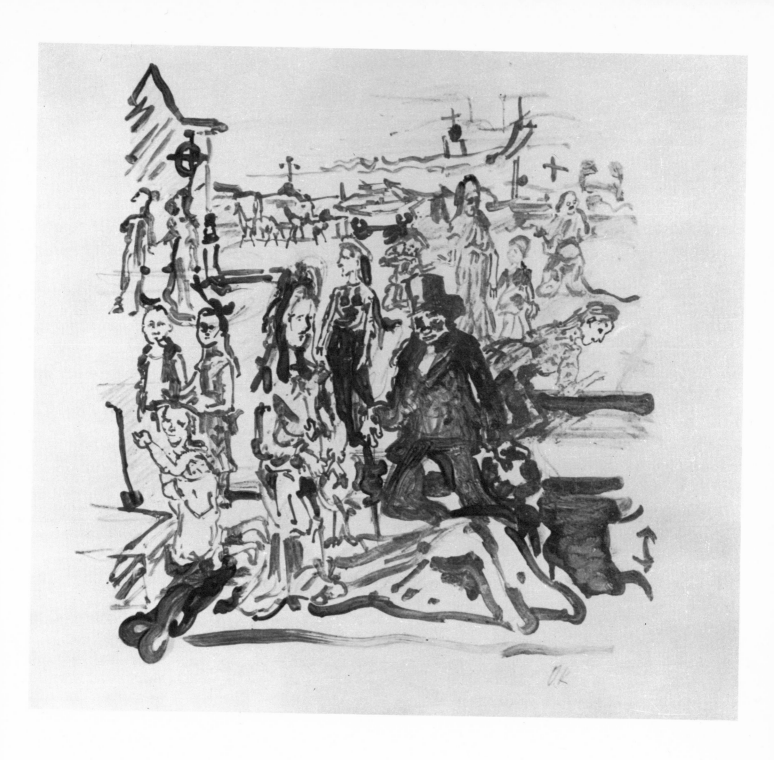

Sketch for the painting *Liebespaar mit Katze,*
Käthe Richter and Walter Hasenclever, Wingler 116.
1917. Brush, wash, watercolor. 32.6 x 43 centimeters.
Hans M. Wingler, Darmstadt.

Signed lower right:
Skizze zum Liebespaar OKokoschka.

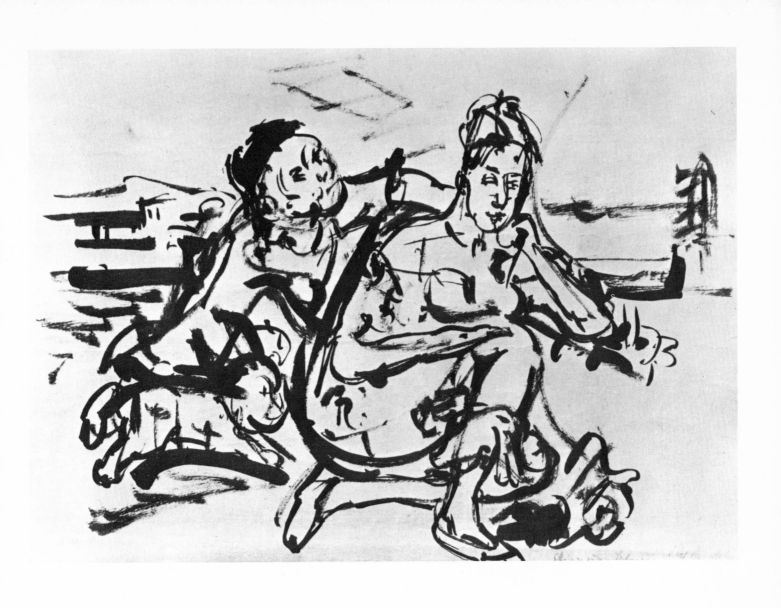

Female study.
1917. Wash, watercolor. 26 x 35 centimeters.
Mrs. Alfred Scharf, London.

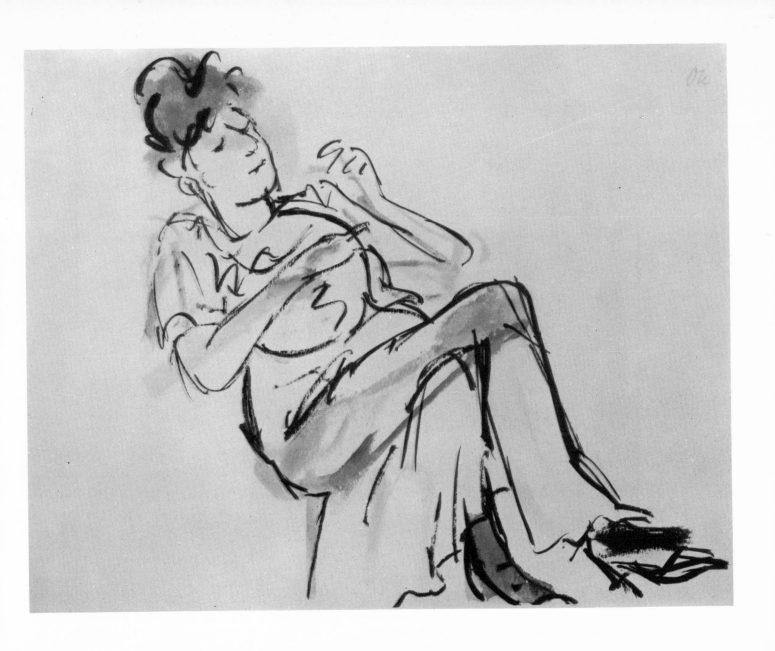

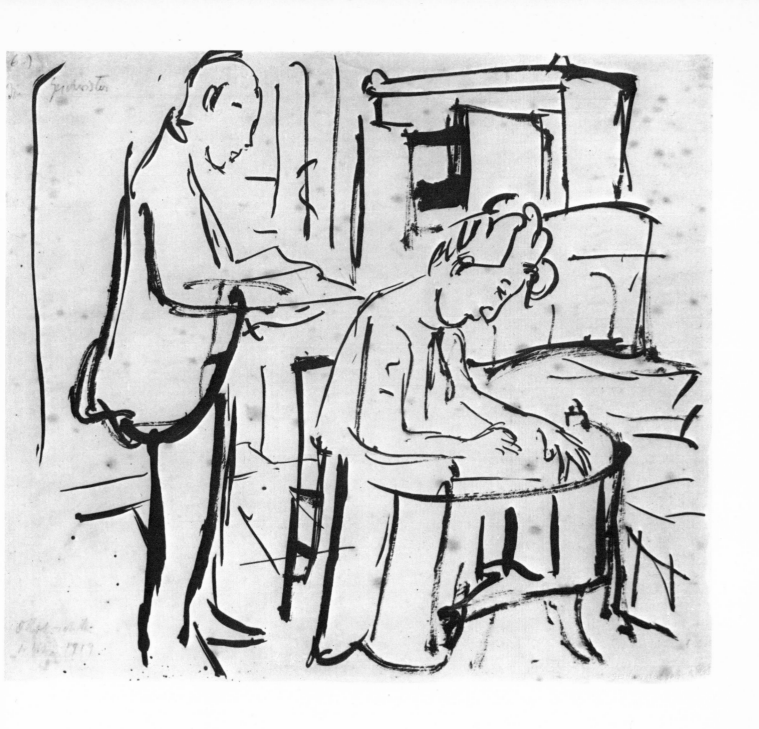

115

Devotion.
1919. Pen, wash. 53 x 38 centimeters.
Lleslie Roden, San Francisco.

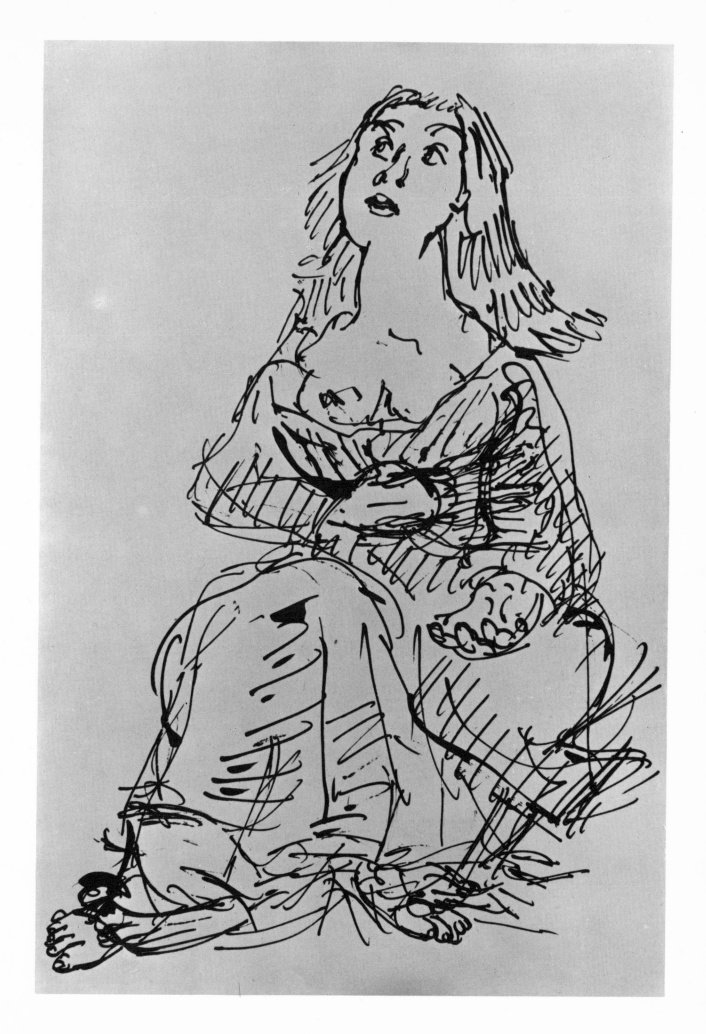

Study for *Frau in Blau*, Wingler 126.
1919. Reed pen. 38/35.5 x 47 centimeters.
Welz Gallery, Salzburg.

Subsequently signed lower right:
Hans Maria Wingler
und seiner lieben Frau
mit freundlichen Gedanken
Oskar Kokoschka
dieses Blatt stammt aus
dem Jahr 1919, Studie zur "blauen Frau."
The dedication was written inadvertently.

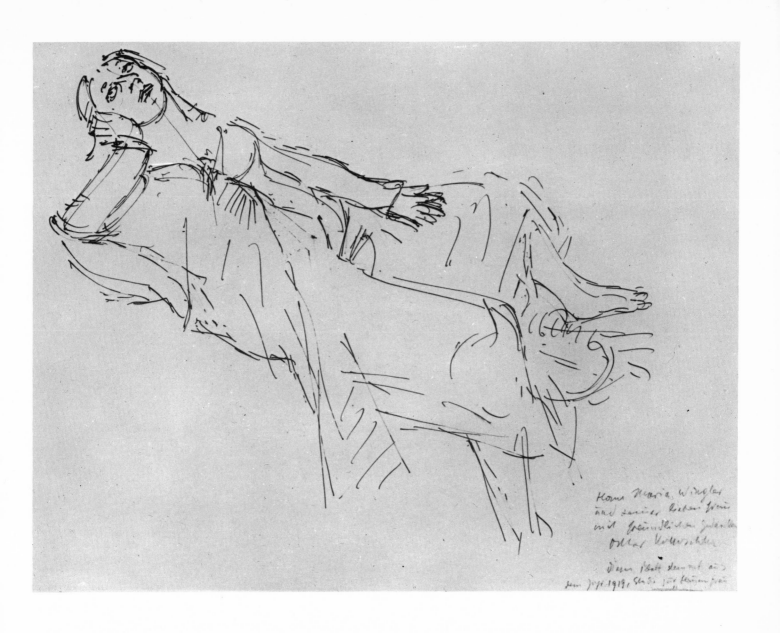

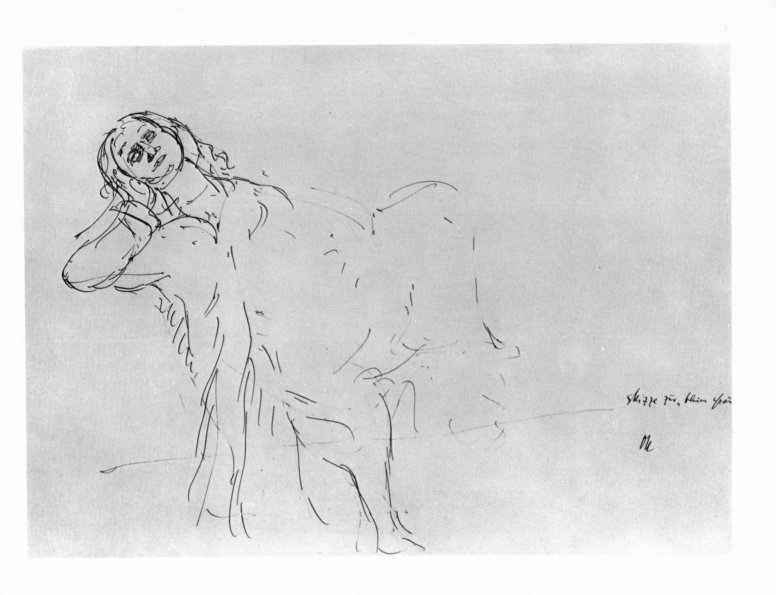

Skizze für, klein Spät

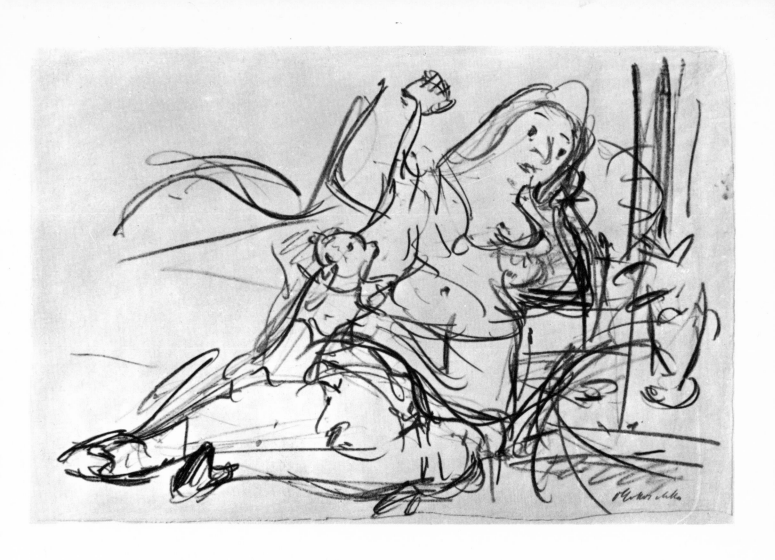

Study for *Frau in Blau*.
1919. Grüne Kreide (a type of chalk crayon) 36/38 x 57.6/56.5 centimeters.
Karlheinz Gabler, Frankfurt on the Main.

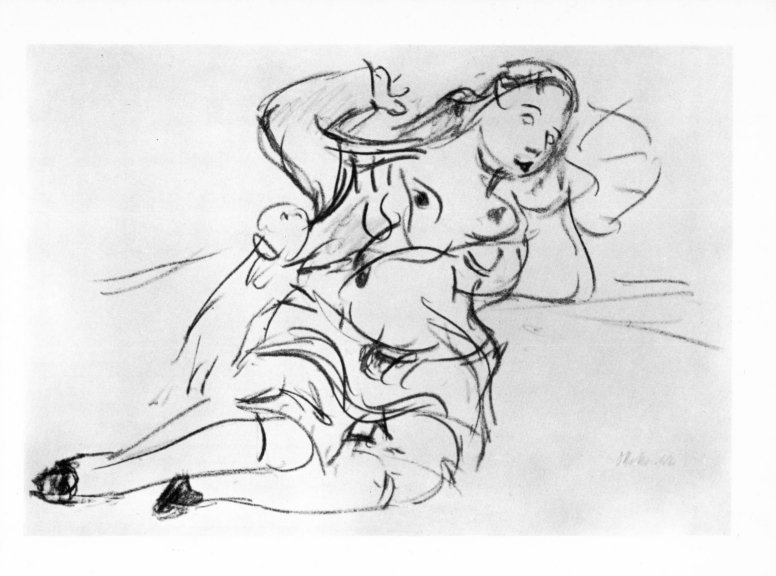

125

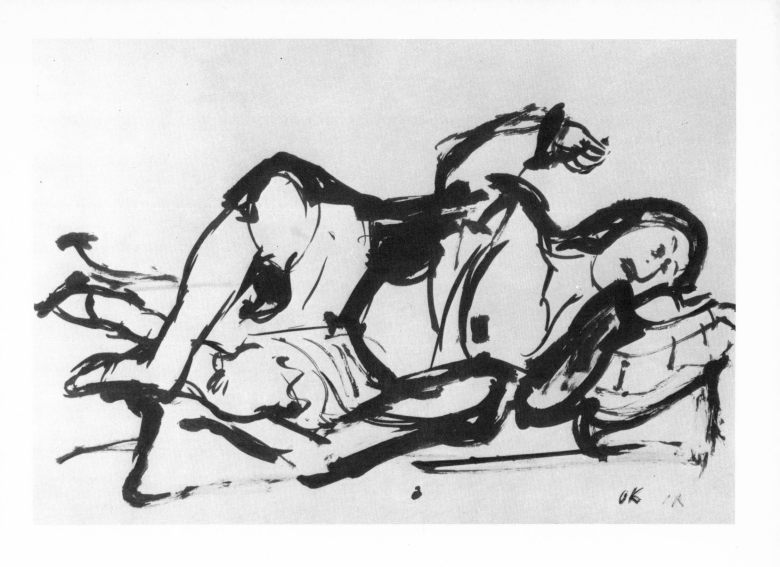

127

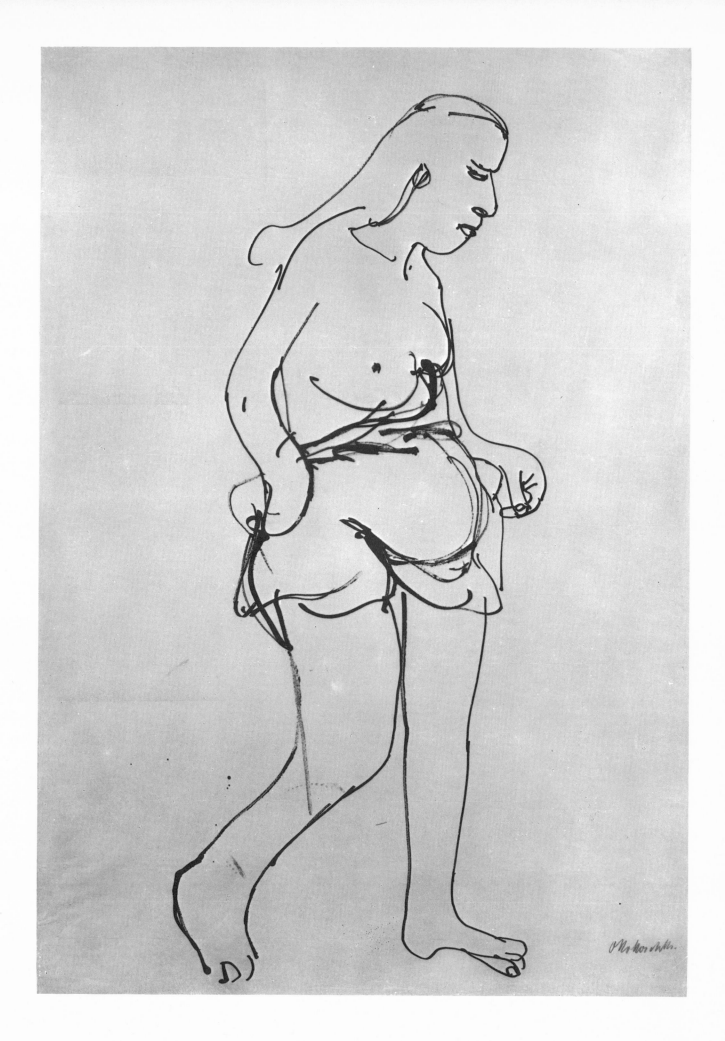

129

Kneeling Girl.
1919. Reed pen, wash. 57 x 43 centimeters.
Professor Emil Frey, Mannheim.

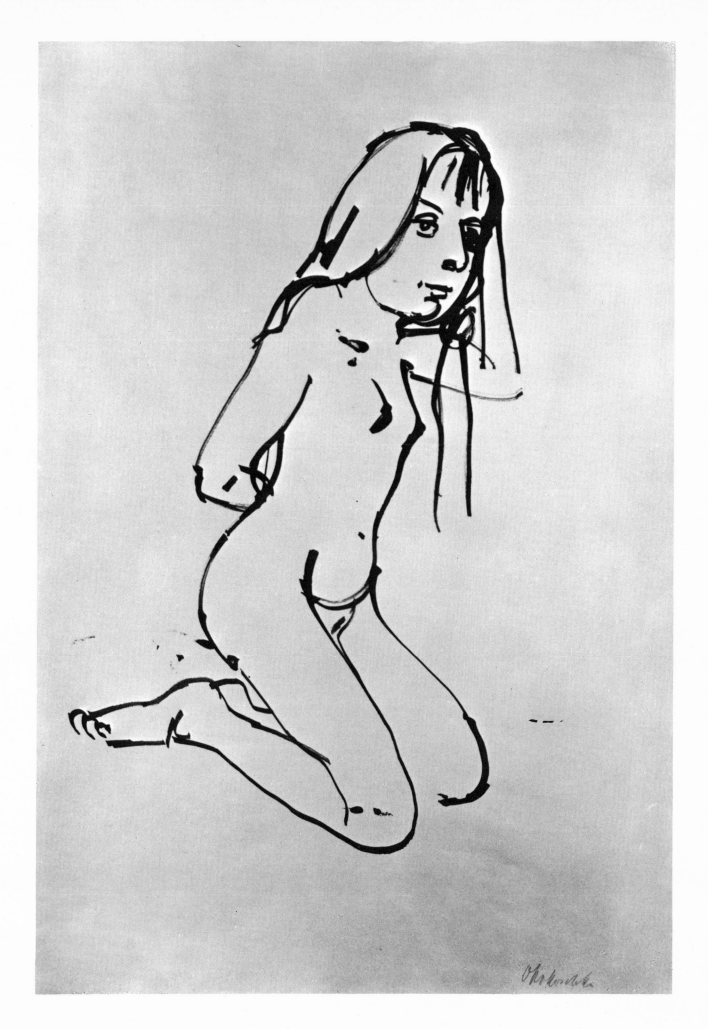

Standing Girl.
1919. Black wash. 69 x 52 centimeters.
Elisabeth Furtwängler, Clarens, Canton Vaud, Switzerland.

Signed lower right:
Oskar Kokoschka
Dresden 1921
(subsequent dating).

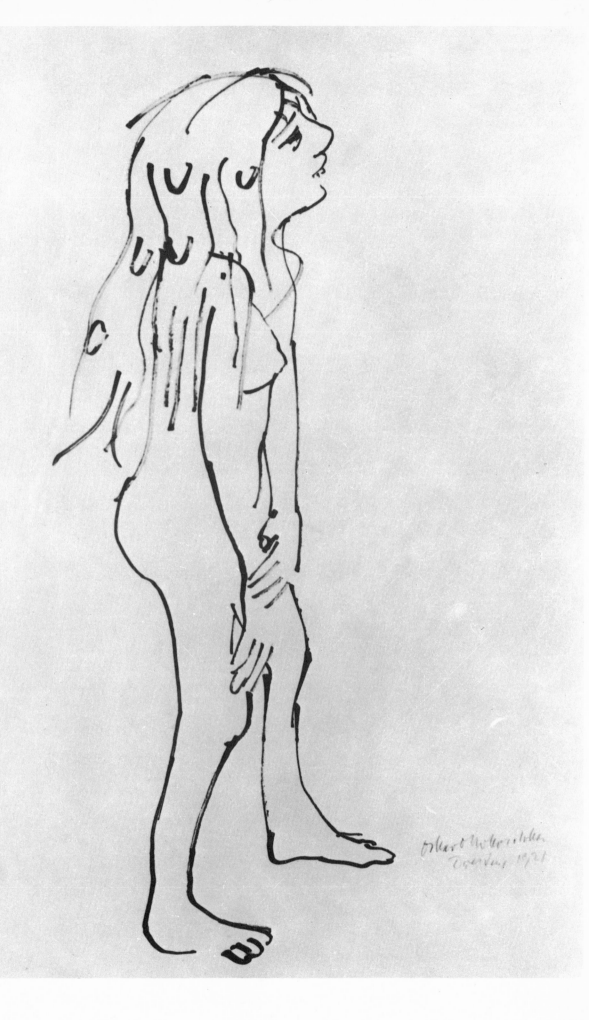

The Pilot Kobe with Käthe Richter.
1919. Brush, wash. 35.5 x 46.5 centimeters.
Marlborough Fine Art Ltd., London.

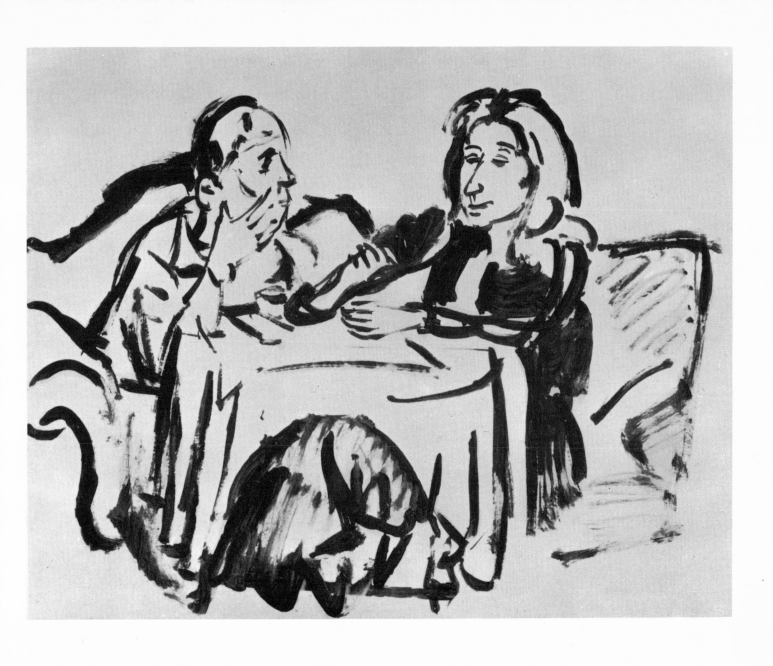

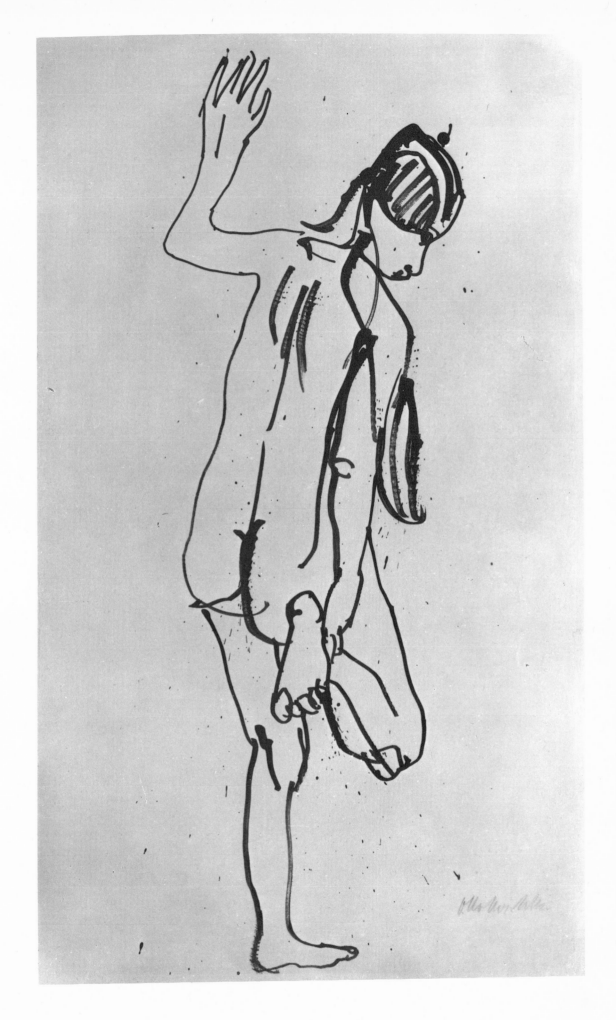

Reclining Girl, Reading.
1920. Reed pen, wash.

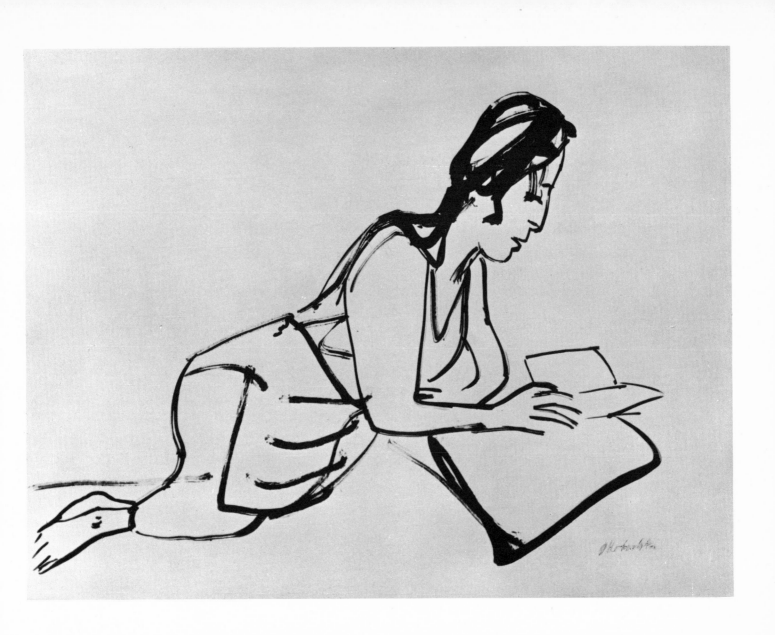

Clothed Girl, Walking.
1920. Reed pen, wash. 69.3 x 51 centimeters.
Schocken Library, Jerusalem.

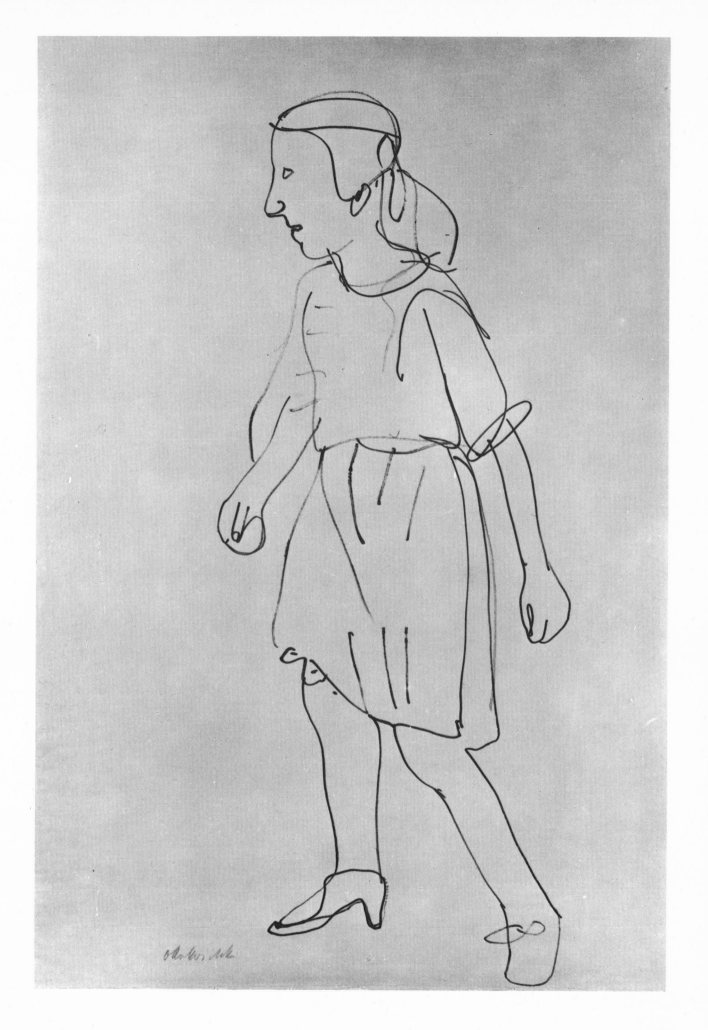

141

Girl Wearing a Cap.
About 1920. Chalk crayon.
Photograph from the Welz Gallery, Salzburg.

Signed upper right:
Für Schwester
Bibschl Ihr
Bruder OK,
lower right:
OKokoschka.

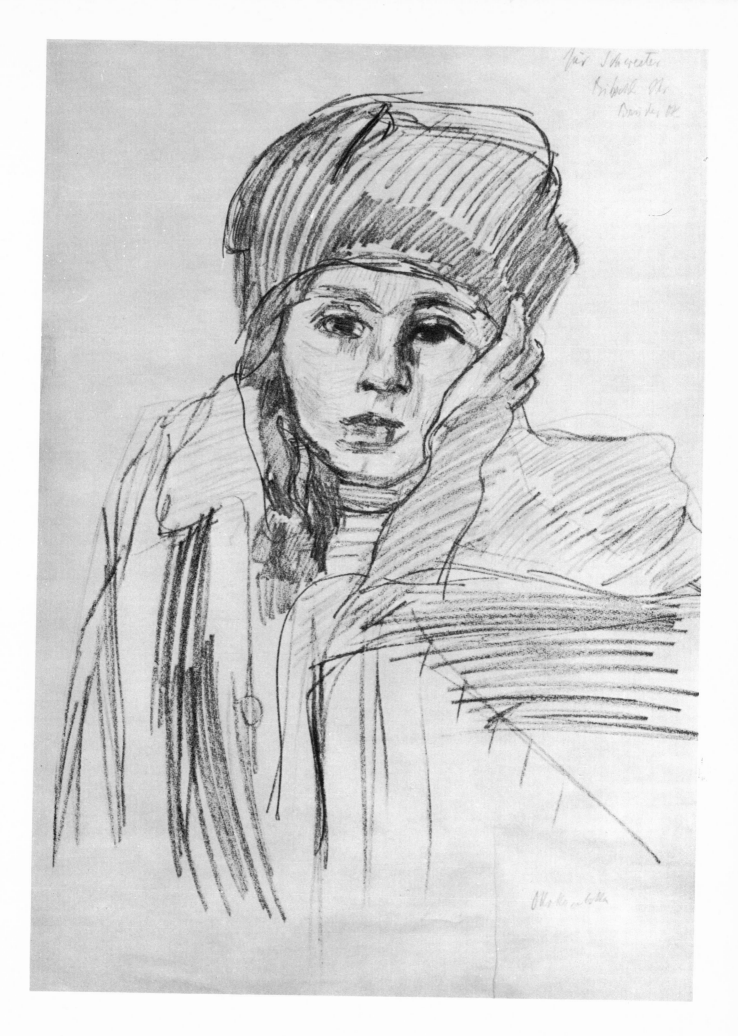

144

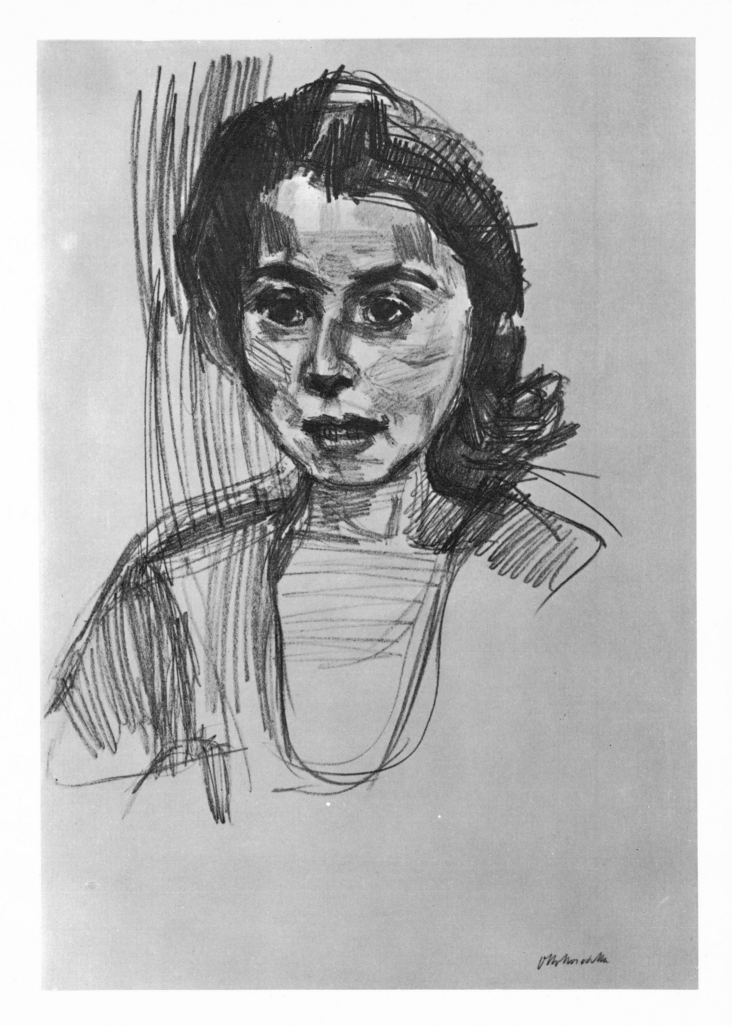

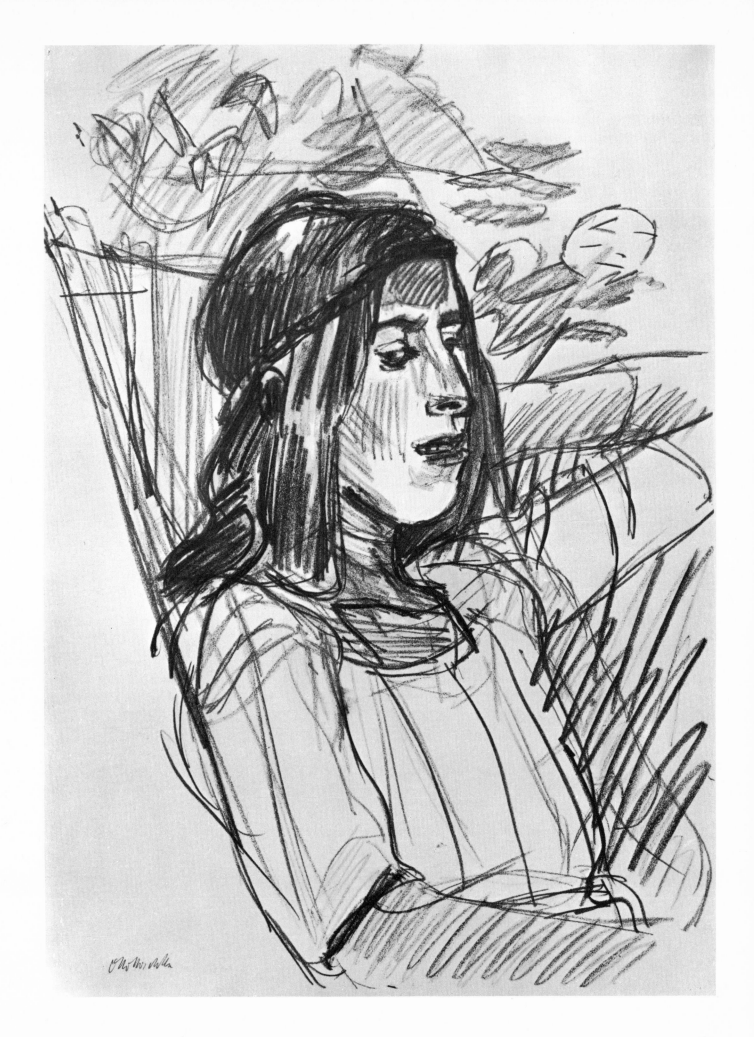

147

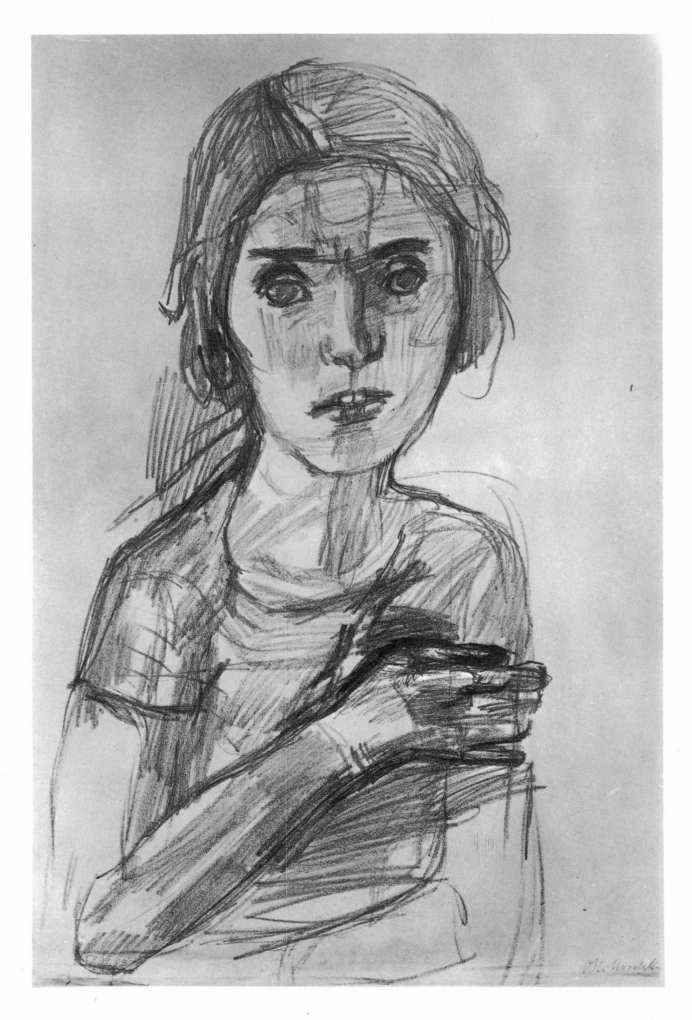

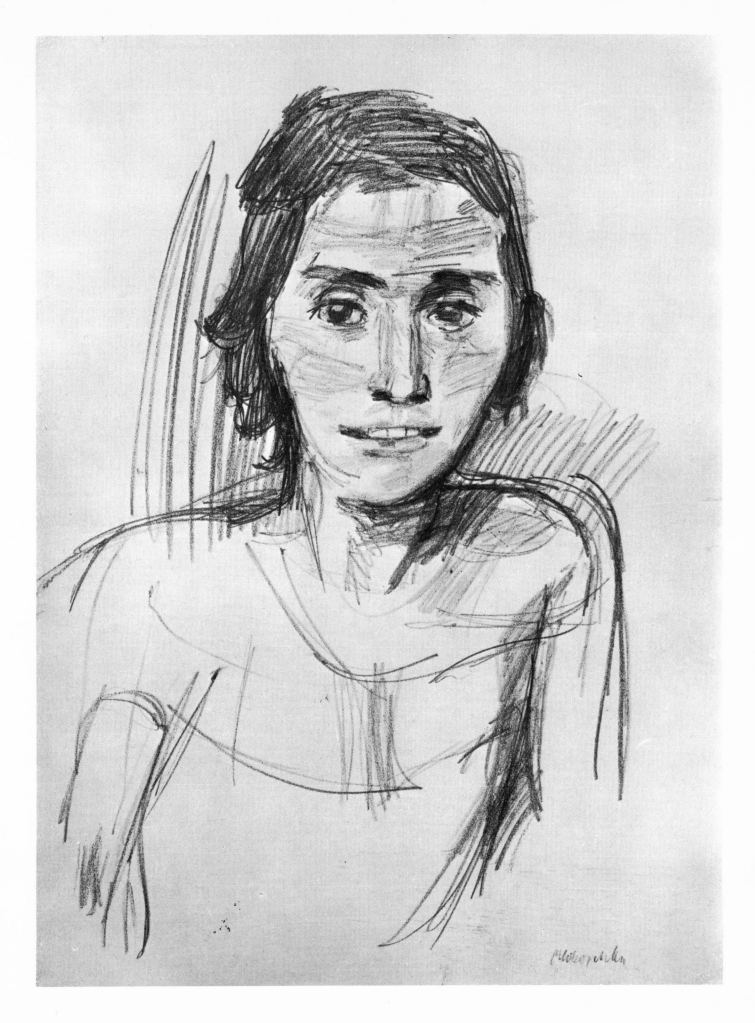

151

Seated Girl.
1921. Reed pen, brush, wash, watercolor. 52 x 69.8 centimeters.
Private ownership.

Signed lower left:
OKokoschka
Dresden, 1921.

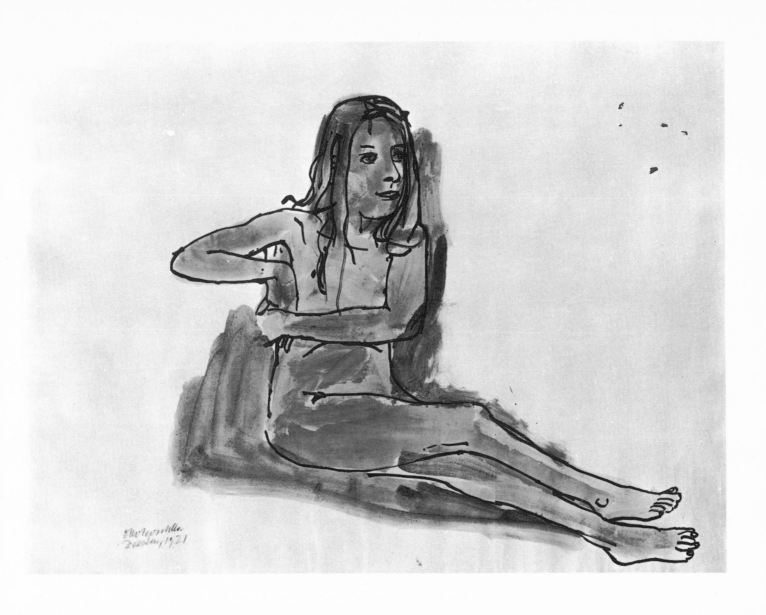

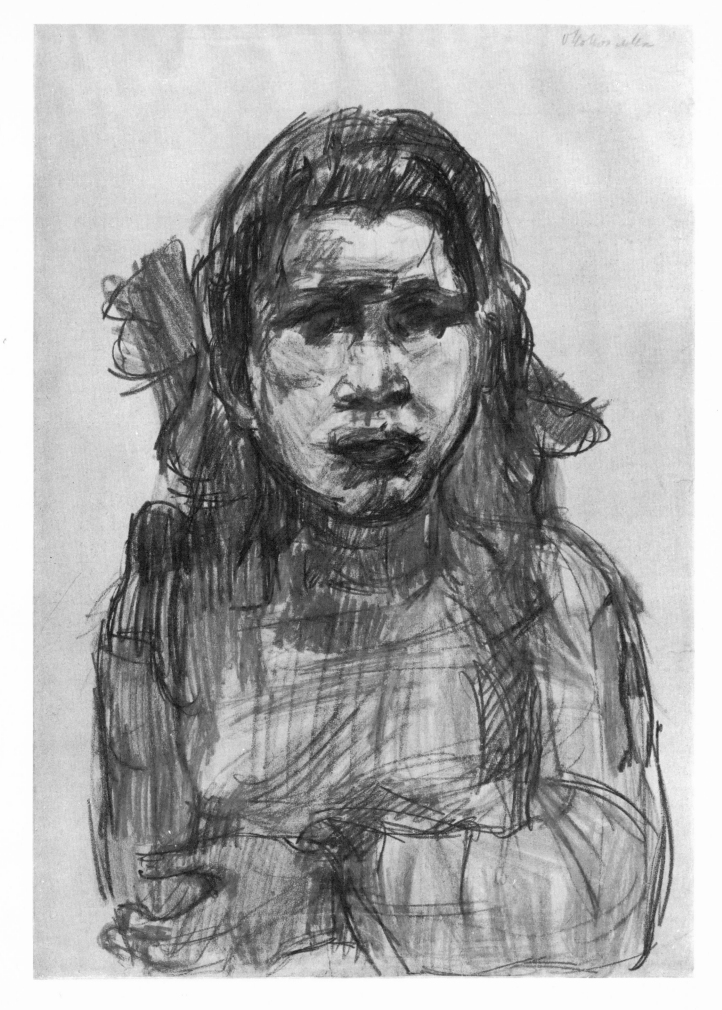

155

Study for a lithograph of the series *Töchter des Bundes (Esther)*.
1922. Chalk crayon.
W. R. Valentiner collection, Detroit.
Photograph from Edith Hoffmann.

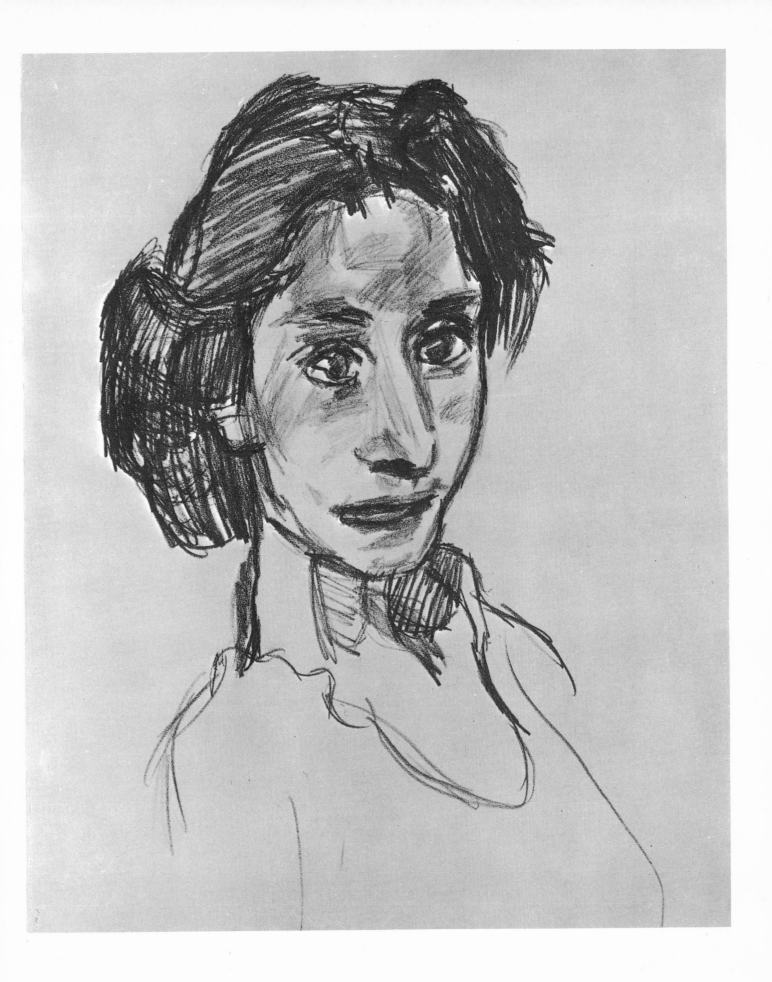

Girl on a Couch.
About 1922. Brush, wash. 51.8 x 68.9 centimeters.
Neue Staatsgalerie, Munich, gift of Sofie and Emanuel Fohn.

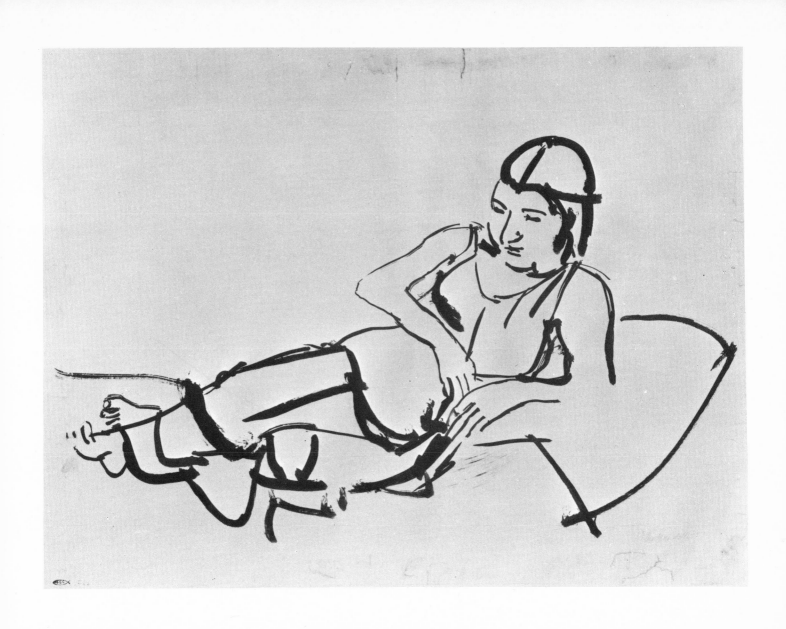

Man Before his Filmed Image at the Cinema, for Victor Dirsztay's *Doppelgänger*.
1923. Reed pen, wash. 29.5 x 22.8 centimeters.
Mrs. George R. Brown, Houston.

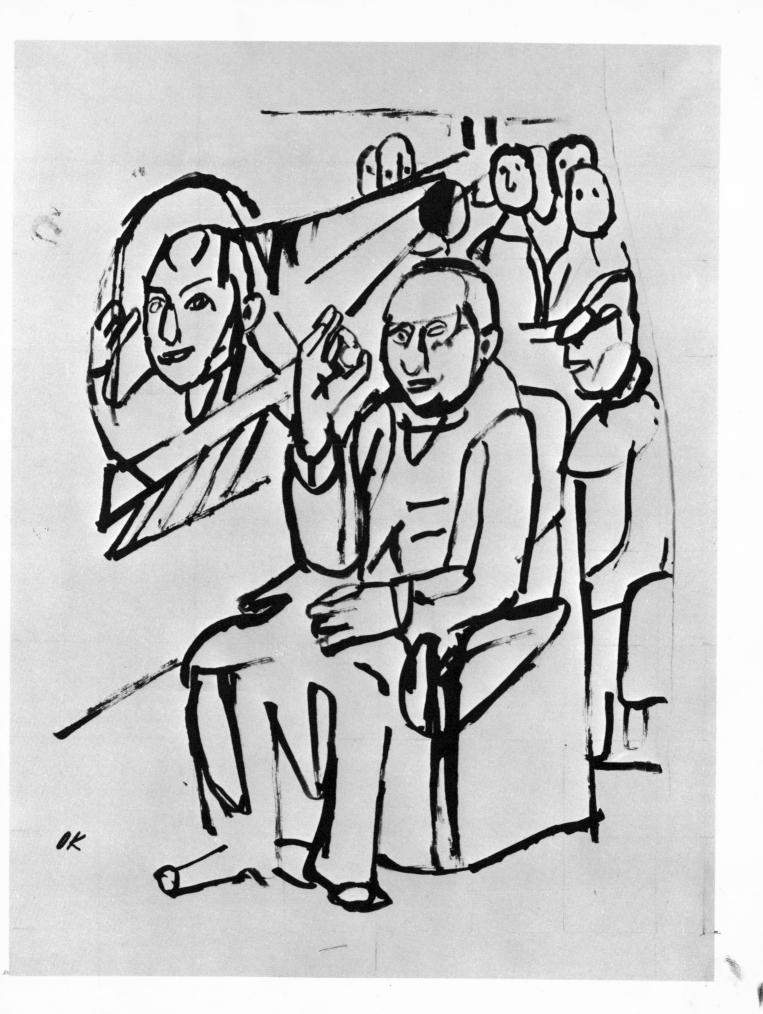

Lotte Mandel, Seated.
Winter 1923-1924. Pencil. 29 x 22.5 centimeters.
Mrs. Lotte Friedlander, New York.

Signed upper left:
Lotte bevor sie
Braut war;
lower left:
OKokoschka.

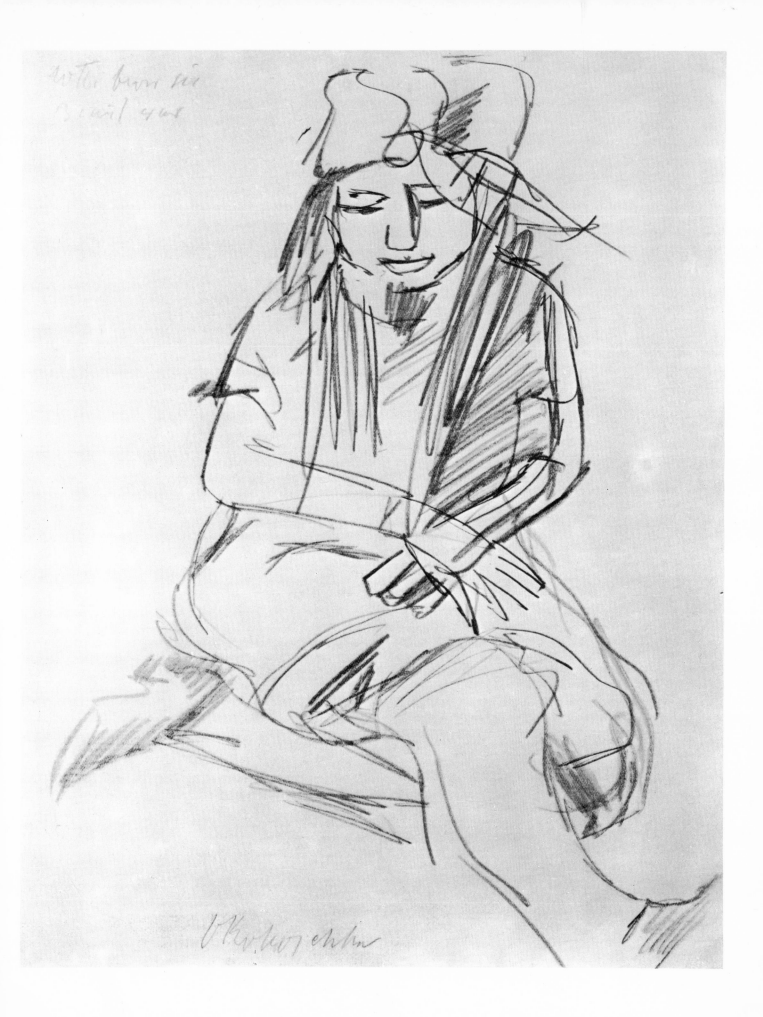

Lotte Mandel at a Table with a Flower Vase.
Winter 1923-1924. Pencil. 29 x 22.5 centimeters.
Mrs. Lotte Friedlander, New York.

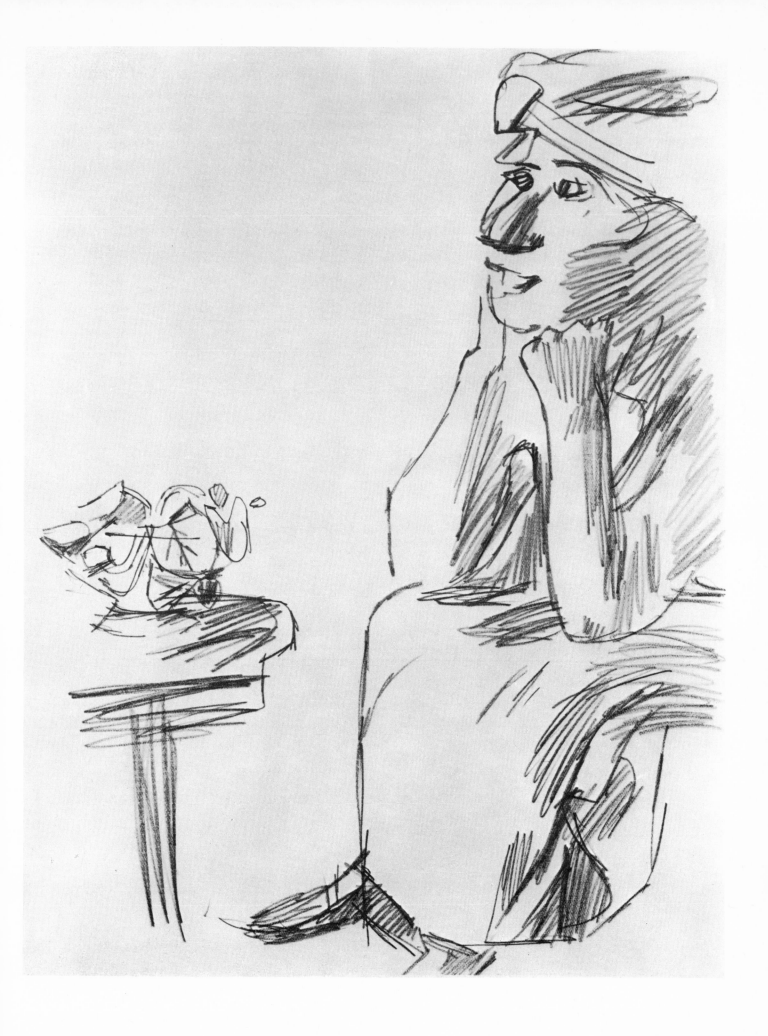

Lotte Mandel.
Winter 1923-1924. Pencil. 29 x 22.5 centimeters.
Mrs. Lotte Friedlander, New York.

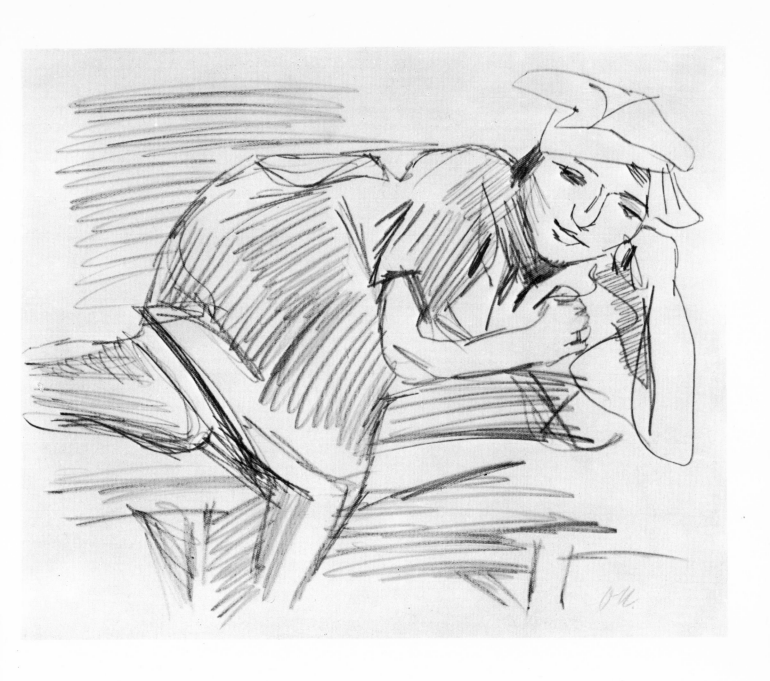

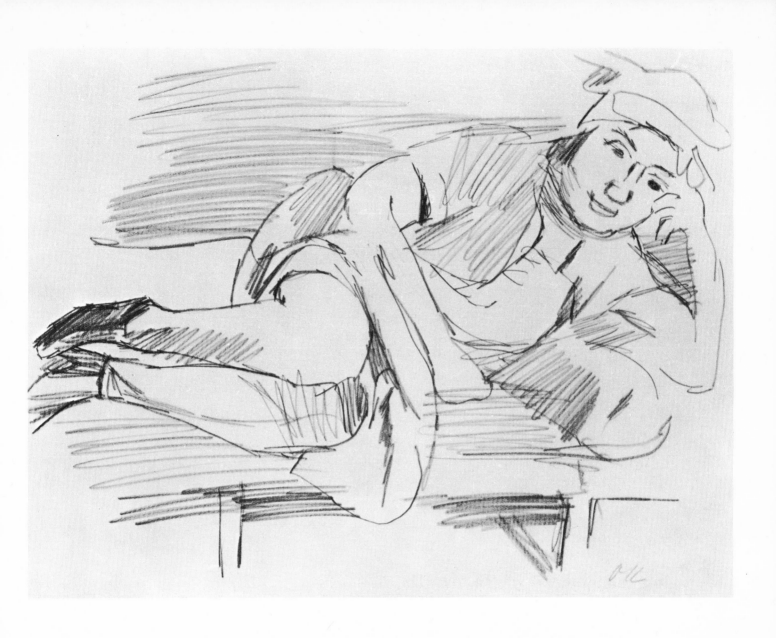

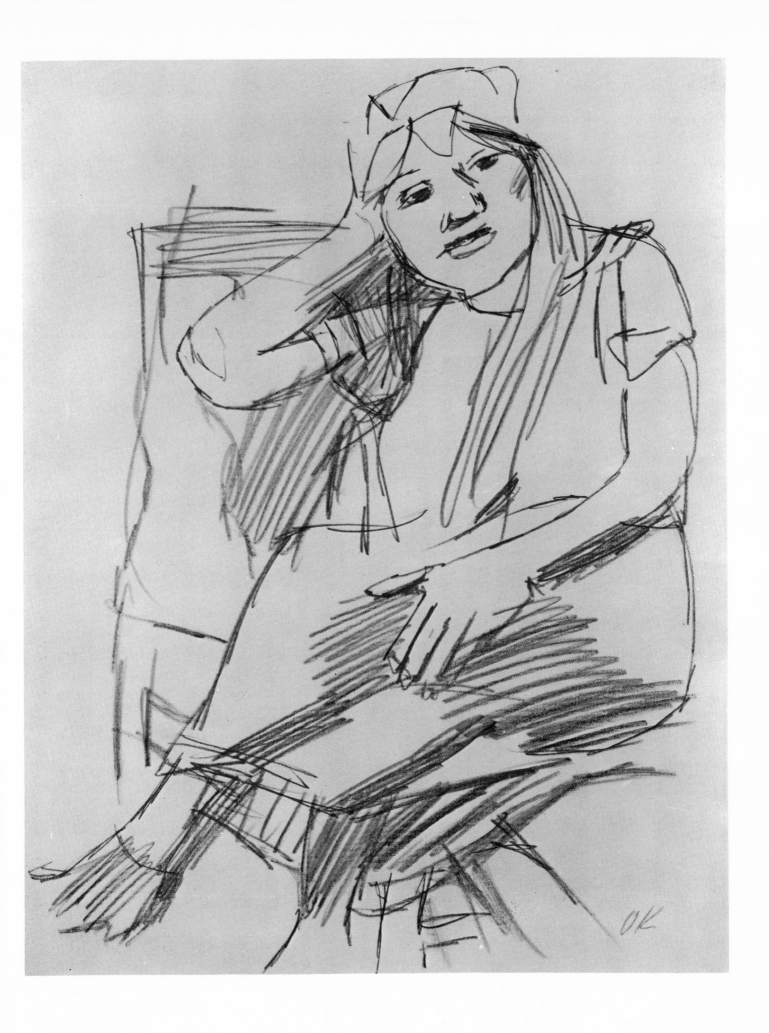

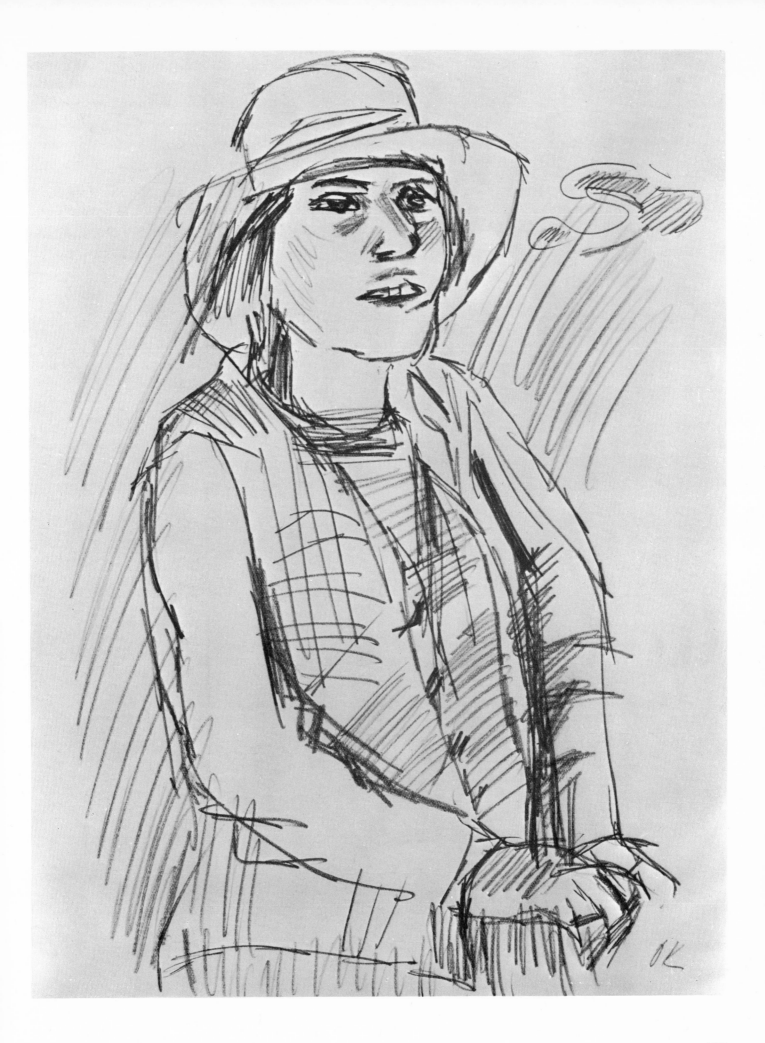

Die Kleine Mandl (Lotte Mandel).
1924. Chalk crayon. 23 x 29 centimeters.
Robert Lewin, Brook Street Gallery, London.

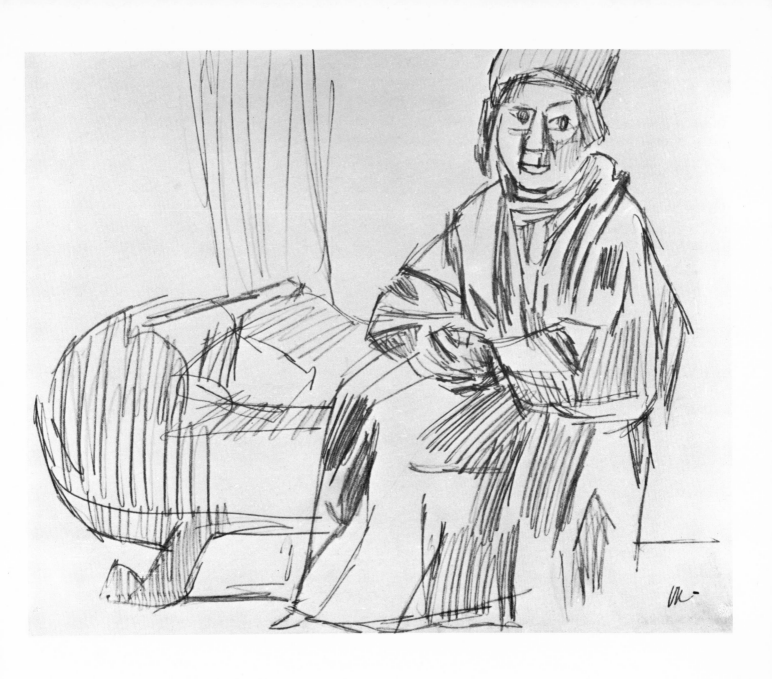

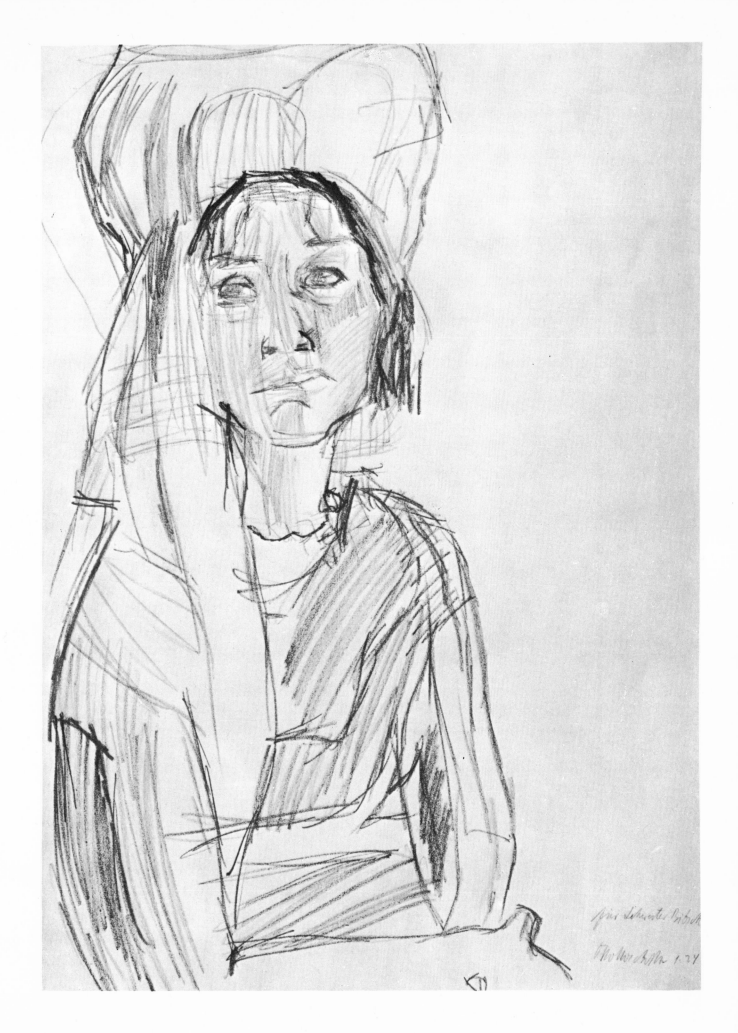

King Saul.
1924. Chalk crayon. 69.5 x 49.5 centimeters.
Kunsthalle, Bremen.

Signed lower right:
Zum Wiener Besuch für meinen lieben Freund
Hugo Erfurth 31. 3. 24
OKokoschka.

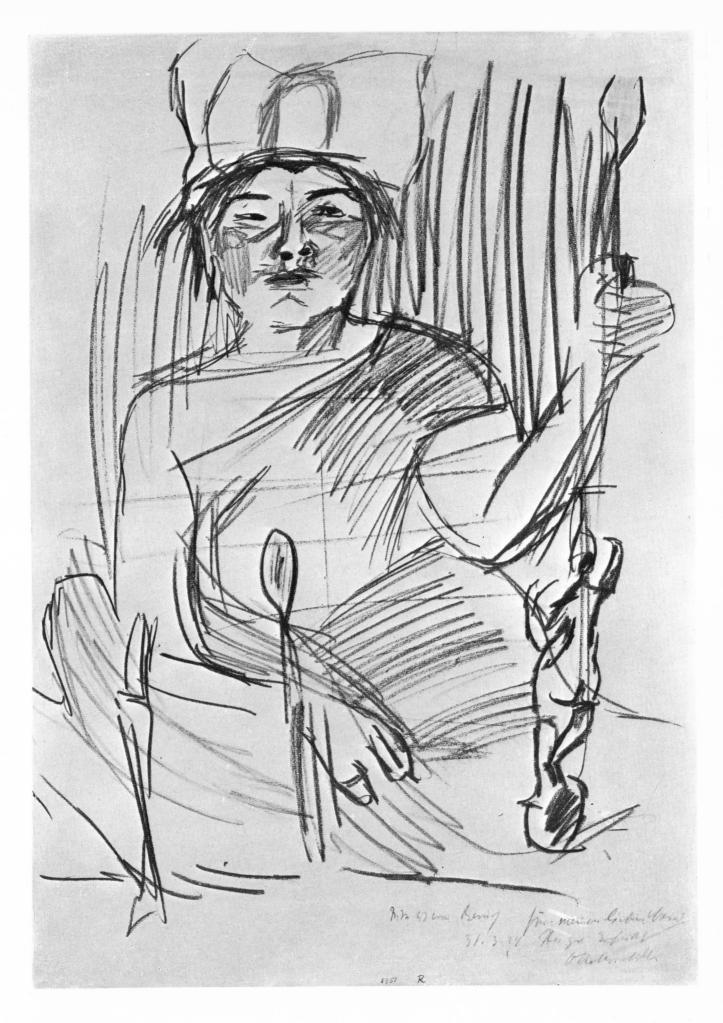

Nude.
Before 1926. Rötel (red chalk). 56 x 45.5 centimeters.

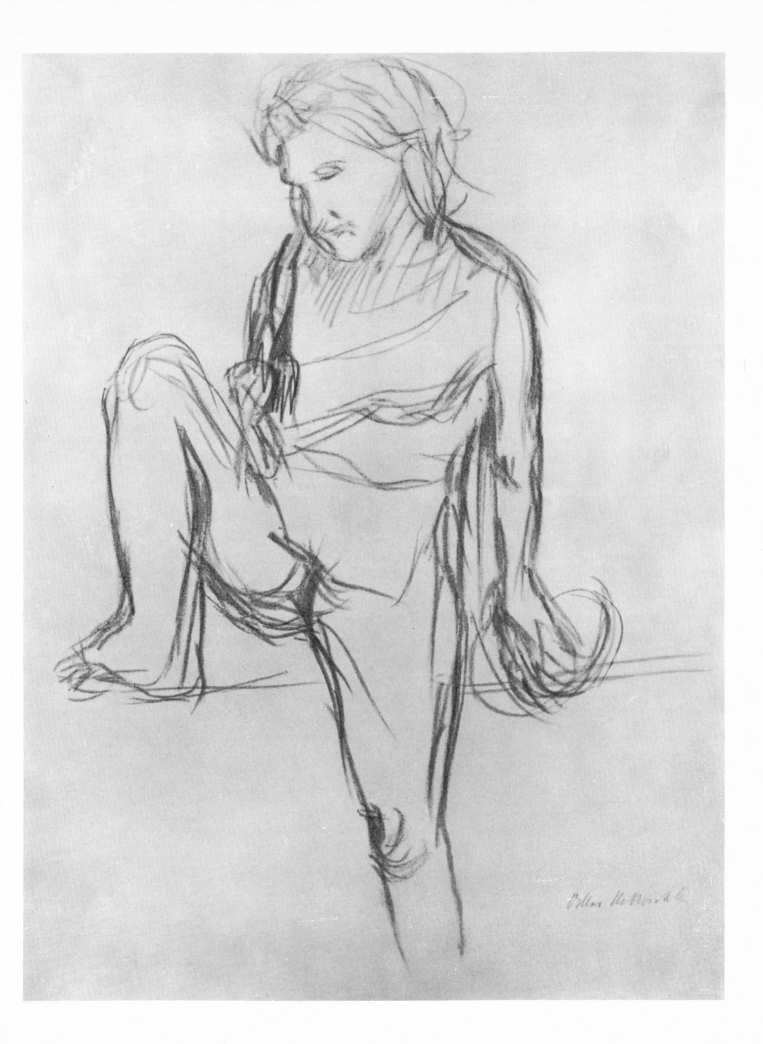

Portrait of a Girl.
1926. Chalk crayon.
Photograph from the Welz Gallery, Salzburg.

Signed lower right:
Für das liebe
Schwesterlein
OKokoschka.

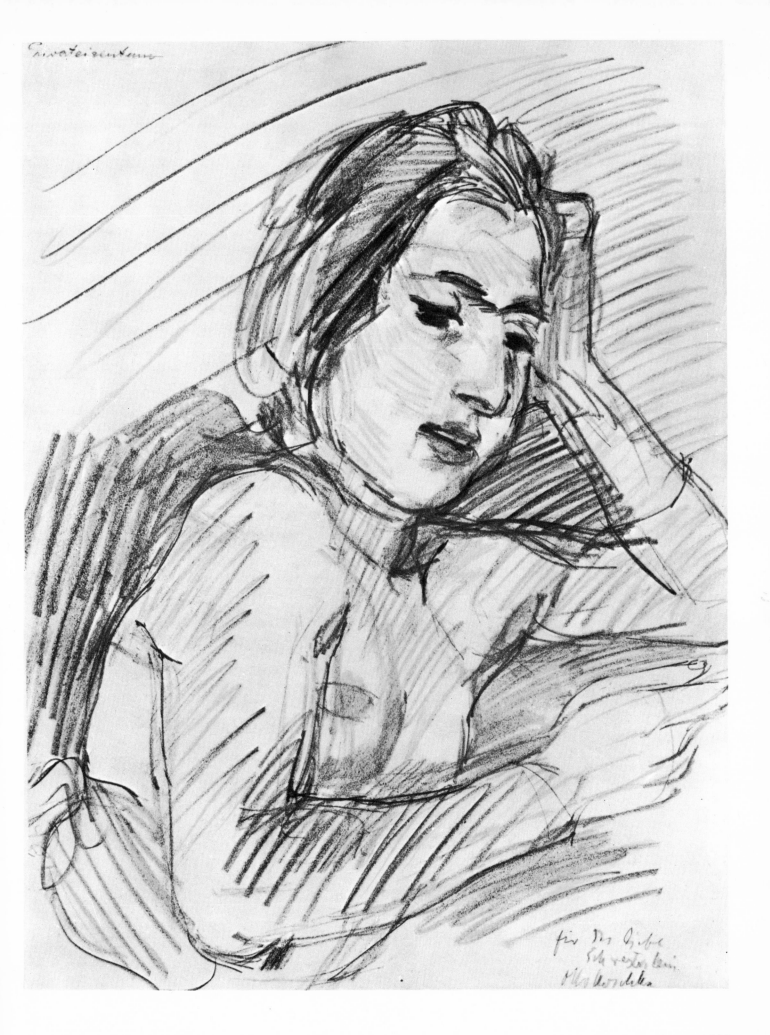

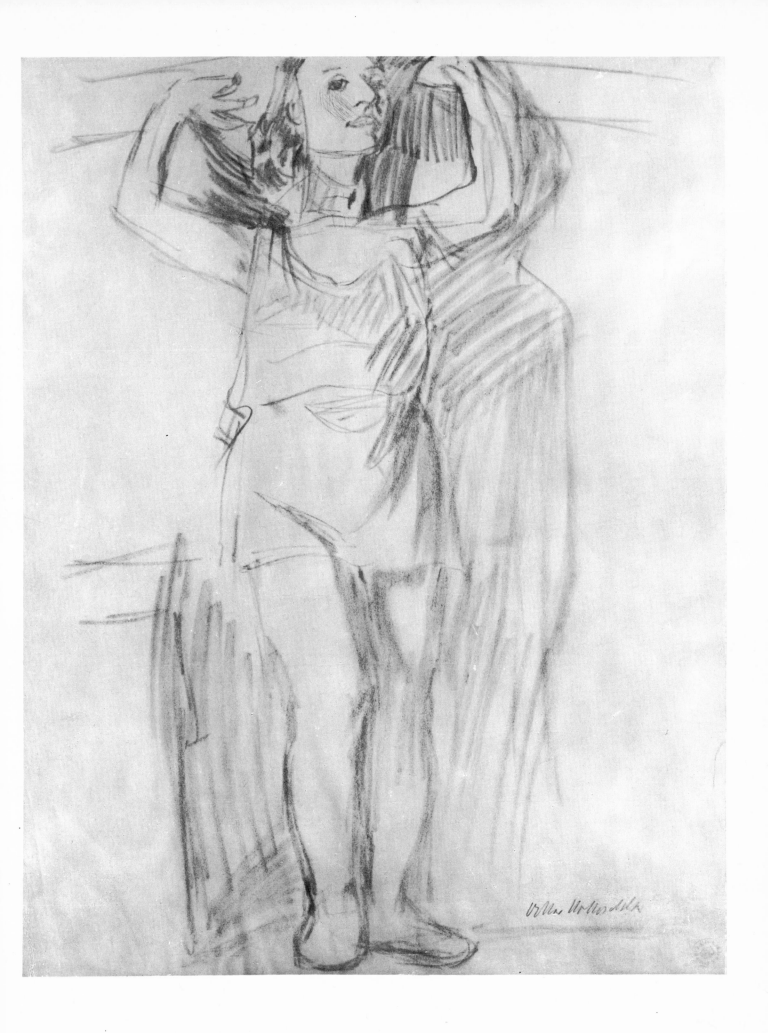

Mary (Mrs. Merson).
1931. Rötel (red chalk). 56 x 45 centimeters.
Marianne Feilchenfeldt, Zurich.

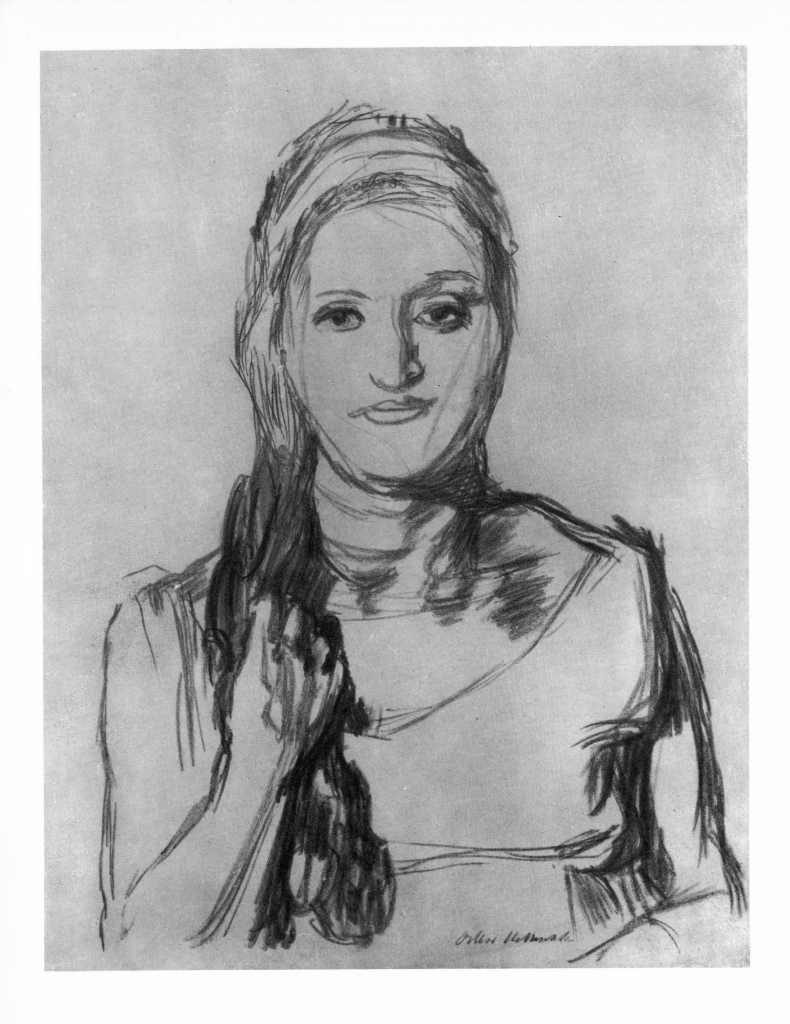

Mrs. Merson.
1931. Rötel (red chalk).
Photograph from Edith Hoffmann.

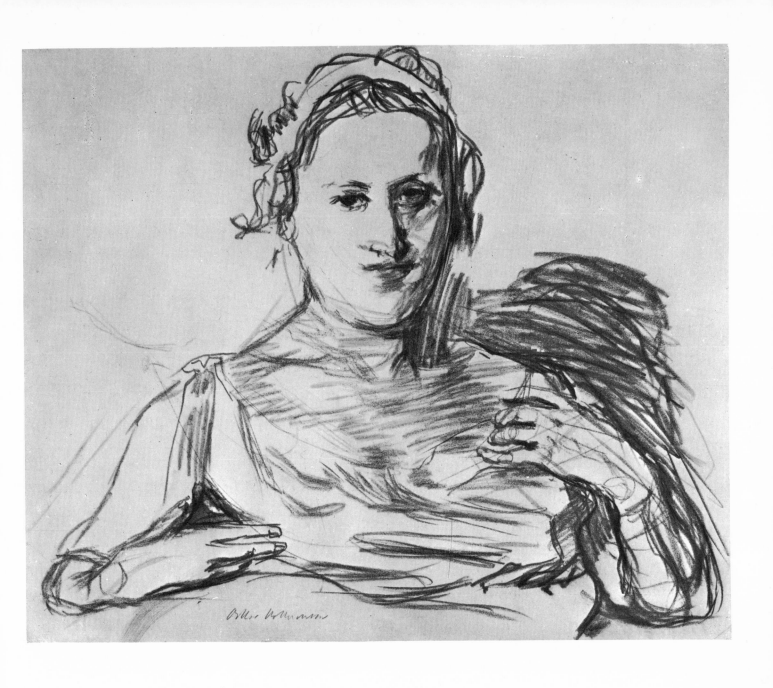

189

Mrs. Merson.
1931. Rötel (red chalk). 44.9 x 55.3 centimeters.
Art Institute of Chicago, gift of Tiffany and Margaret Blake.

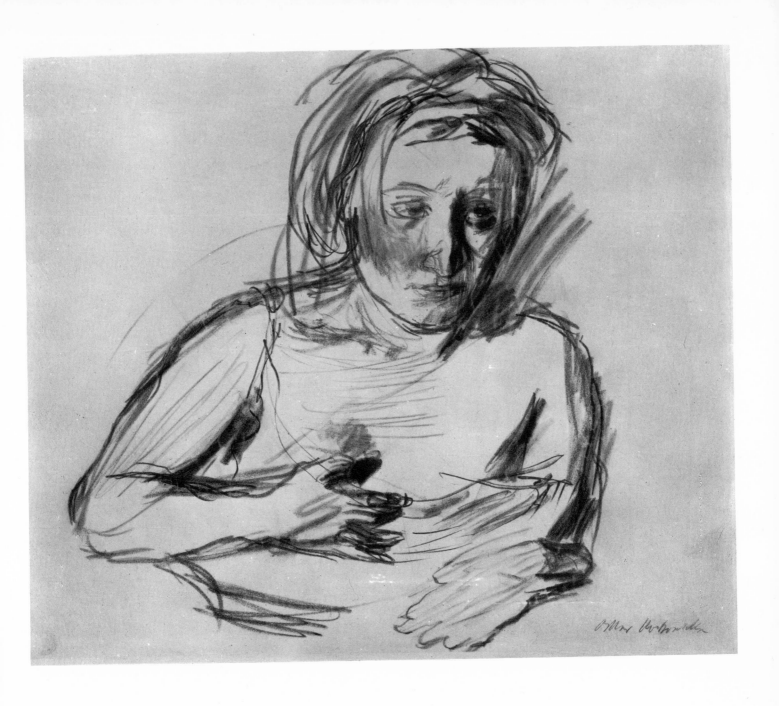

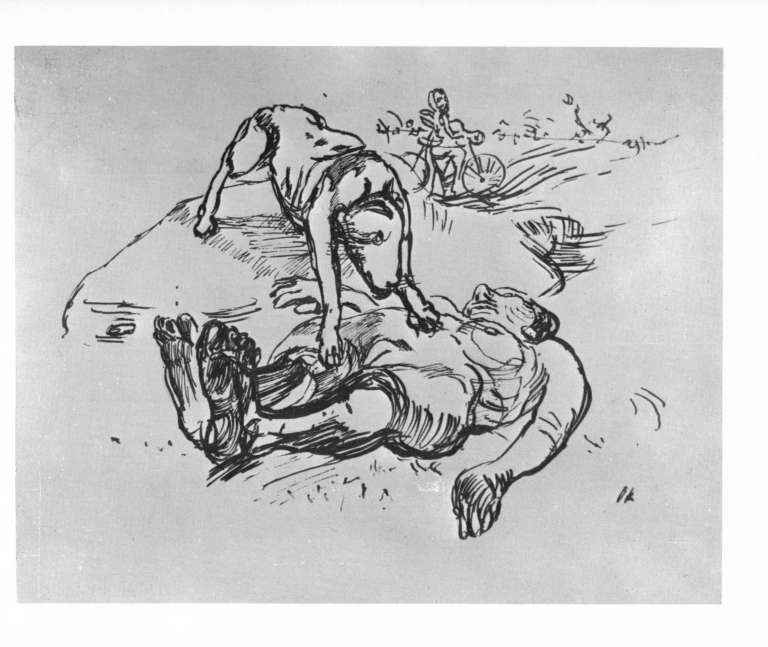

Trudl.
1931. Chalk crayon. 49.5 x 35 centimeters.
J. H. Angehrn, Thalwil.

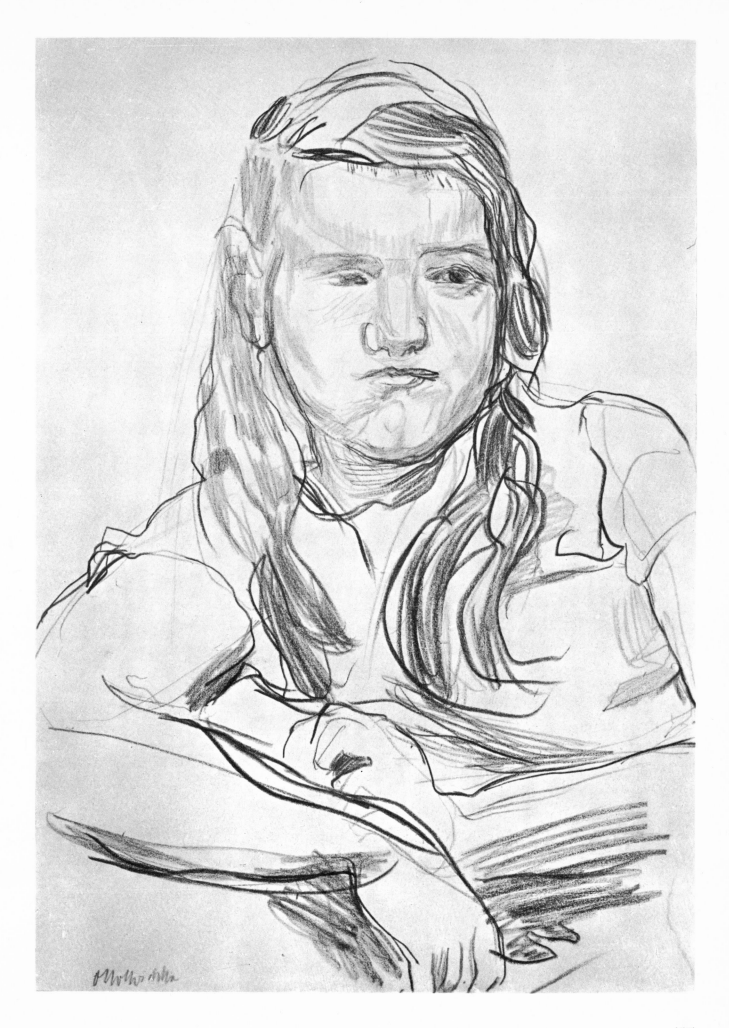

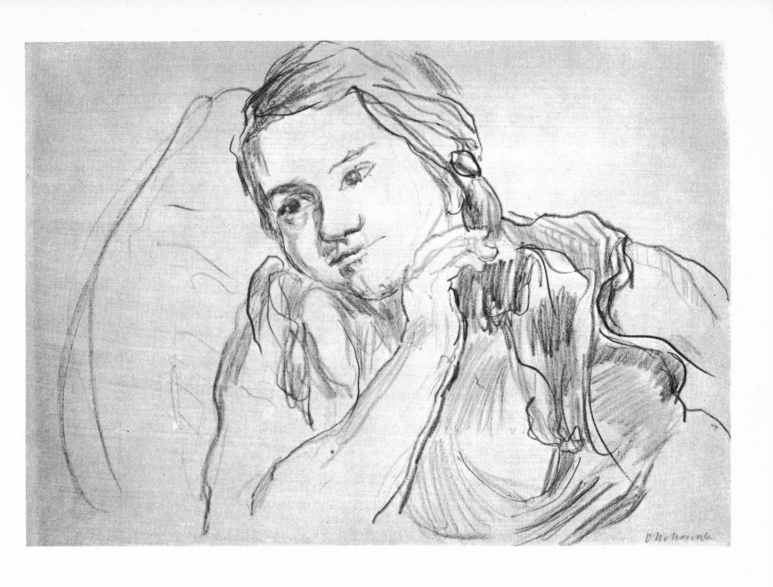

Trudl.
1931. Chalk crayon. 50 x 35 centimeters.
Photograph from the Welz Gallery, Salzburg.

Signed lower left:
Meinem lieben Emilio
(Emil, the artist's brother-in-law)
als Christkindl 1931
Oskar Kokoschka.

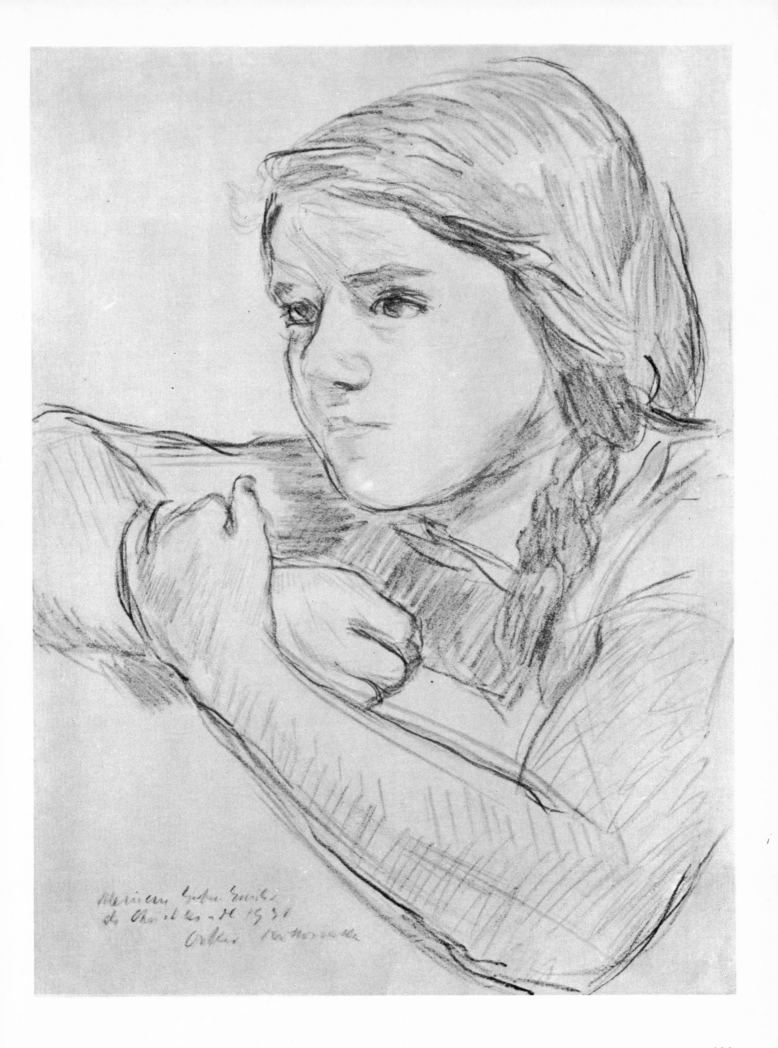

199

Trudl.
1931. Chalk crayon. 35 x 26 centimeters.
Photograph from the Welz Gallery, Salzburg.

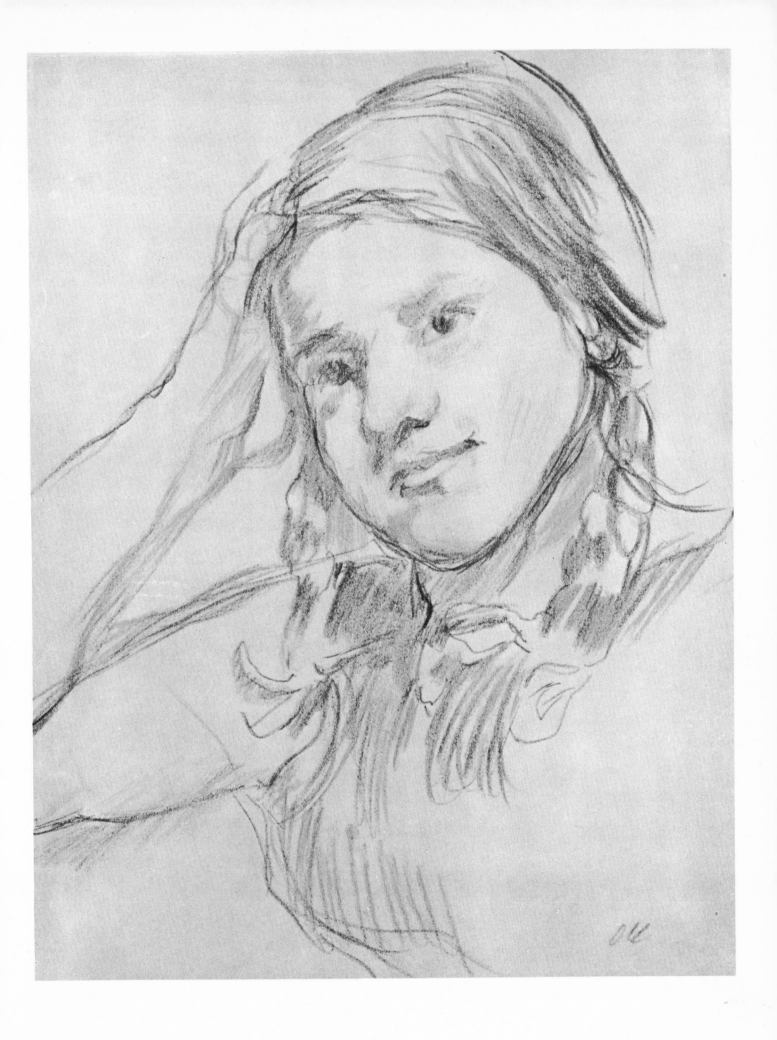

201

Trudl, Seated, Wearing a Cap.
1931. Chalk crayon. 48 x 33.5 centimeters.
Rijksmuseum, Amsterdam.

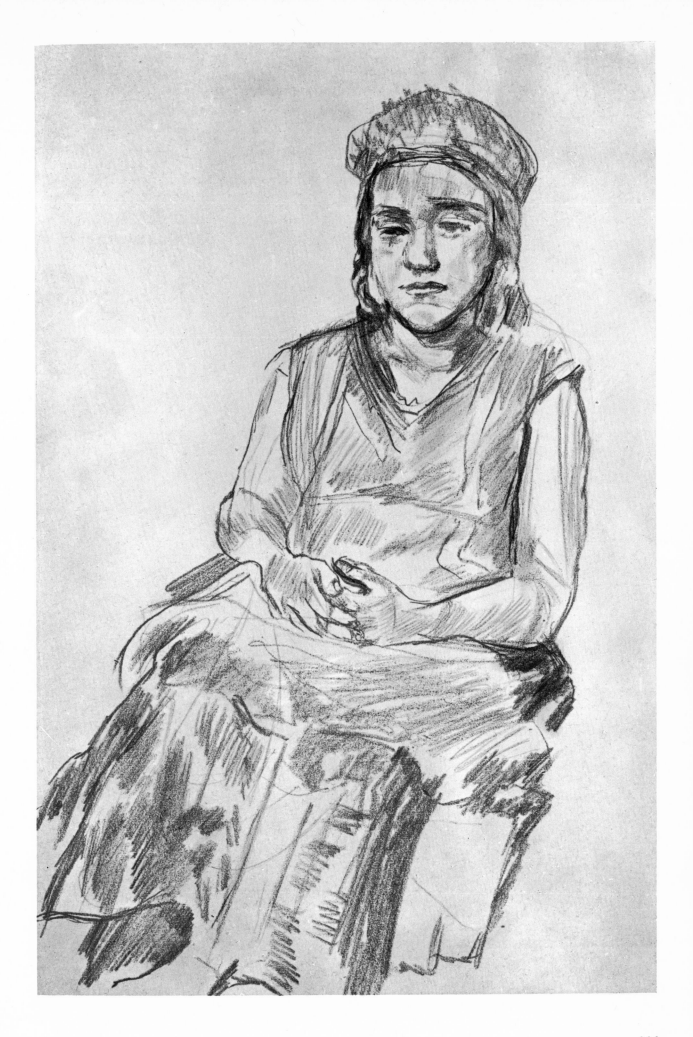

Trudl, Seated, Leaning on an Arm.
1931. Chalk crayon.

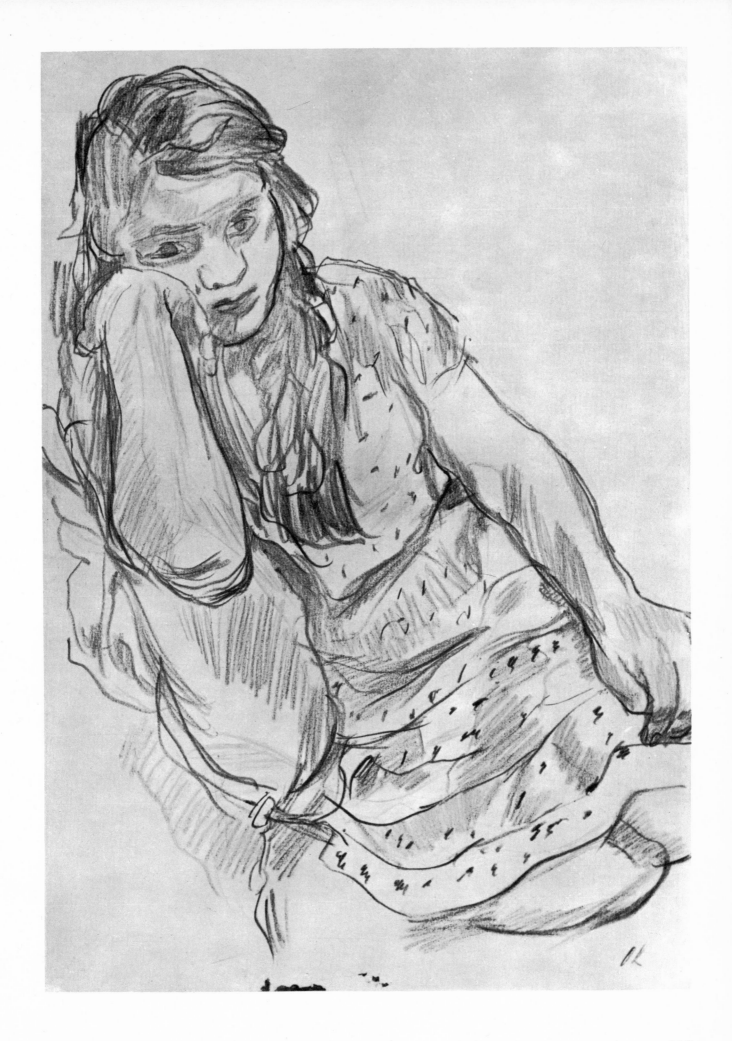

Trudl, Wearing a Straw Hat.
1931. Chalk crayon. 33.3 x 47.8 centimeters.
Rijksmuseum, Amsterdam.

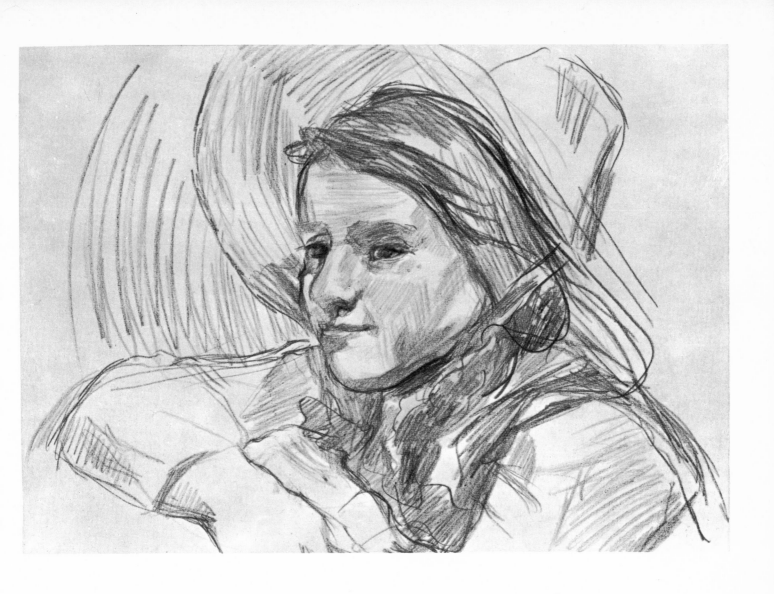

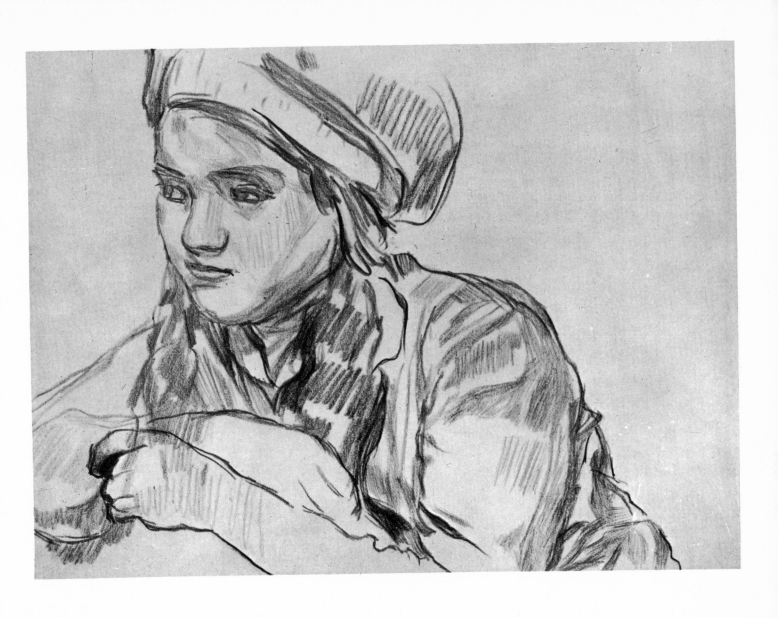

Trudl, Wearing a Cap.
1931. Chalk crayon.

Signed lower right:
für meinen lieben Emilio
damit er nicht wieder die schöne
Lebenszeit mit Kranksein vergisst.
Das darf überhaupt nie mehr vorkommen.
Nicht einmal Zahnreissen ! ! !
Dein Oskar K.

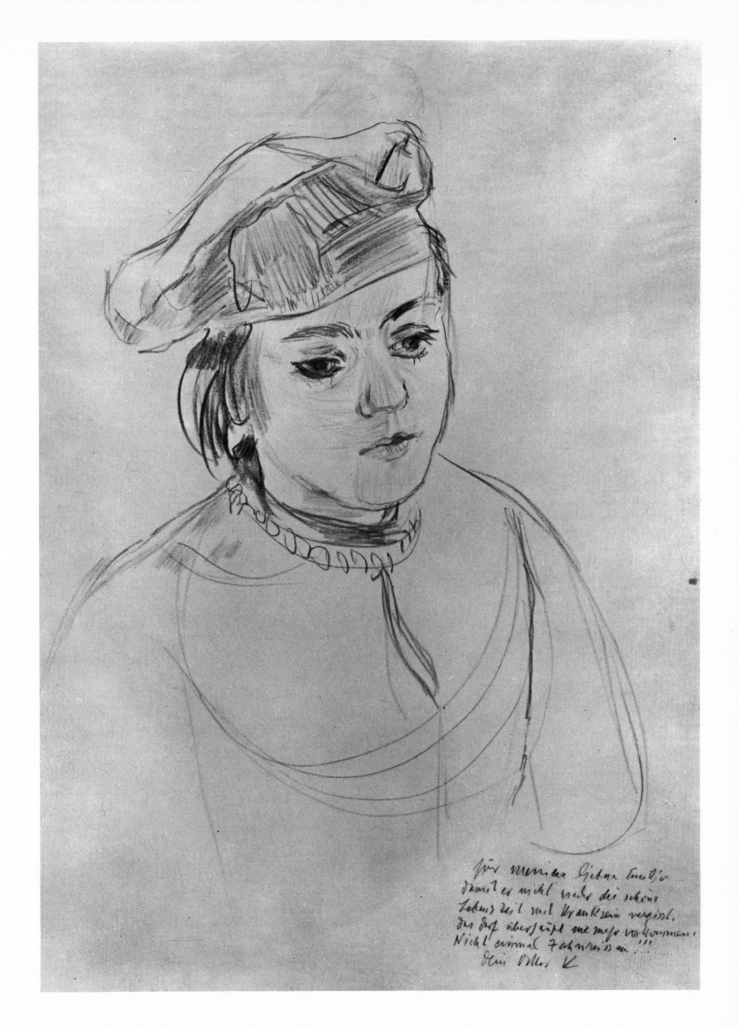

Für meinen lieben Freund
damit er nicht mehr die schöne
Lebenszeit mit Kranksein vergisst,
das darf überhaupt nie mehr vorkommen!
Nicht einmal Zahnreissen!!!
Dein alter K

211

Two Images of Trudl Combined in one Drawing.
1931. Chalk crayon. 35 x 24.5 centimeters (window of mount).
Albertina, Vienna.

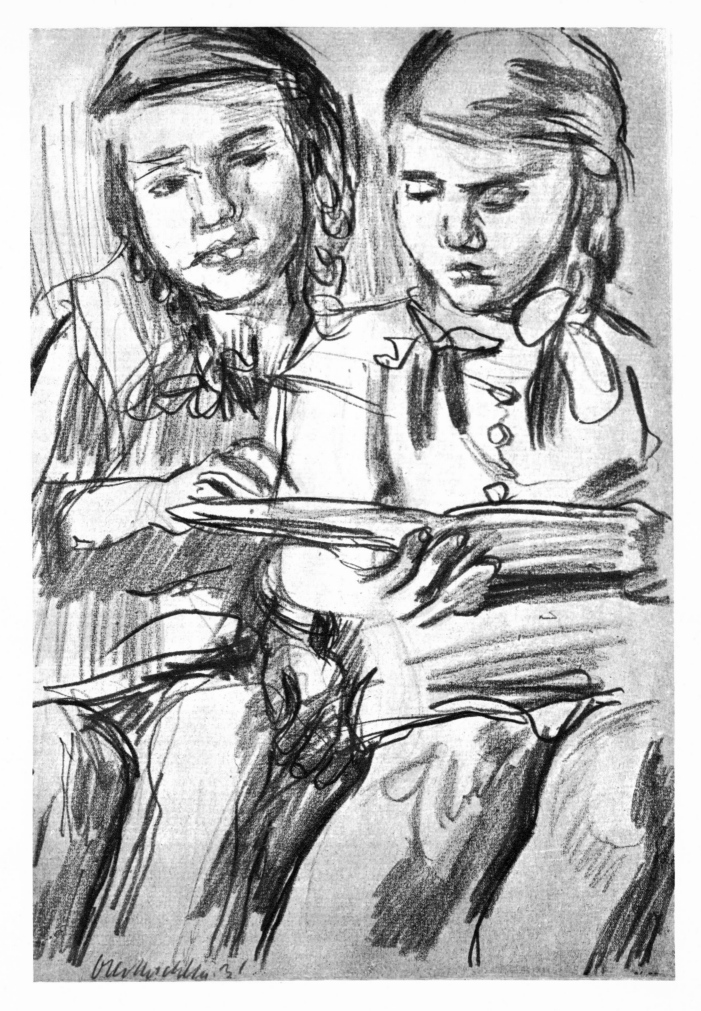

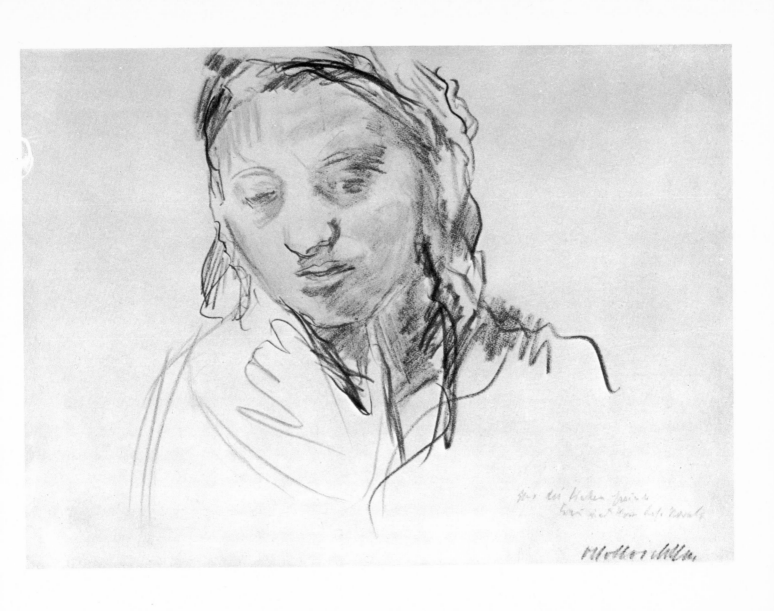

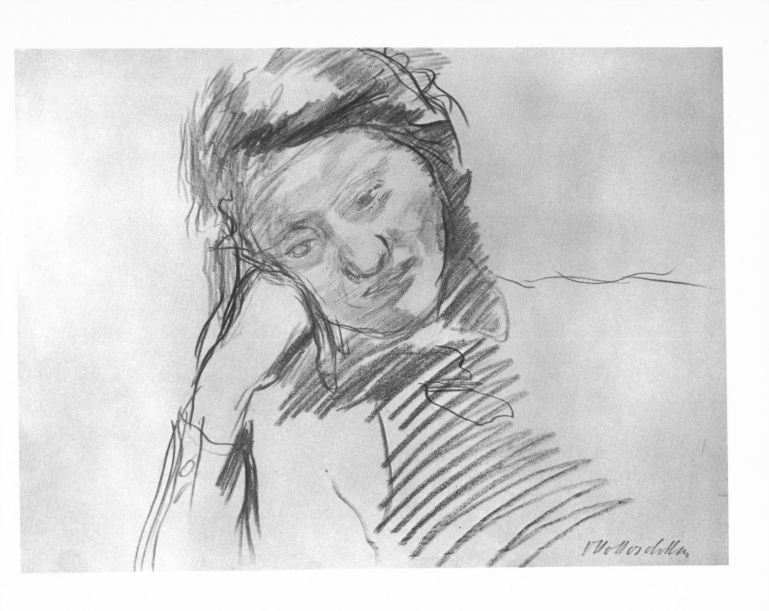

217

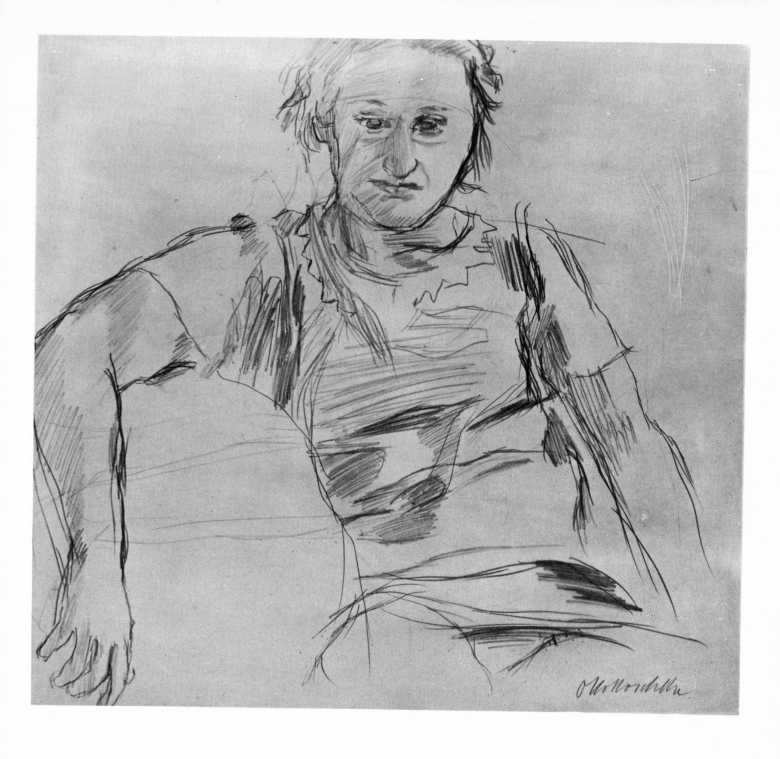

Olda.

1935. Rötel (red chalk). 42 x 32 centimeters.
Photograph from the Welz Gallery, Salzburg.

Signed lower right:
Meinem Quellgeist
Dr. Palky OK.

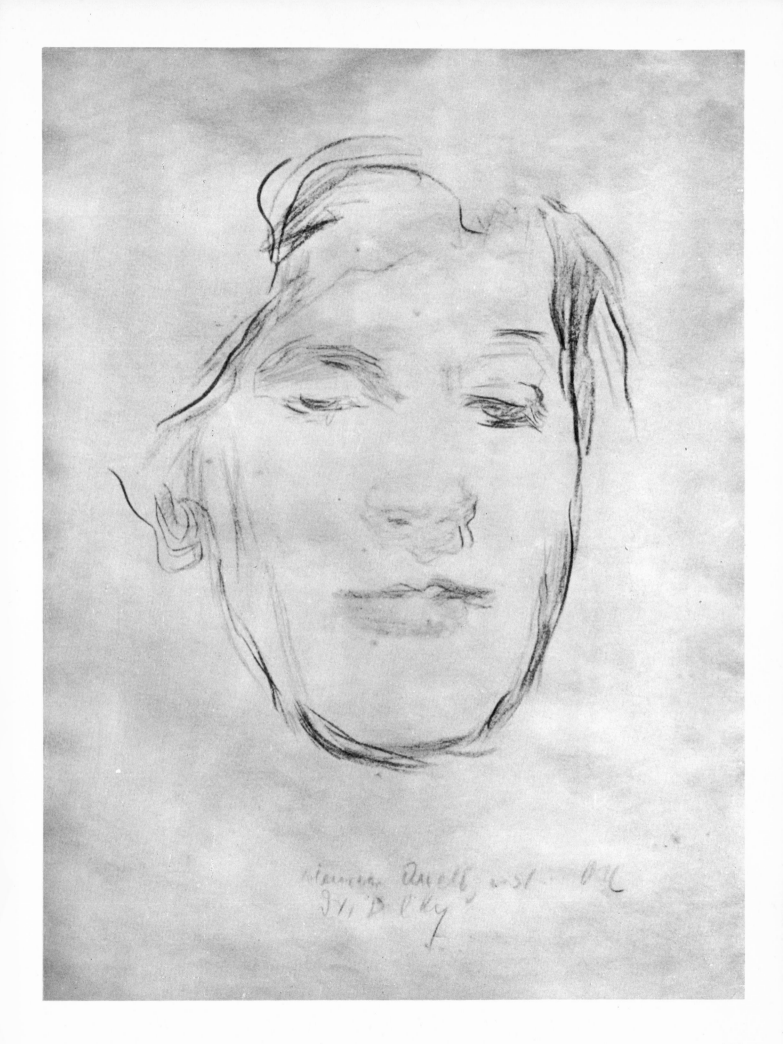

Olda.
1936. Rötel (red chalk). 35 x 30 centimeters.

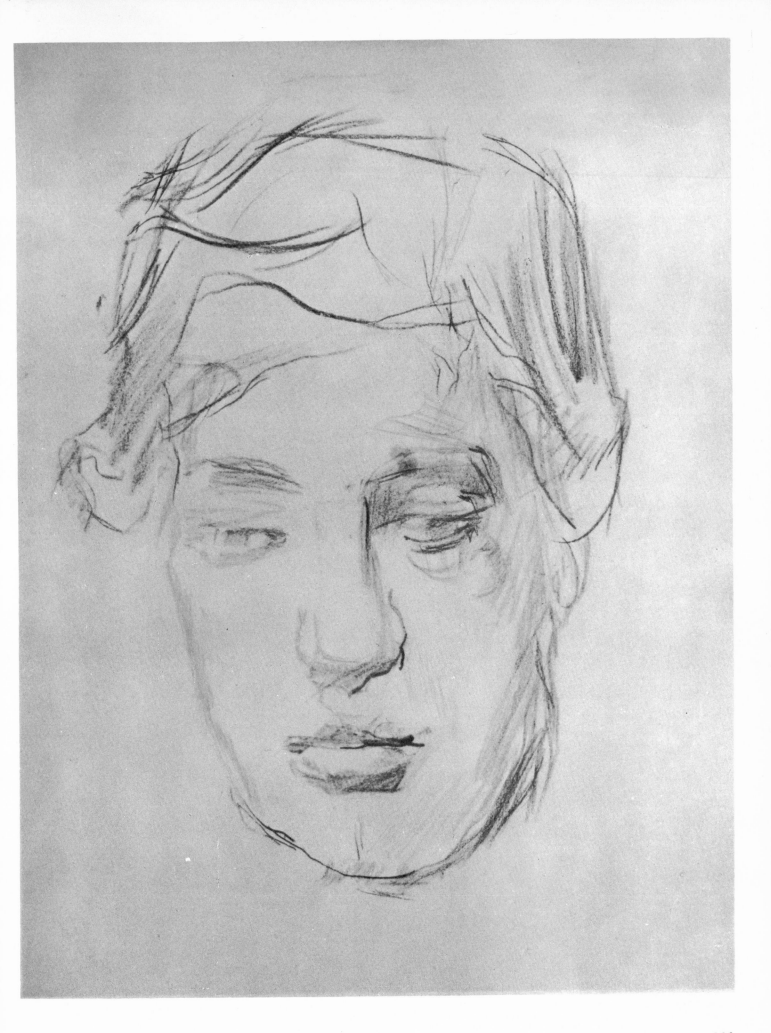

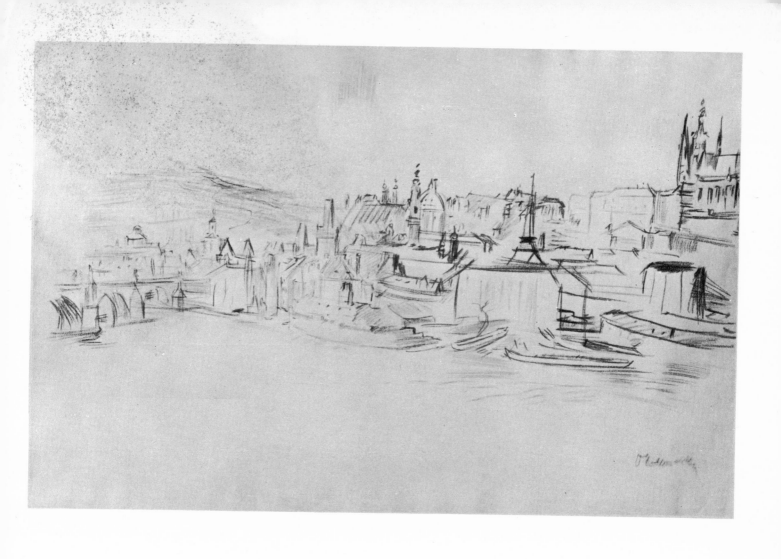

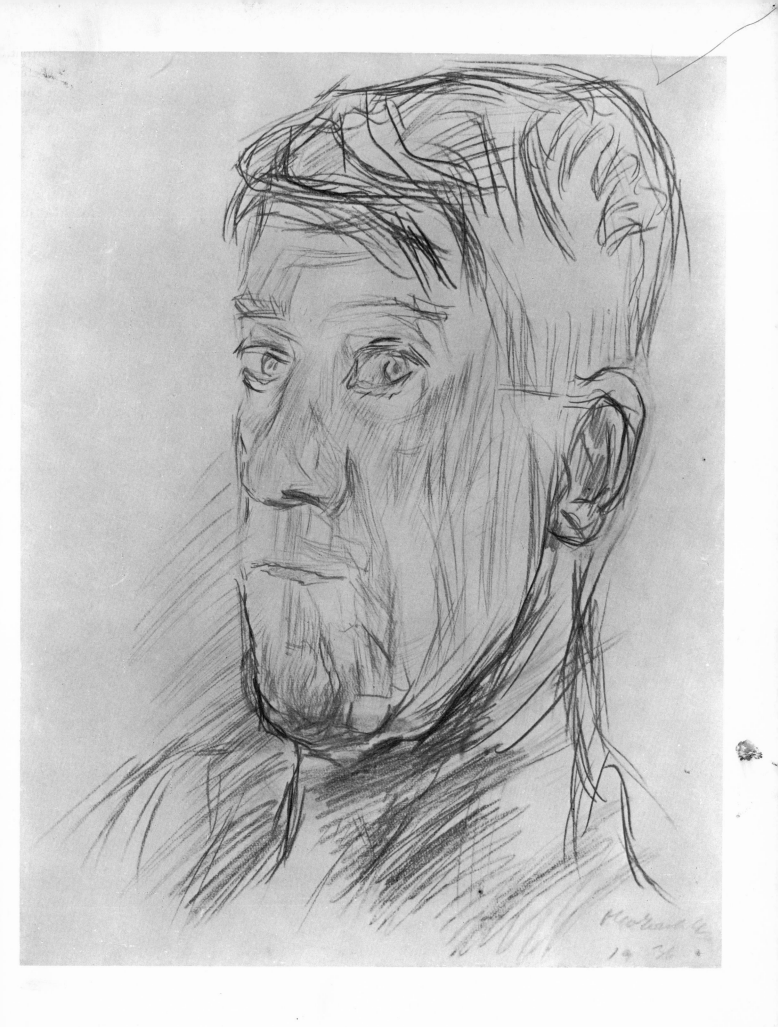

Design for a poster appeal for Basque children, Prague.
1937. Wash. 105 x 80 centimeters.
The Honorable Mrs. Frost, London and Portugal.

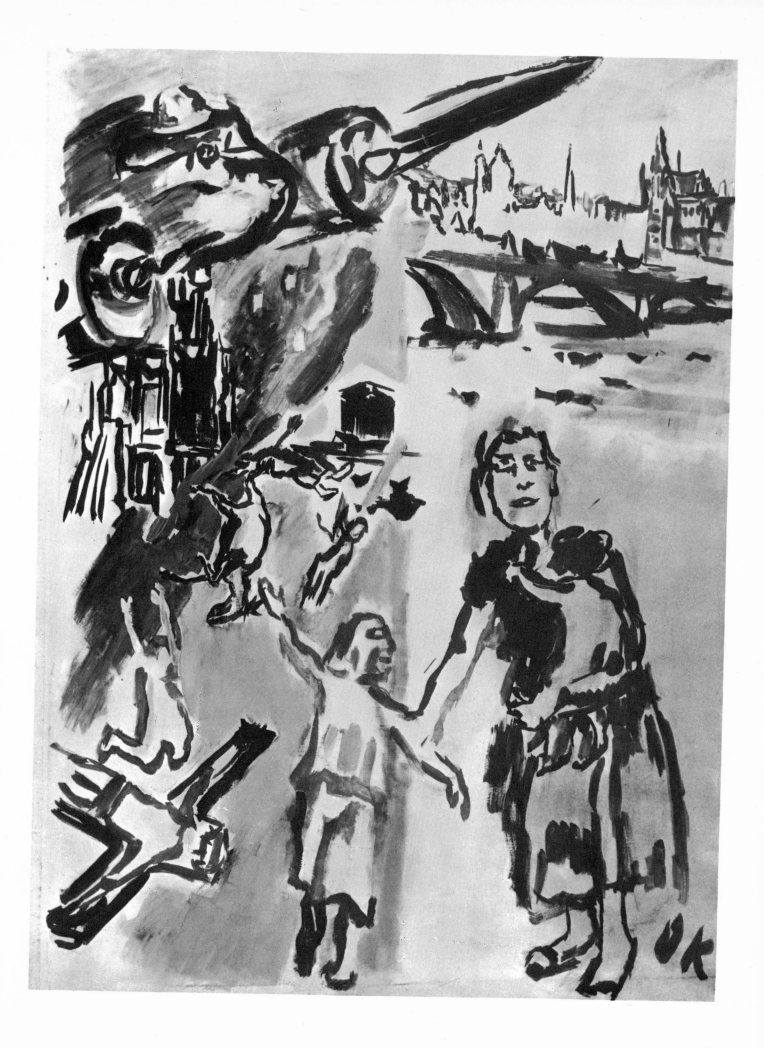

Olda with Flowers in Her Hair.
1938. Rötel (red chalk). 43.2 x 34 centimeters.
Photograph from the Welz Gallery, Salzburg.

Signed lower right:
OKokoschka
Prag 38.

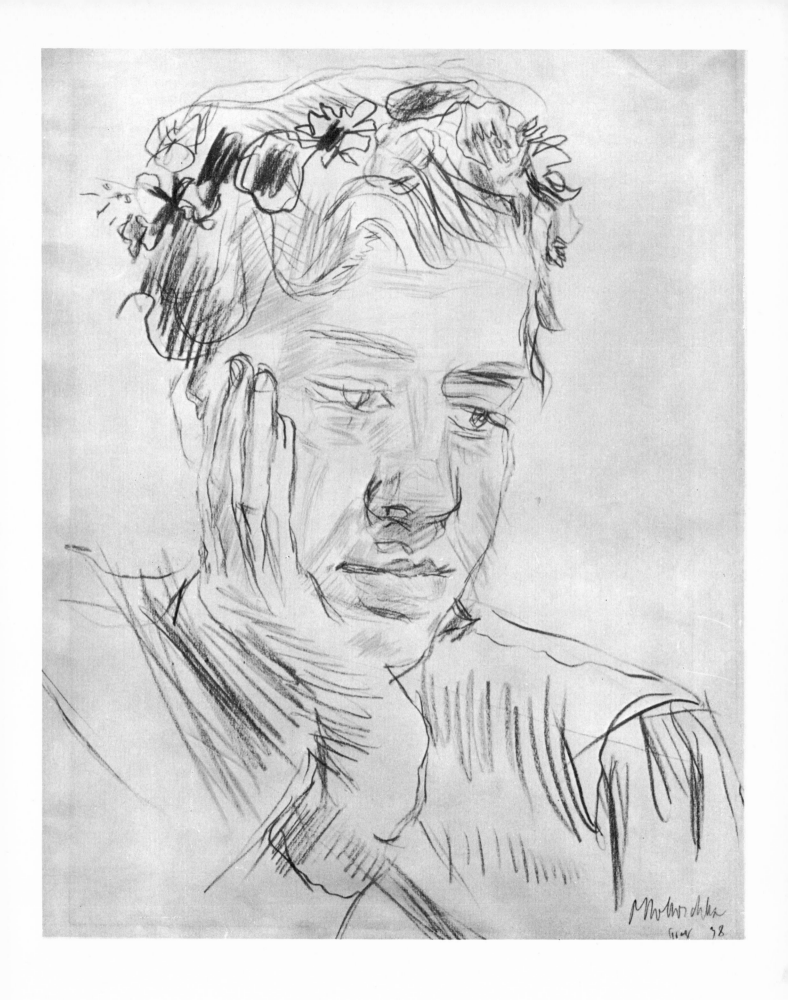

Scottish Farm with Returning Cattle.
1941. Colored crayon. 25 x 35 centimeters.
Wolfgang Gurlitt Gallery, Munich.

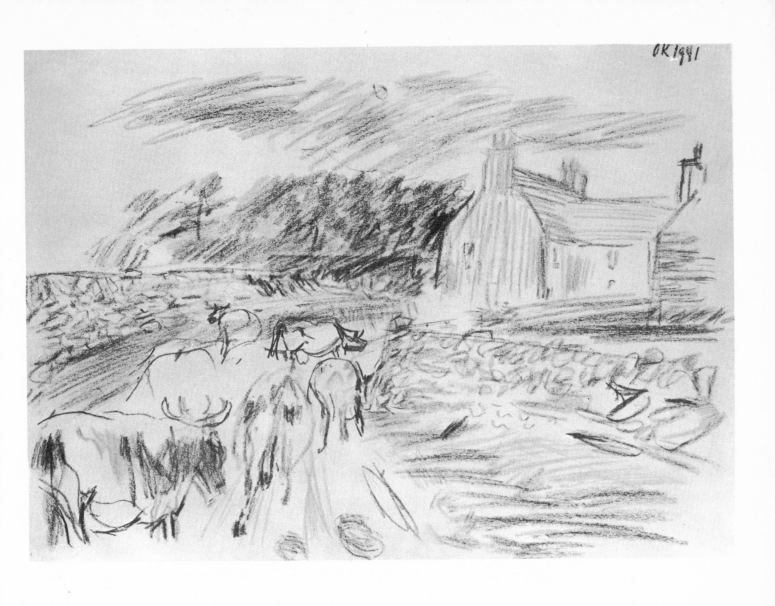

Constance.
1945. Oil crayon. 38 x 28 centimeters.

Signed lower right:
OKokoschka
London 1945.

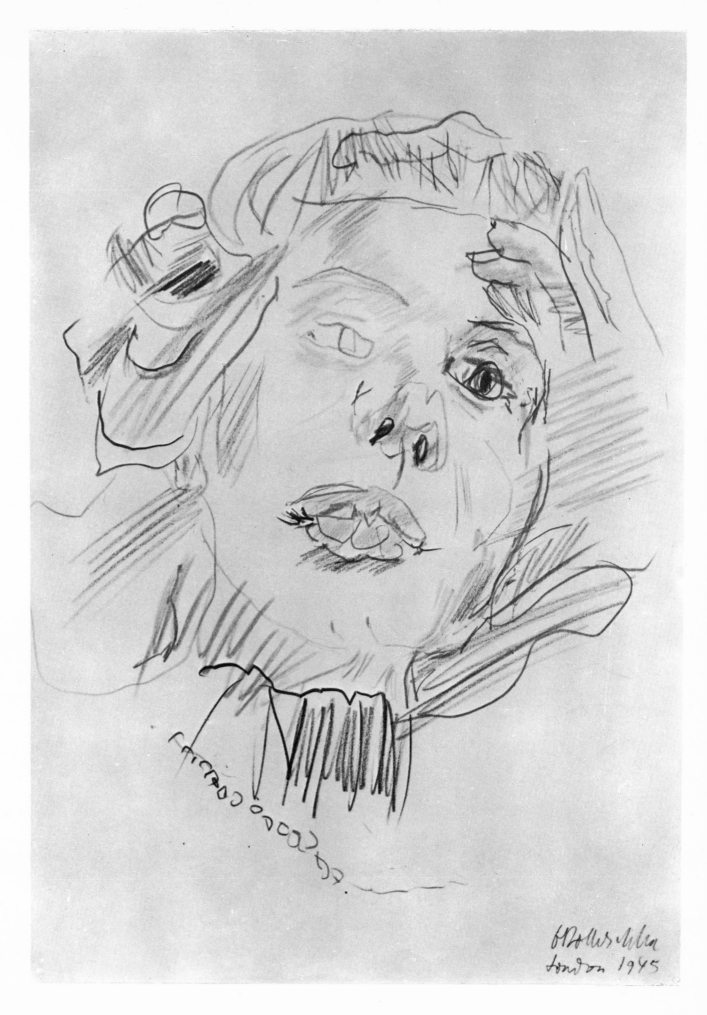

Illustration for Bohuslav (Bohi) Kokoschka's *Ketten in das Meer* ("IV").
1947. Pen, wash. 22.7 x 24.5 centimeters.
Albertina, Vienna.

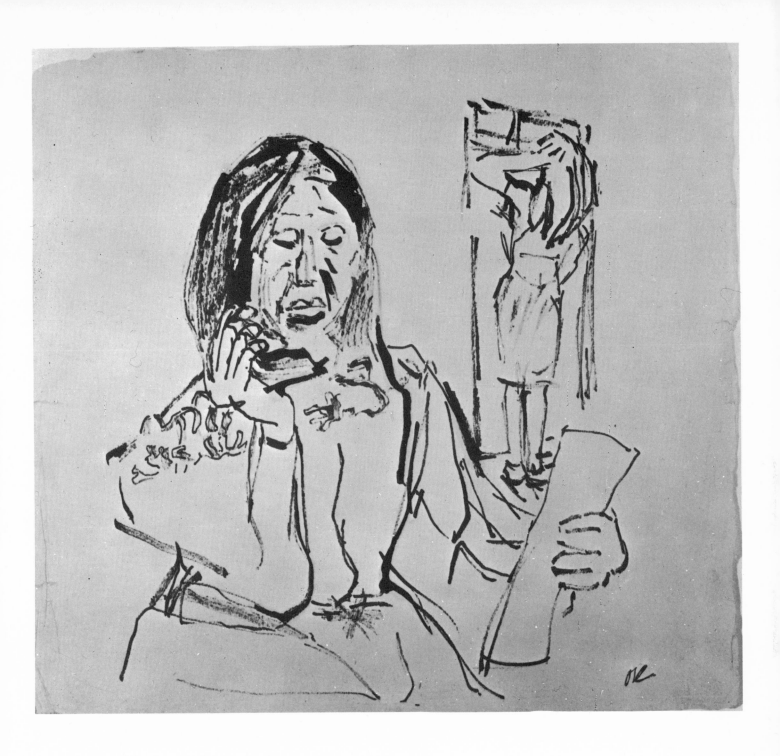

Reclining Female Nude.
1953. Oil crayon. 45.5 x 60.5 centimeters.

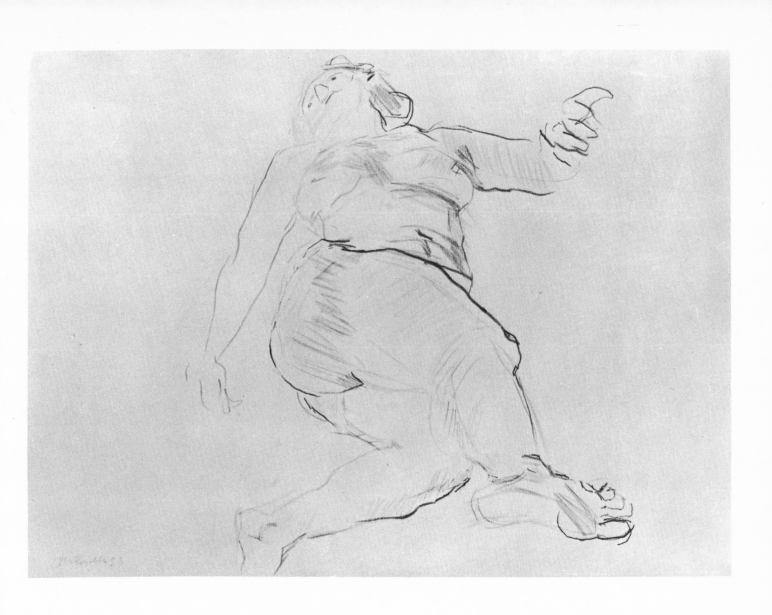

Female Nude, Walking with Arms Raised.
1953. Oil crayon. 40 x 30 centimeters.

Signed lower left:
OK 53, Salzburg.

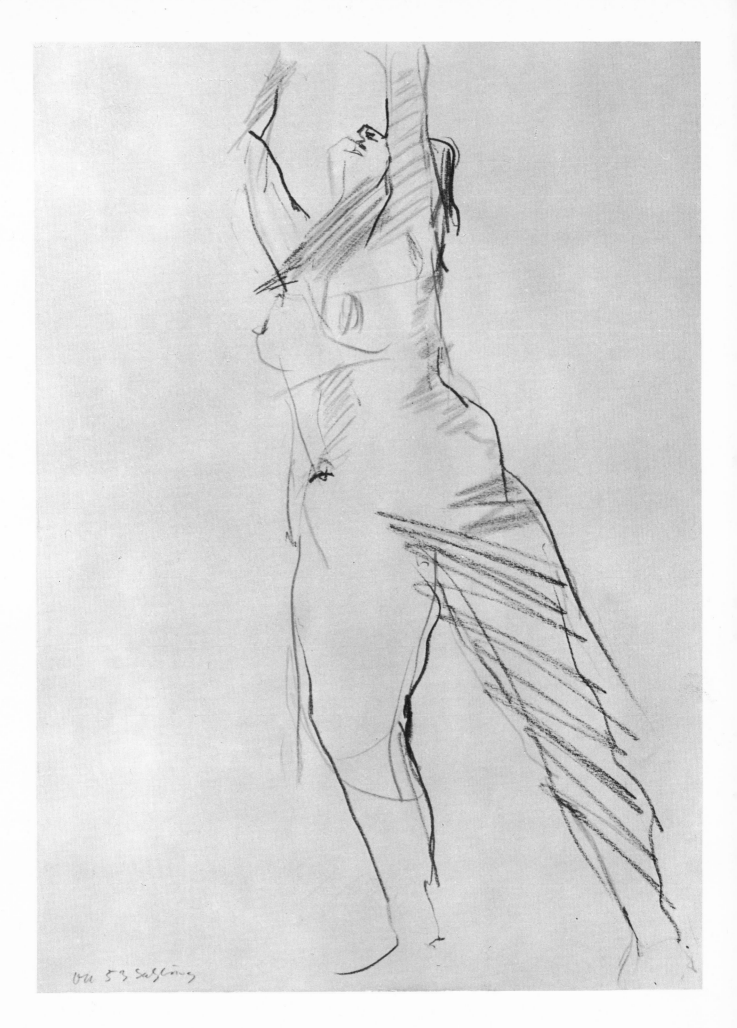

Oct 53 Salzburg

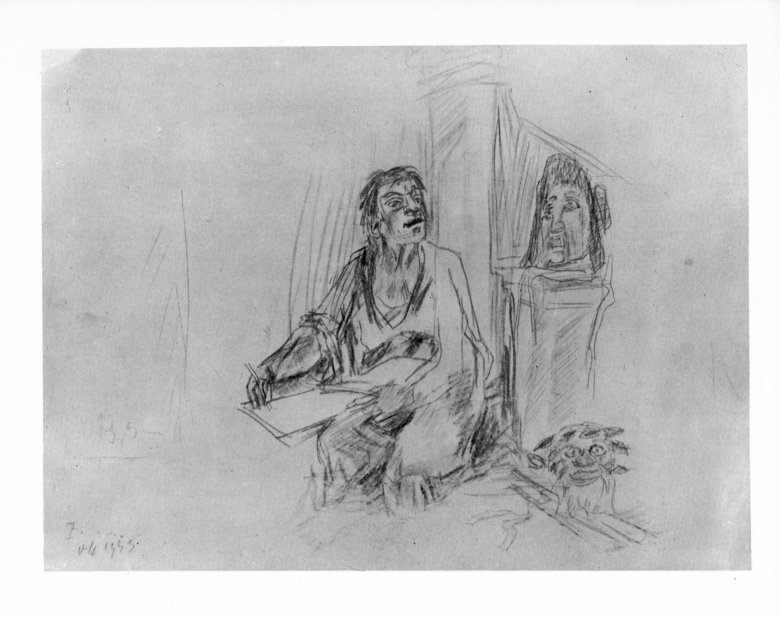

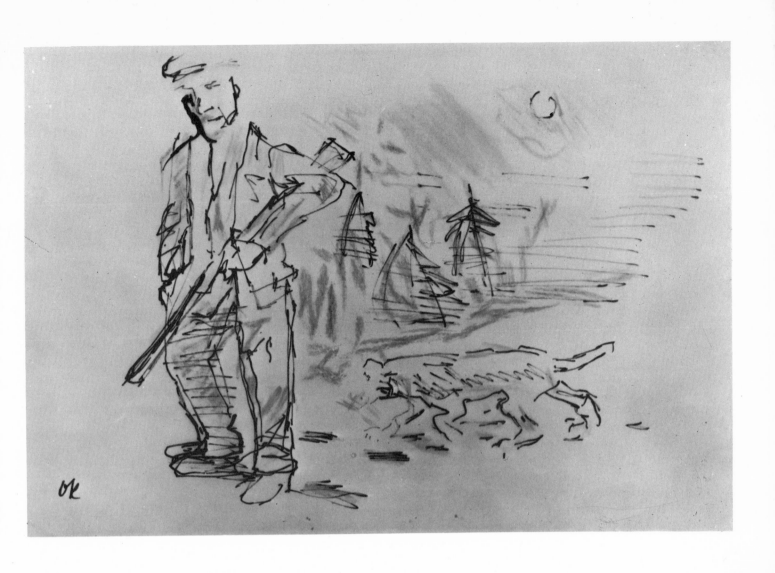

Ernest Rathenau.
1958. Chalk crayon. 60.2 x 49.2 centimeters.
Ernest Rathenau, New York.

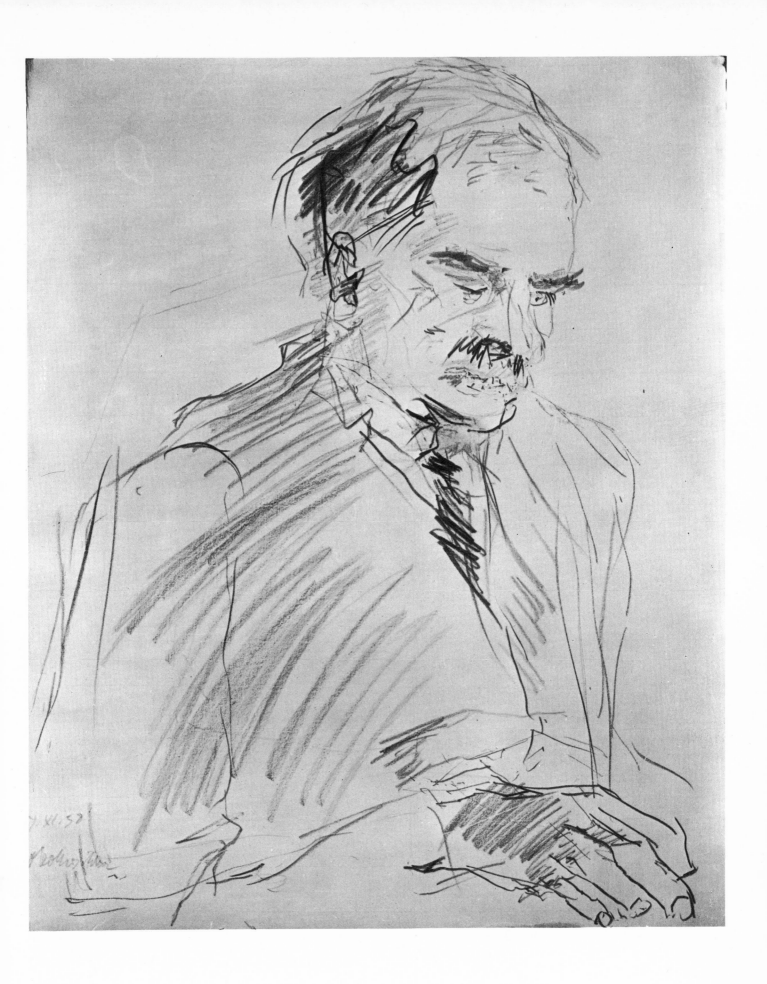

247

Herodotos.
1961. Wash. 46.5 x 38 centimeters.
In the possession of the artist.

Title page for *The* (London) *Times Literary Supplement*, October 13, 1961.
Signed upper left: *Herodotos*.
lower right: *OK*.

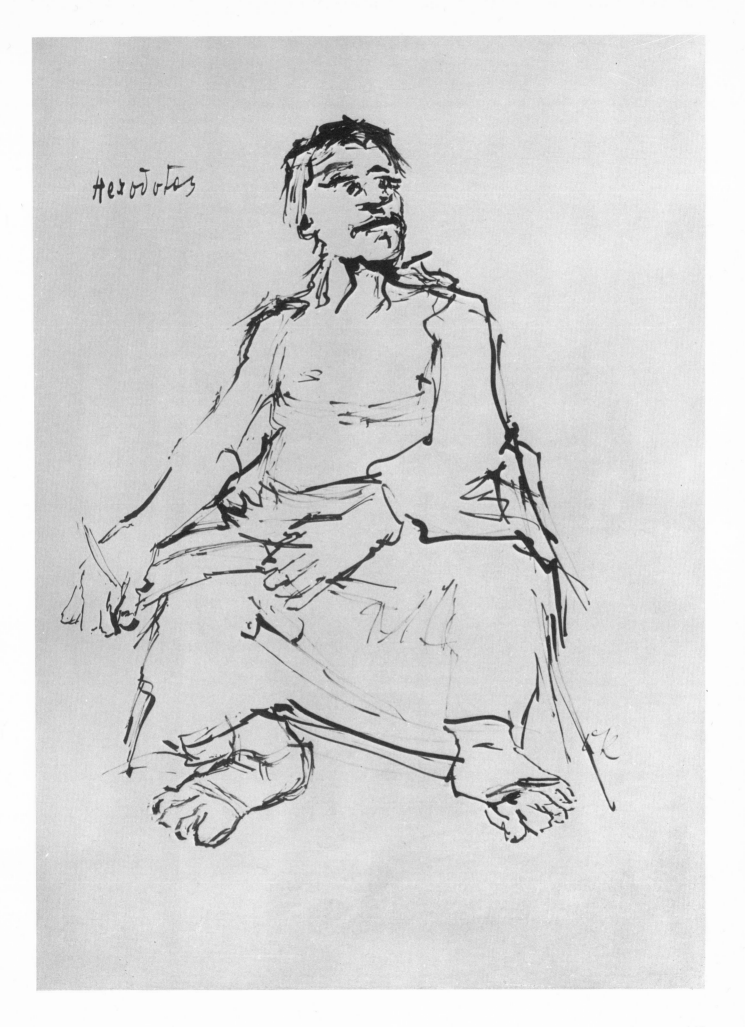

Herodotos

249

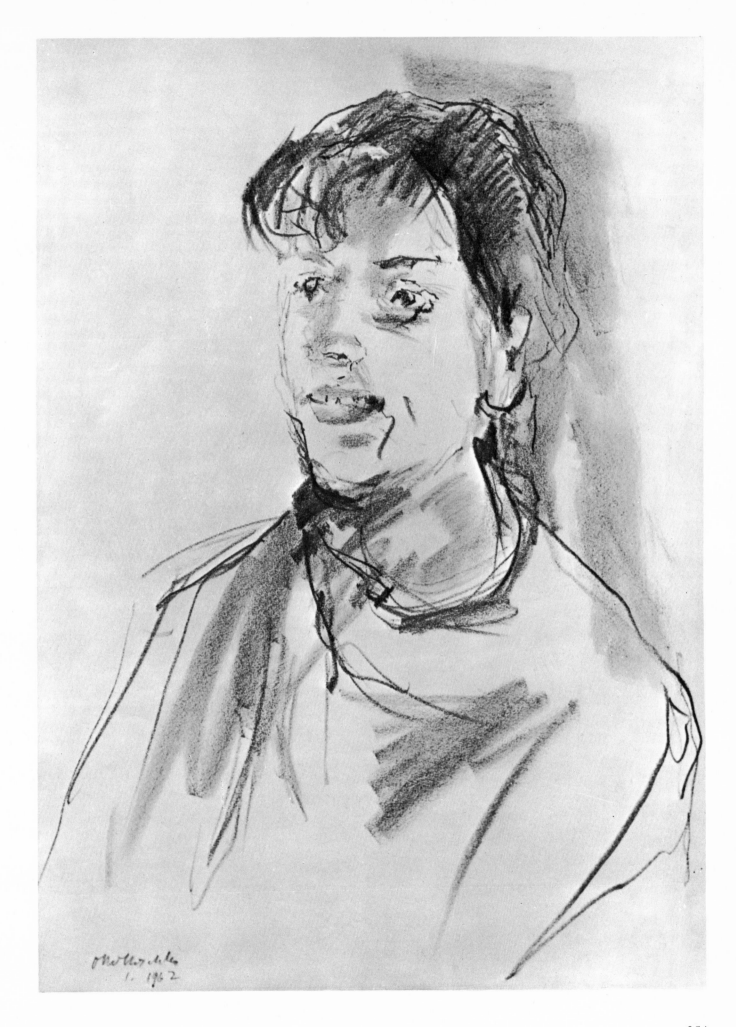

Lion Cub, Feeding.
1962. Oil crayon. 24.5 x 35.5 centimeters.

Signed lower left:
OK London Zoo, 62.

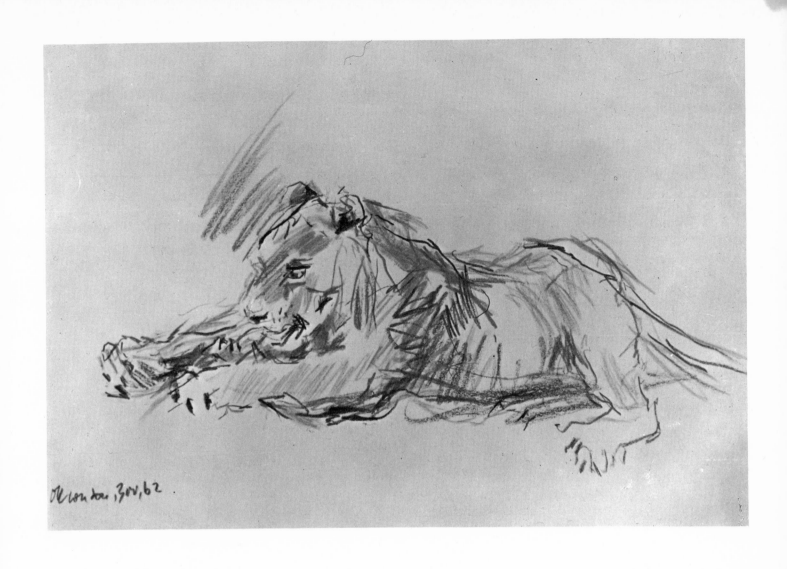

London, 3.IV.62

Elephant.
1963. Oil crayon. 24.5 x 34.5 centimeters.

Signed lower left:
OK Zircus Knie, 63, London.

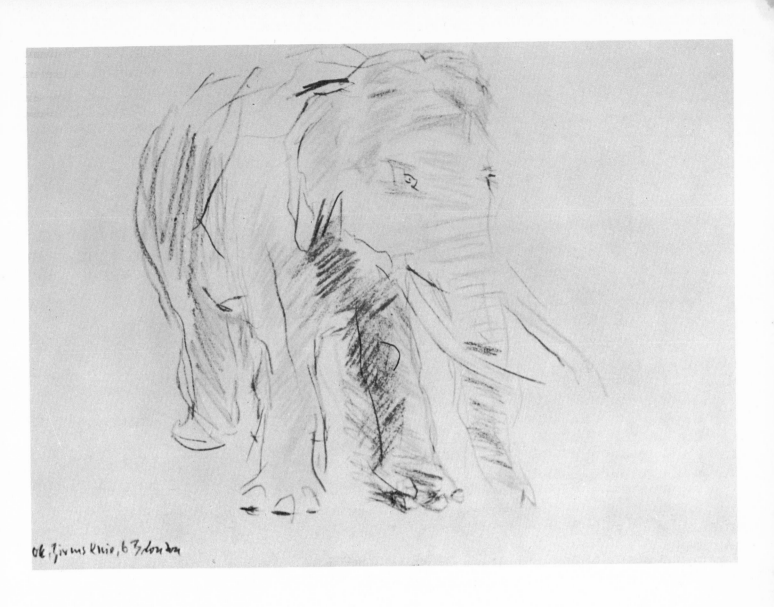

Ok, Givens Knie, 6.3. London

Study for Portrait of Alice.
1963. Chalk crayon. 58 x 45.8 centimeters.
Collection of Dr. and Mrs. John Rewald, New York.

Signed upper left:
Alice
OK
63

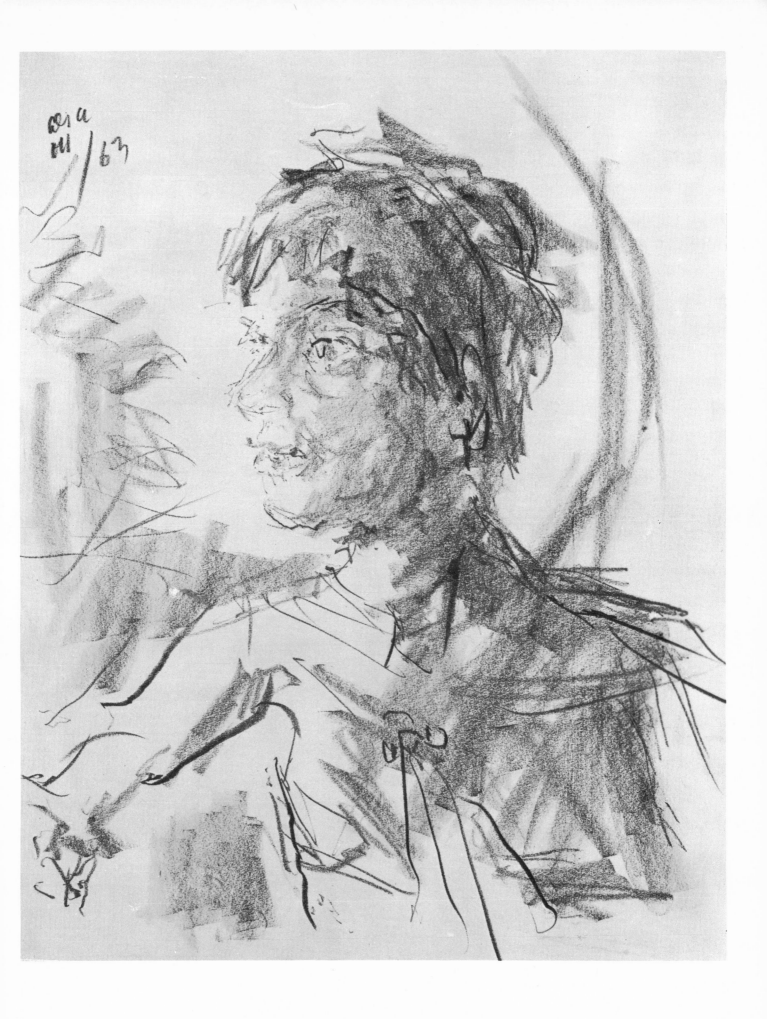

257

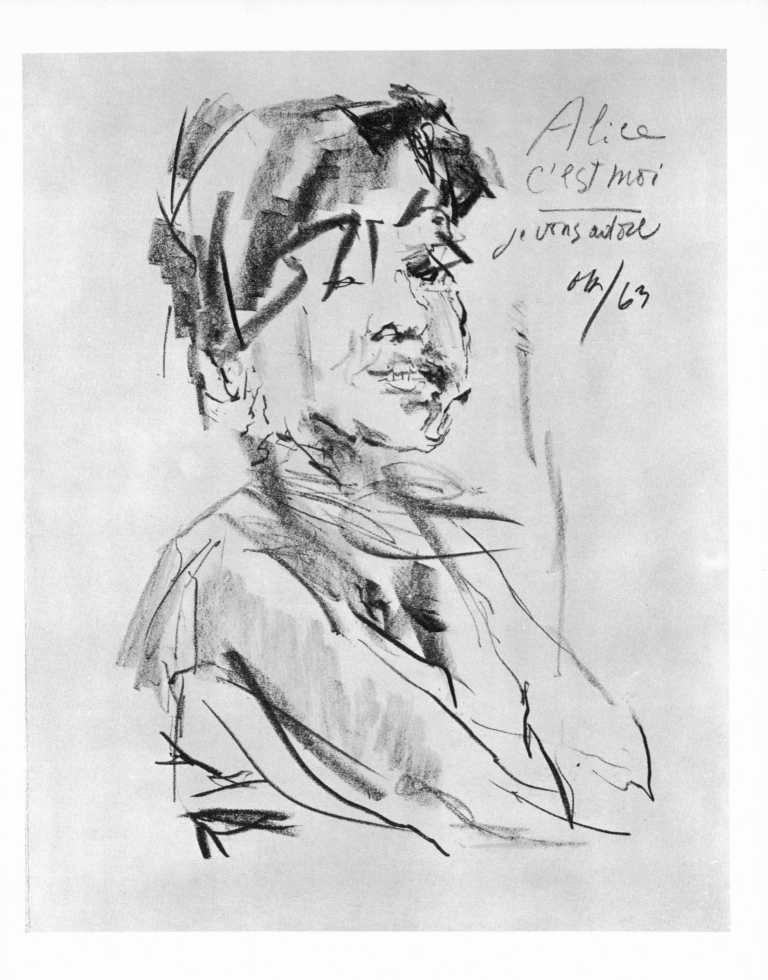

Ezra Pound.
1963. Grease crayon. 57 x 45 centimeters.
In the possession of the artist.

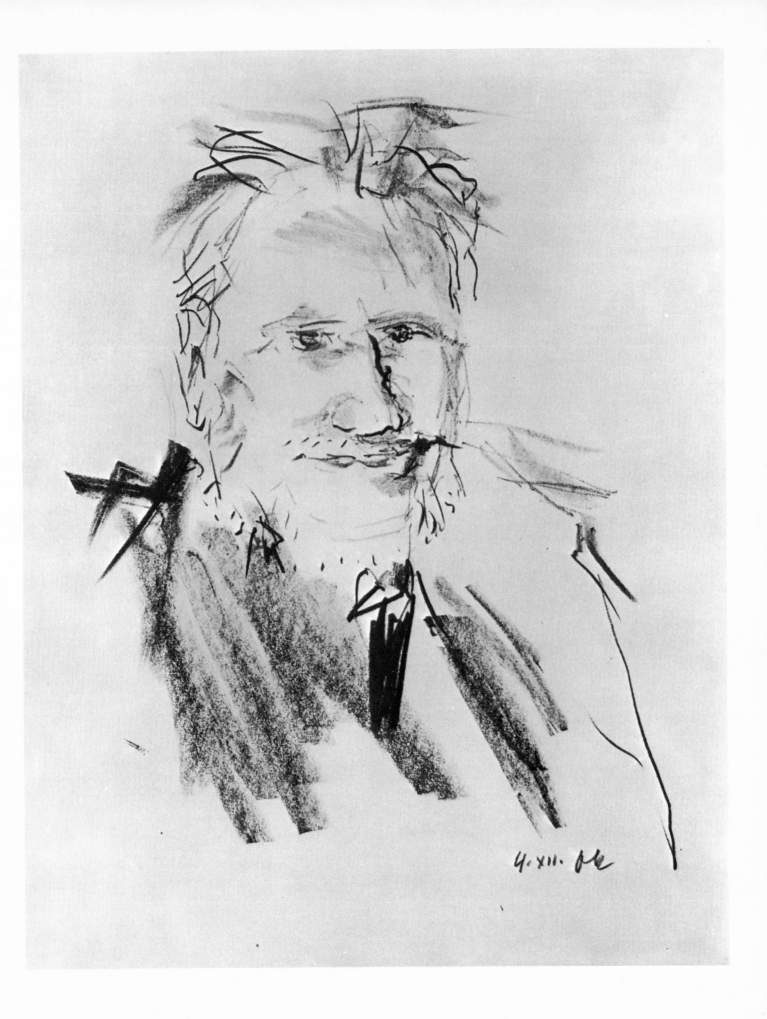

Veska, Frontal View.
1964. Chalk crayon. 58.5 x 46 centimeters.

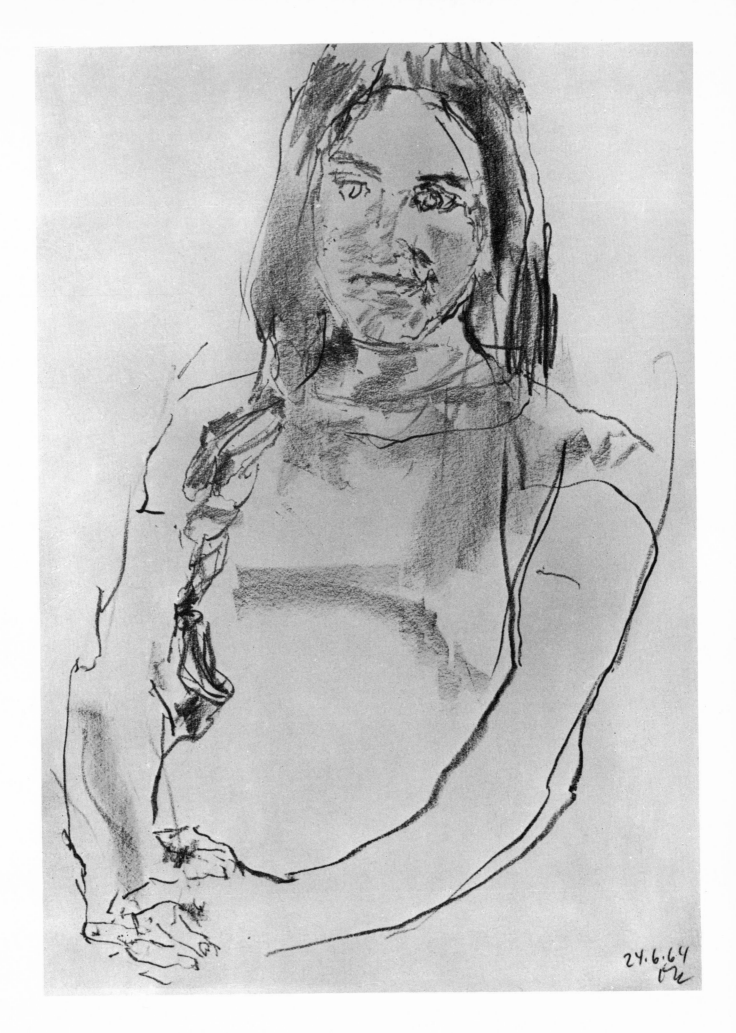

24.6.64

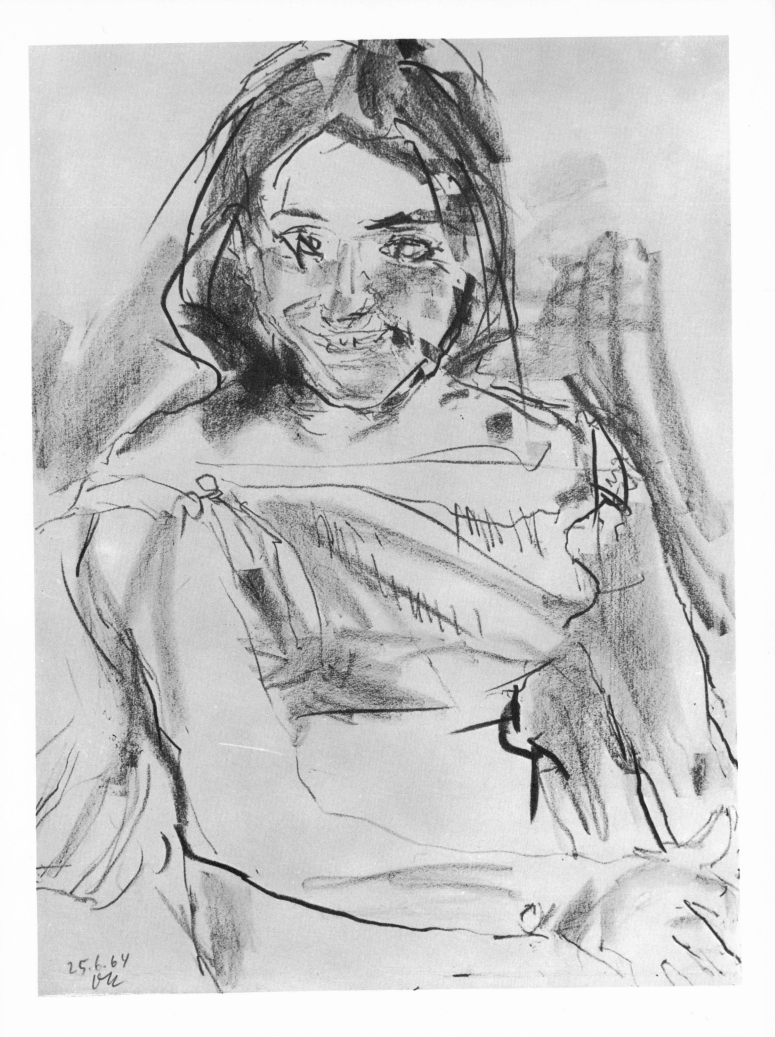

25.6.64

265

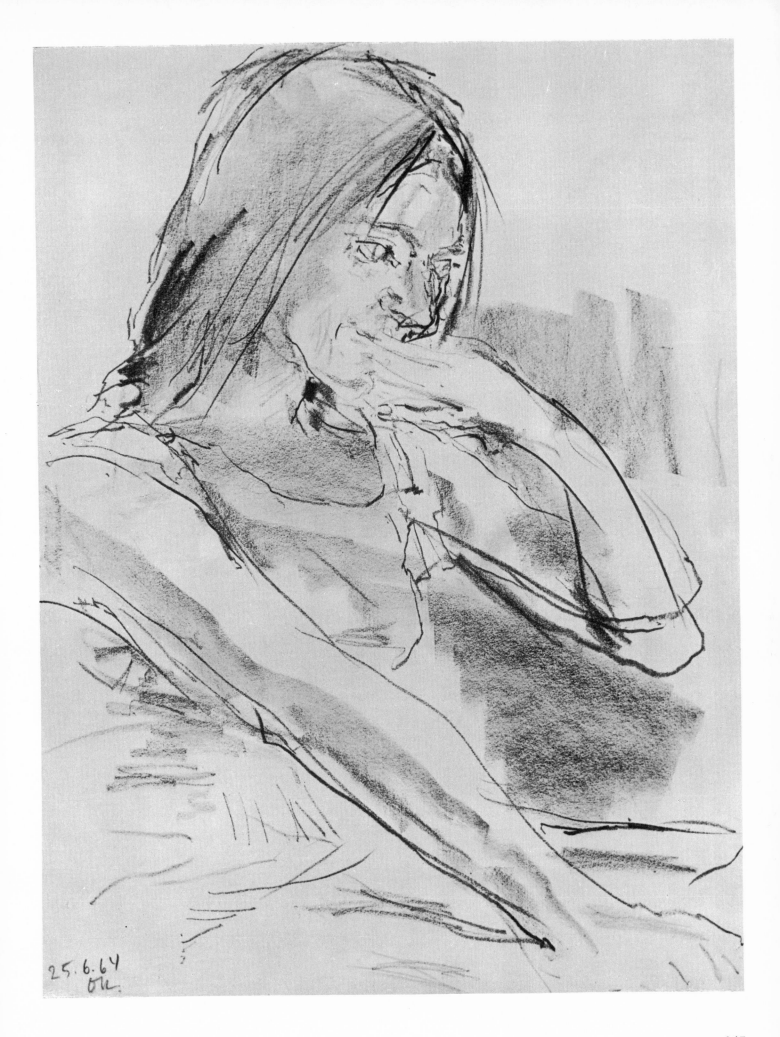

25.6.64
OK.

Carl Georg Heise.
1964. Chalk crayon. 63 x 50.5 centimeters.
Carl Georg Heise, Nussdorf on the Inn.

Signed lower right:
Mein Bassa
1. 8. 64 OKokoschka.

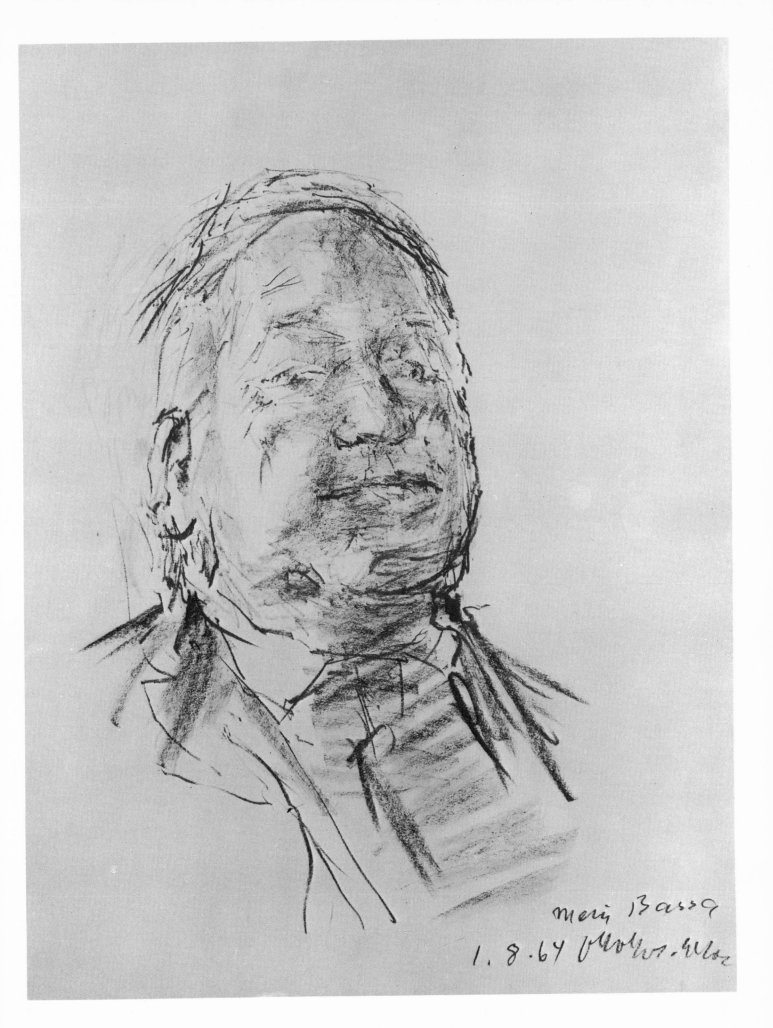

1.8.64

J. P. Hodin.
1964. Chalk crayon. 63 x 48 centimeters.
Dr. J. P. Hodin, London.

Signed lower left:
dies ist mein letzter
Freund, Pepi Hodin,
genannt der Magister Artis,
aus meiner grossen Wiener Zeit
OKokoschka 26
XI. 64.

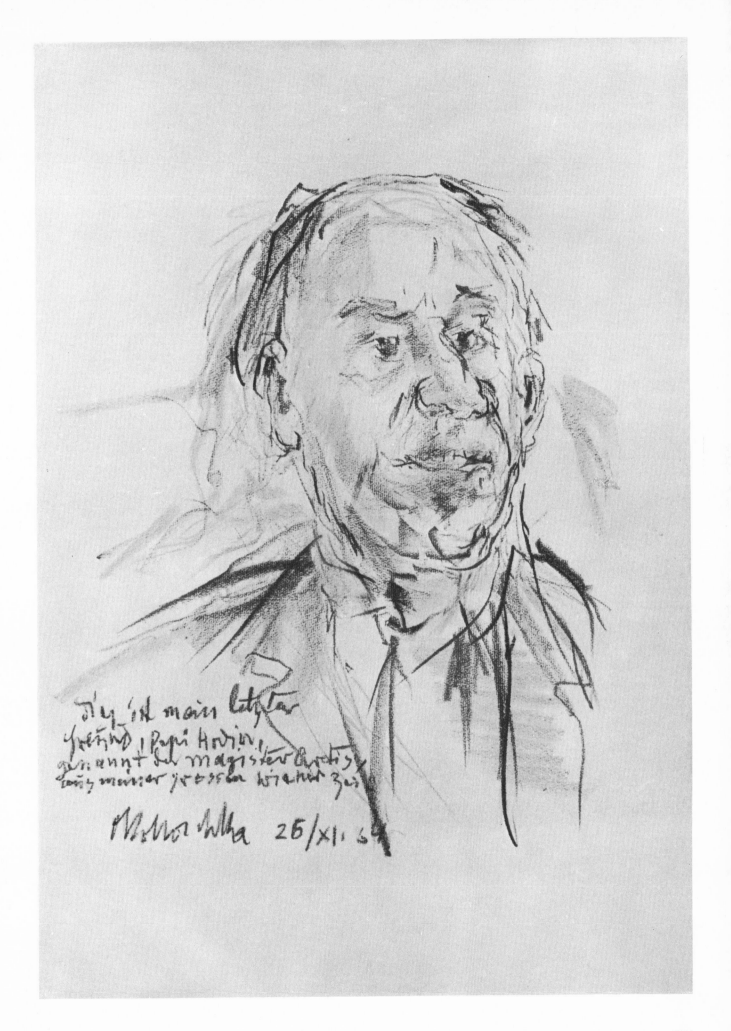

Dies ist mein letzter
Freund, Papi Hodin,
genannt der Magister Legitis,
seit meiner grossen Wiener Zeit

OKokoschka 26/XI 64

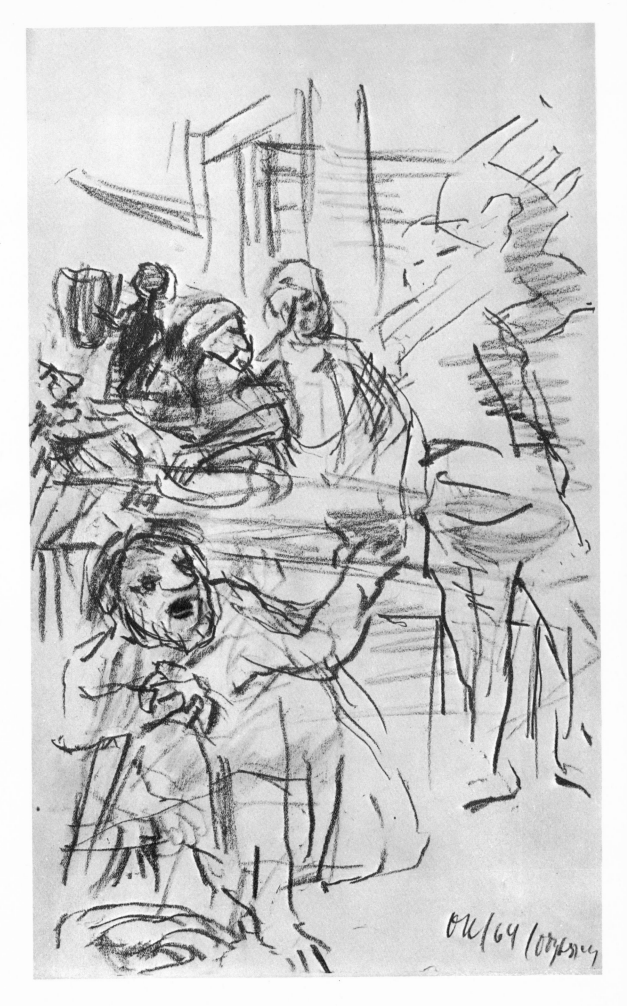

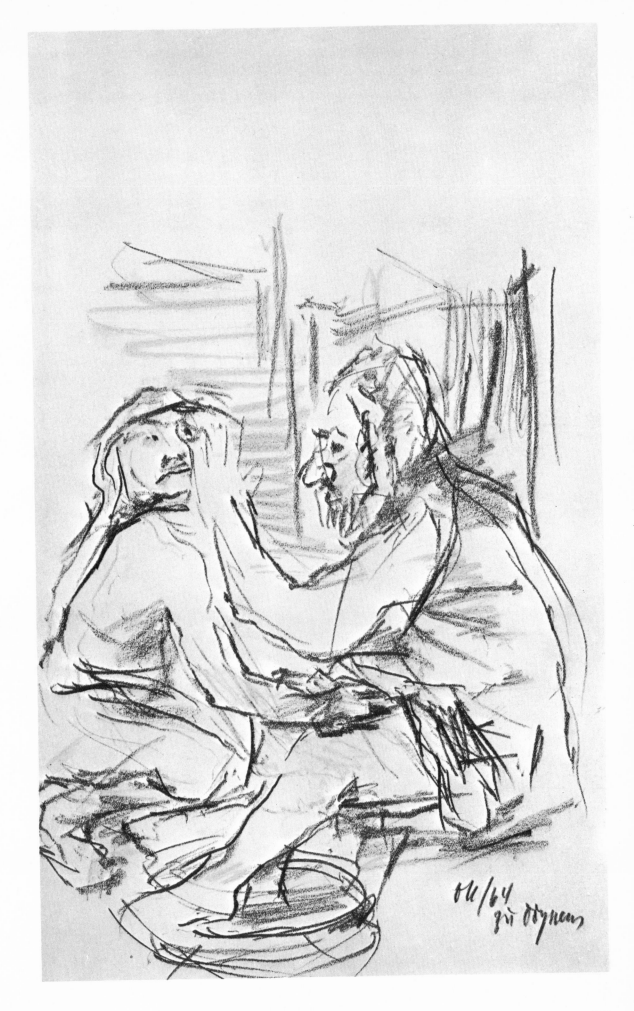

Odyssey, Aeneas and Anchises.
1965. Pencil. 56.5 x 39.5 centimeters.

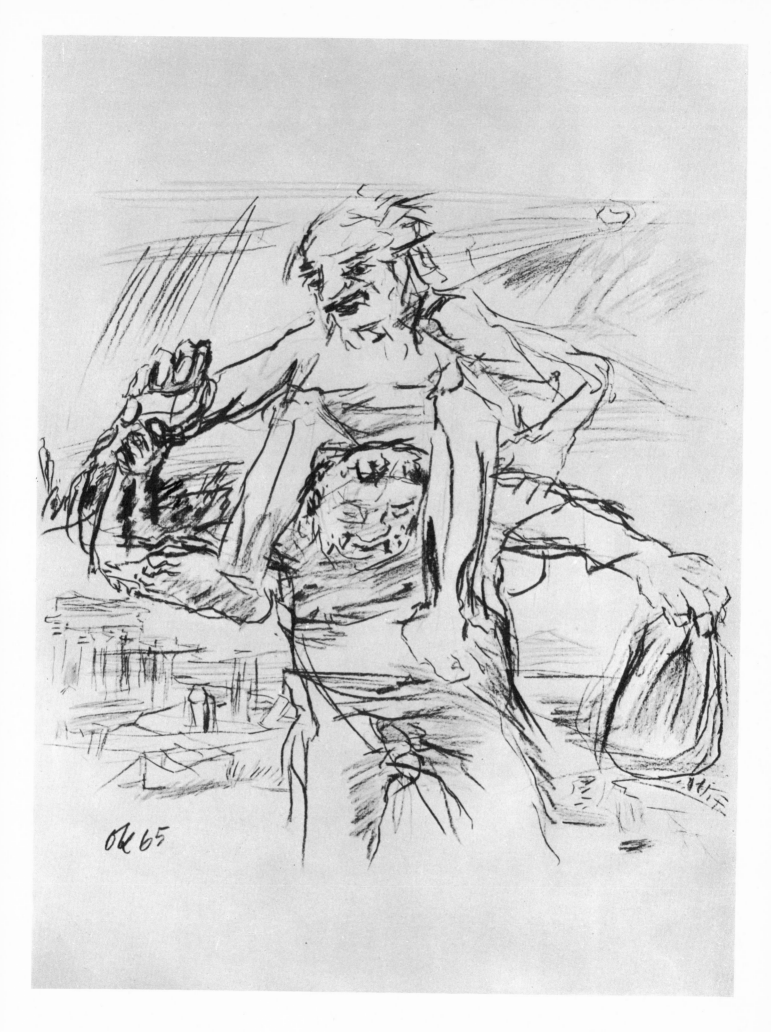

Odyssey, A Boar Wounds the Youthful Ulysses.
1965. Pencil. 56.5 x 39.5 centimeters.

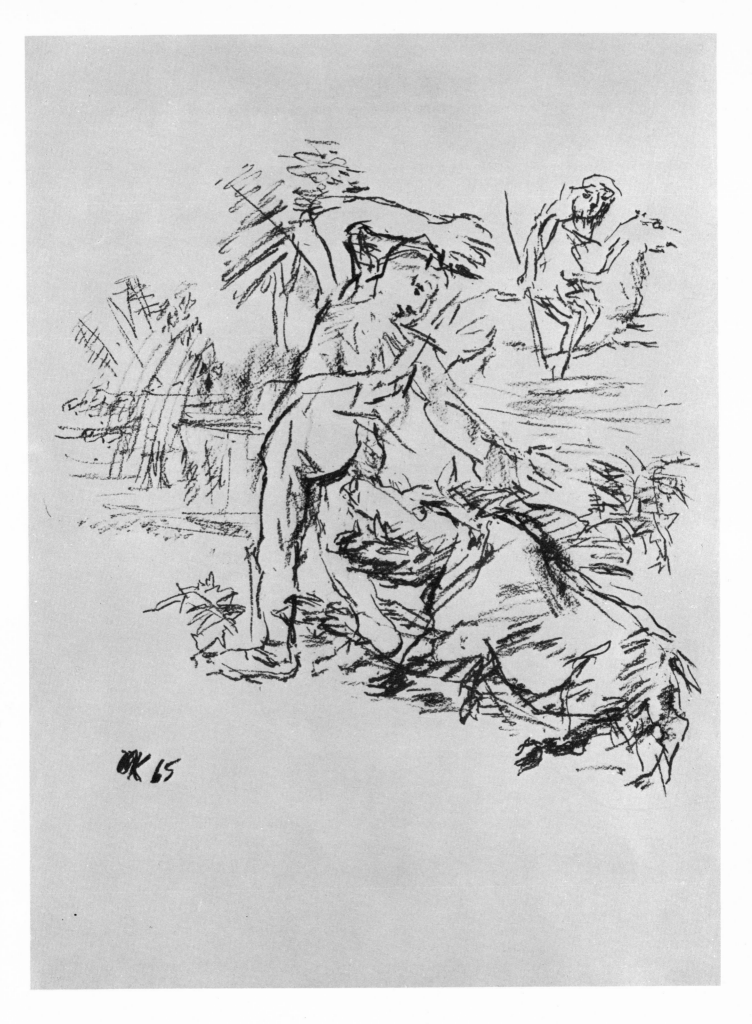

Odyssey, Dancing Slave Girl.
1965. Pencil. 56.5 x 39.5 centimeters.

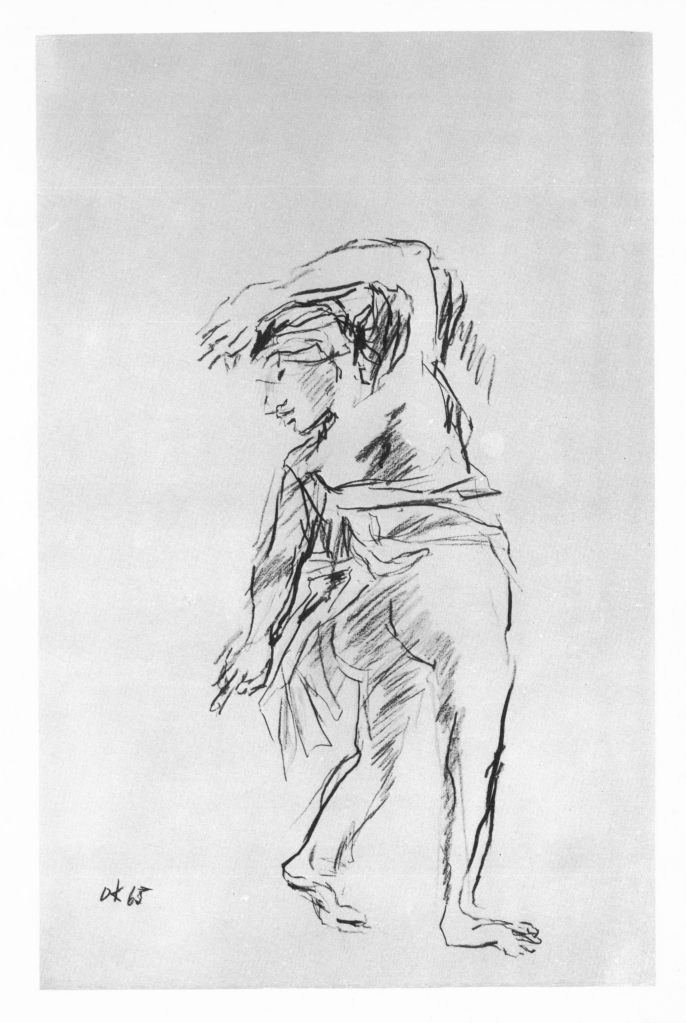

Landscape, Morocco (Atlas Mountains).
1965. Black lithograph crayon. 32.5 x 50 centimeters.

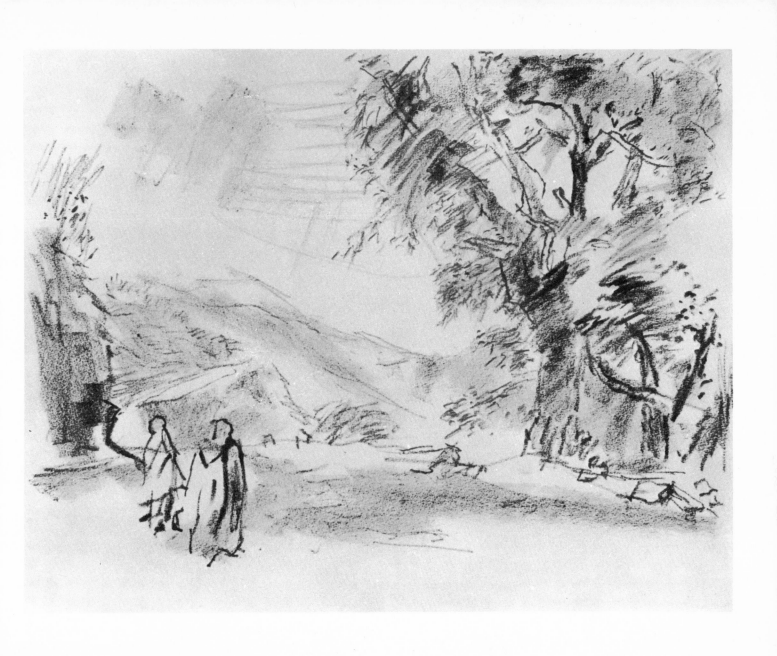

Willy Hahn.
1965. Reed pen, wash. 52.3 x 37.4 centimeters.
Private ownership.

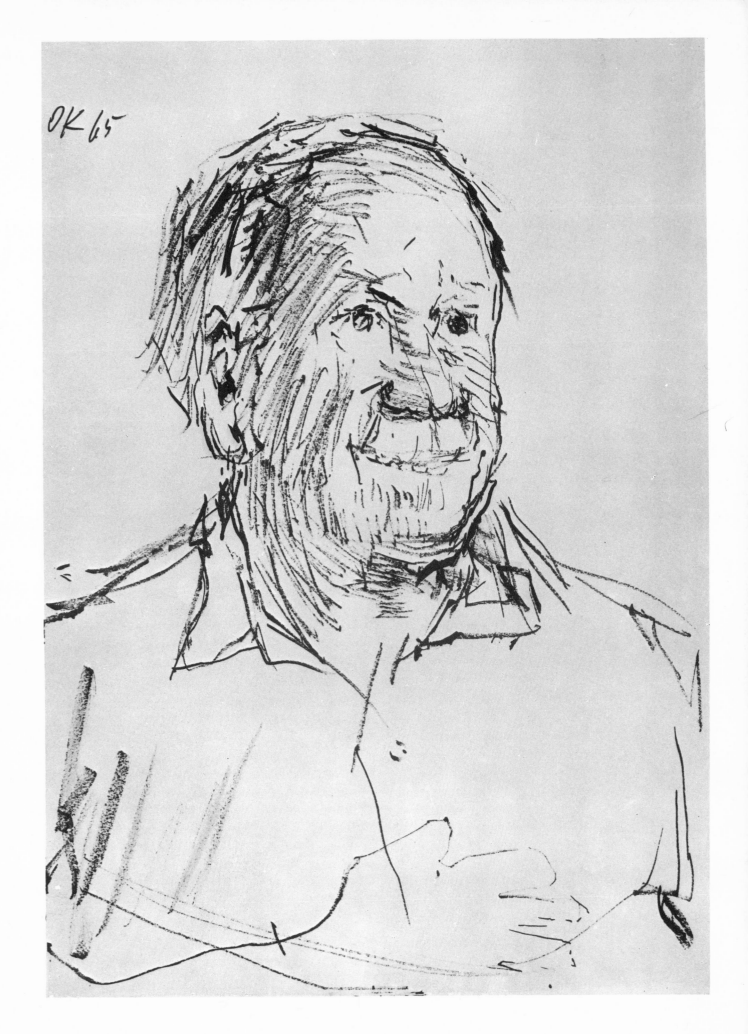

OK 65